COMMUNICATING WITH THE WORLD OF BEINGS

The World Heritage rock art sites in Alta, Arctic Norway

Published in the United Kingdom in 2014 by
OXBOW BOOKS
10 Hythe Bridge Street, Oxford OX1 2EW

and in the United States by
OXBOW BOOKS
908 Darby Road, Havertown, PA 19083

Original Norwegian version published by:	Tromsø University Museum, UiT The Arctic University of Norway, Tromsø Museums Skrifter XXXIII 2012
Photographs:	Knut Helskog, unless otherwise indicated
Layout and design:	Ernst Høgtun
Digital photo processing:	Adnan Icagic

English edition © Oxbow Books and Knut Helskog; Tromsø University Museum, UiT The Arctic University of Norway
Published with financial support from: SpareBank 1 Nord-Norge

Hardcover Edition: ISBN 978-1-78297-411-6
Digital Edition: ISBN 978-1-78297-412-3

A CIP record for this book is available from the British Library

All rights reserved. No part of this book may be reproduced or transmitted in any form or by any means, electronic or mechanical including photocopying, recording or by any information storage and retrieval system, without permission from the publisher in writing.

Printed in the United Kingdom by Berforts Information Press

For a complete list of Oxbow titles, please contact:

UNITED KINGDOM
Oxbow Books
Telephone (01865) 241249, Fax (01865) 794449
Email: oxbow@oxbowbooks.com
www.oxbowbooks.com

UNITED STATES OF AMERICA
Oxbow Books
Telephone (800) 791-9354, Fax (610) 853-9146
Email: queries@casemateacademic.com
www.casemateacademic.com/oxbow

Oxbow Books is part of the Casemate Group

Front cover: Human-like figures lifting poles shaped at the top like the head of an elk cow © Knut Helskog
Back cover: A large composition on one of the panels in Hjemmeluft © Knut Helskog

COMMUNICATING WITH THE WORLD OF BEINGS

The World Heritage rock art sites
in Alta, Arctic Norway

Knut Helskog

Translated by Tim Challman

Oxbow Books
Oxford & Philadelphia

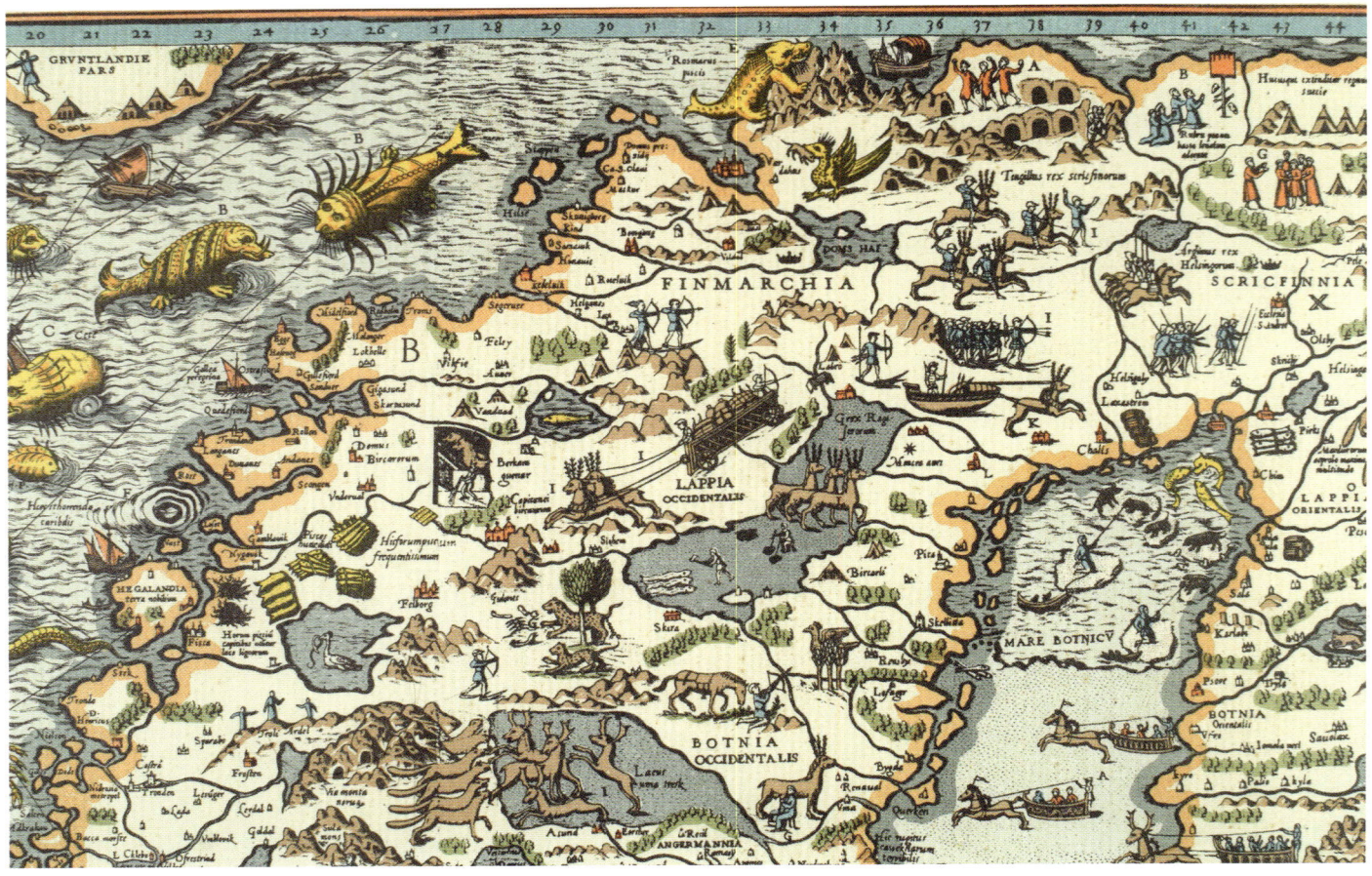

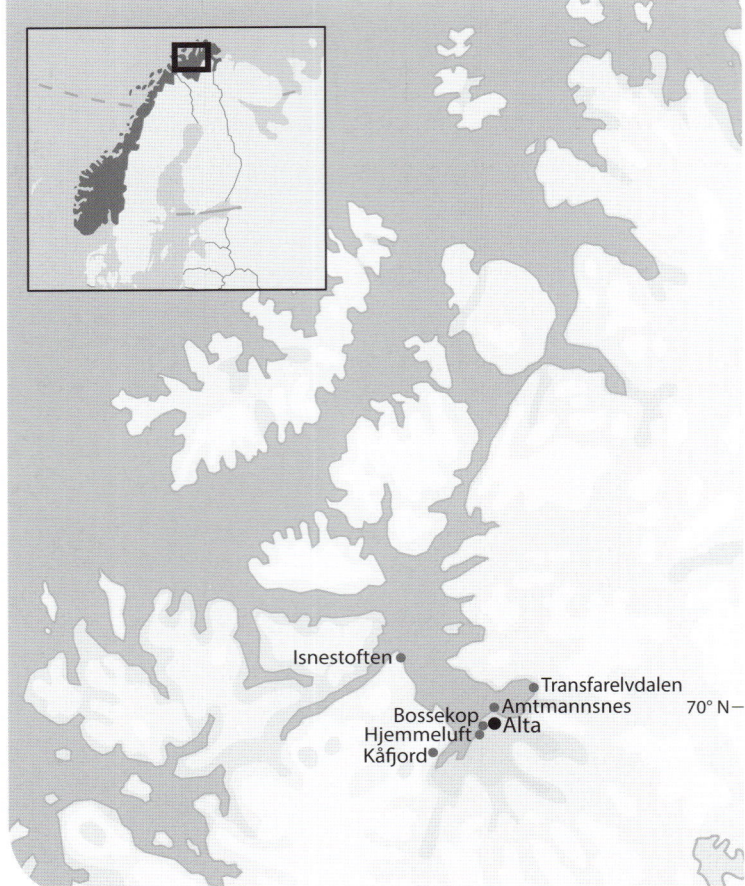

A section of the Carta Marina developed by Olaus Magnus and published in Venice in 1539. The map illustrates a coastal and inland area rich in fauna, and people hunting and at prayer, as well as some armed for battle. Alta is located in one of the small fjords to the left of the inscription Finnmarchia.

Altafjord today, with the rock art sites.

FOREWORD	6
INTRODUCTION	10
THE WORLD OF BEINGS	14
THE NATURAL SURROUNDINGS	24
AGE	28
MAKING ROCK ART	34
PERIOD I	40
PERIOD II	46
Human Figures	51
Reindeer	58
Elk	68
Bear	74
Other land animals and birds	86
Fish and sea mammals	88
Boats	89
Equipment	94
Abstract Figures	95
Summary	98
PERIOD III	108
Human Figures	115
Reindeer	119
Elk	124
Bear	128
Birds	132
Fish and sea mammals	134
Boats	135
Equipment	142
Abstract Figures	144
Summary	145
PERIOD IV	150
Human Figures	160
Reindeer	165
Other members of the deer family	167
Bear	170
Other animals and fish	171
Abstract Figures	172
Summary	173
PERIOD V	178
Human Figures	182
Reindeer and Elk	185
Other animals	190
Boats	192
Summary	196
PERIOD VI	200
Summary	205
PAINTINGS	210
A NORTHERN FENNOSCANDIAN PERSPECTIVE	216
FINAL PHASE OF ROCK ART	224
WORLD CULTURAL HERITAGE IN ALTA	226
References	234

FOREWORD

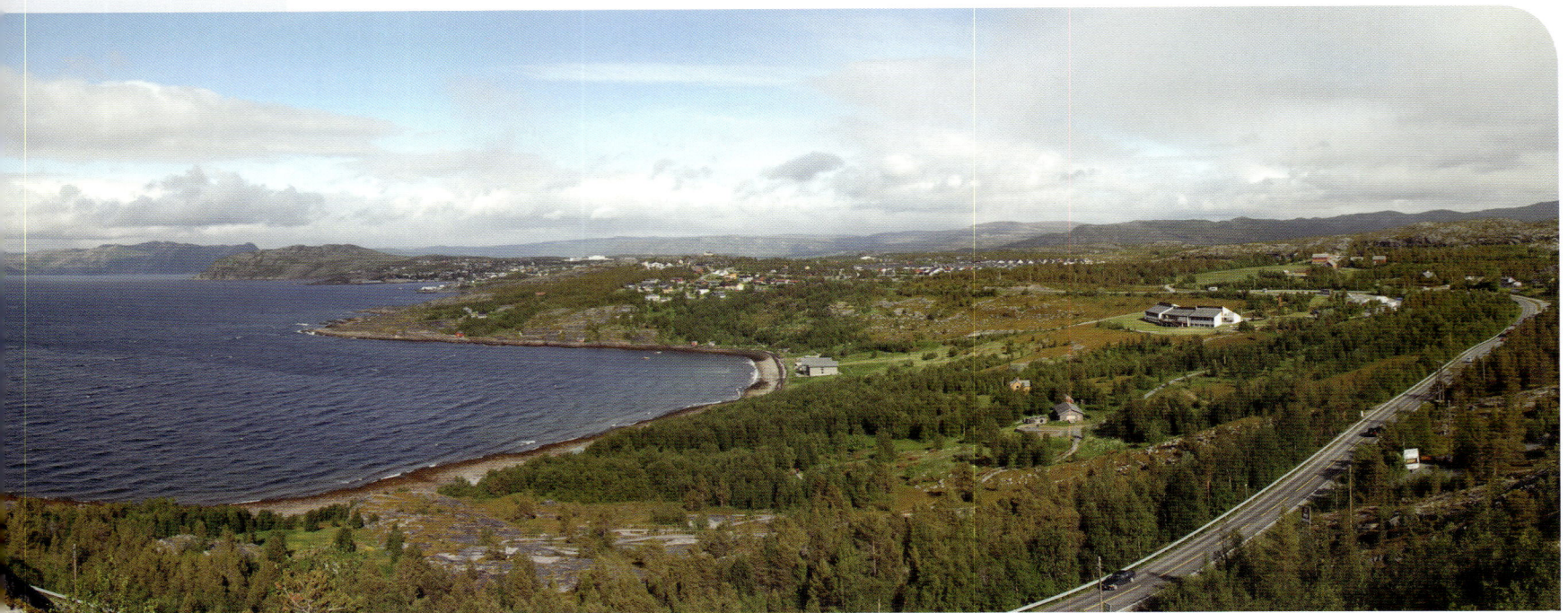

Figure 1
Alta Museum, to the right in the photo, lies at the head of Altafjord with a beautiful panorama northward out over the fjord. The largest collection of rock art lies in the area around the bay.

The rock art found in the Alta area is nothing less than a sensation, and it took only twelve years from the time of the first systematic surveys until they were inscribed on UNESCO's list of World Heritage sites. When the very first rock carvings in the Alta area were discovered on the outermost western side of Altafjord at the end of the 1940s, no one could have imagined that about 23 years later, thousands of figures would be discovered farther inside the fjord and that the nature of these would attract the attention of the world. Systematic investigations in autumn 1973 and summer 1975 showed there were vast panels in which the larger land animals, such as reindeer and elk, predominated over fish, birds, boats, humans and geometric patterns. The content varied from well defined scenes in which numerous figures acted together such as in hunting and fishing and rituals, to figures pecked into the rock that had no clear association to any of the other figures. Investigations during the latter half of the 1970s and early 1980s showed that the figures were extraordinary in number and beauty and were carved during several periods spanning at least 4200 years. On 3 December 1985, the rock art of Alta was incorporated into UNESCO's World Heritage list, and the new Alta Museum building was inaugurated in 1991. Two years later, in 1993, the museum received the distinction of being named European Museum of the Year, and annually thousands of visitors now use the walkways and platforms that connect some of the most important rock art sites. Memorable cultural experiences abound, both outdoors and inside the exhibit halls.

Since work began with the rock art in Alta in autumn 1973 much has changed in terms of insight and interpretation, in addition to the fact that increasingly more carvings have been discovered. There has been active professional, local and national political involvement associated with the rock art during these years. Today, Alta Museum is reorganised as an intermunicipal company, the World Heritage Rock Art Centre – Alta Museum, attending to tasks and responsibilities associated with management and presentation of the cultural monuments and the area.

Concurrent with the increase in the number of visitors, products and motifs based on the rock art have been developed. These include tee-shirts, jackets and sweaters, pieces of slate on which figures have been sand blasted, glass etched with figures and, not least, jewellery. At the same time, the figures have been published as illustrations of Sami prehistory in literature (Hætta 1996; 1994), and they have been linked to Sami culture in the form of graphics and paintings. This demonstrates how fascinating and important these figures are, and illustrates that they will also be perceived, used and presented in various contexts in the future. They represent a part of the material that is available for learning about the

people who lived in this northern area from about 5000 BC up until the birth of Christ, about their forms of organisation, hunting and trapping, beliefs, rituals, stories, legends, myths and culture, changes, continuity and history.

The following pages are based on many years of investigation and analysis and are meant for the general public. In this text, I have chosen to place greater emphasis on presenting the wealth of material, results and thoughts, rather than stringent analyses and argumentation. At the same time, emphasis is placed on photographic documentation aimed at illustrating and supplementing the text. Every photo is the product of light conditions. Colours change under different light, from midsummer to midwinter, from sunrise to sunset, and at night when illuminated by bright floodlights. The best conditions are when the light falls on the object from an angle and enhances the contrasts and details in the form and content of the figures. To photograph rock art is a great challenge. It requires being on site at exactly the moment when the light is best, at night as well as during the day. In addition, a number of photos have been taken beneath a black plastic cover, using either a sack over the photographer's body and camera, or a portable 2 × 1.5 × 1.8 m "black box". In both cases, an attempt is made to let light in low and at an angle on the side where the effect appears to best reflect the figures.

With the aim of making the relationship between the figures and the rock panels visible, some of the panels were sketched. This is because the traditional way of portraying the figures does not take into account the topography of the rock surface, a factor that is often difficult to capture with a camera. After some experimentation, a method was chosen that succeeds in capturing the features in the rock without the risk of distortion when the drawings are enlarged or reduced.

An endeavour such as this cannot be completed without having been in contact with many people during both the field work and the follow-up work. The staff members of Alta Museum have always given me their full support and have never hesitated to help when there was a need – they have assisted me in various ways, from help in the field and access to facilities to making waffles and many cups of coffee, not to mention the valuable discussions I have had with them. It has been a pleasure to work in the area and to observe how visitors are so well taken care of by the enthusiastic and thought-provoking

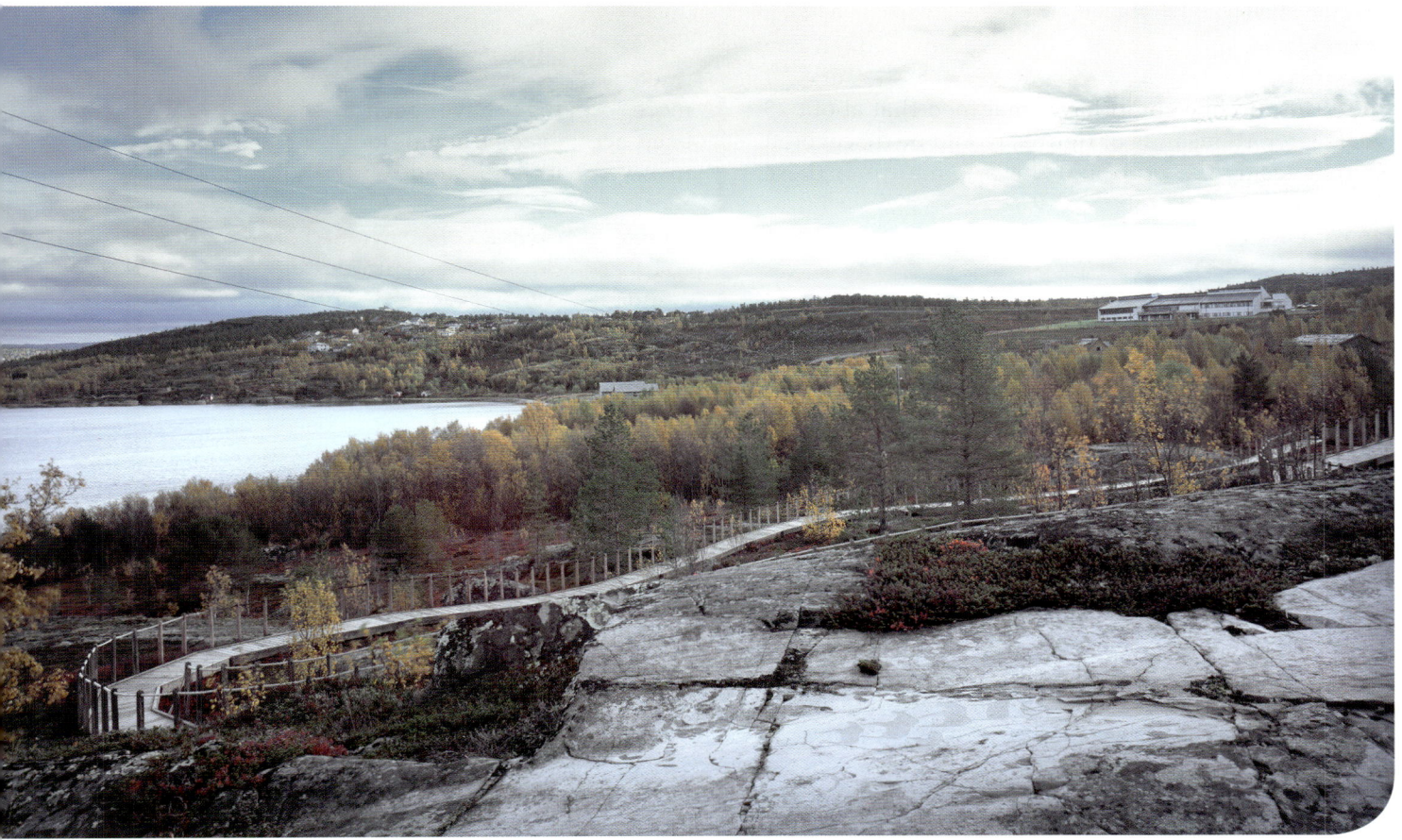

Figure 2
To protect the rock art and the natural surroundings from unnecessary wear and tear, visitors must use the walkways. The walkways meander gracefully through the terrain. It is autumn, and the colours are dazzling.
Photo: Adnan Icagic

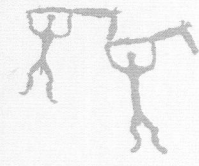

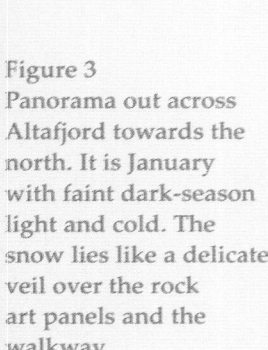

Figure 3
Panorama out across Altafjord towards the north. It is January with faint dark-season light and cold. The snow lies like a delicate veil over the rock art panels and the walkway.

guides who lead them from rock art site to rock art site. The museum has become a dynamic institution with continually changing travelling exhibitions, in addition to concerts and seminars. It has become a sort of public parlour and is a comfortable place to be. Thanks to Hans Christian Søborg, Karin Tansem, Heidi Johansen, Martin Hykkerud, Roar Haugen and Gerd Johanne Valen for their help and comments. Many people in Alta are avid about the rock art, and this was reflected in the friendliness and hospitality shown to me by Britt and Oddvar Nilsen whilst I was working to uncover and document the rock art in Kåfjord.

In connection with the documentation of the rock art, I also had the privilege of working with the Metimur company from Gothenburg, in the interregional project Rock Art of Northern Europe, which did the scanning of the Kåfjord panels. The result is the most detailed documentation of a rock art panel in all of northern Fennoscandia.

My own museum, Tromsø University Museum, UiT The Arctic University of Norway – has supported me in many ways, including financially. Without this support, the work would not have been possible. Thanks to illustrator and graphic designer Ernst

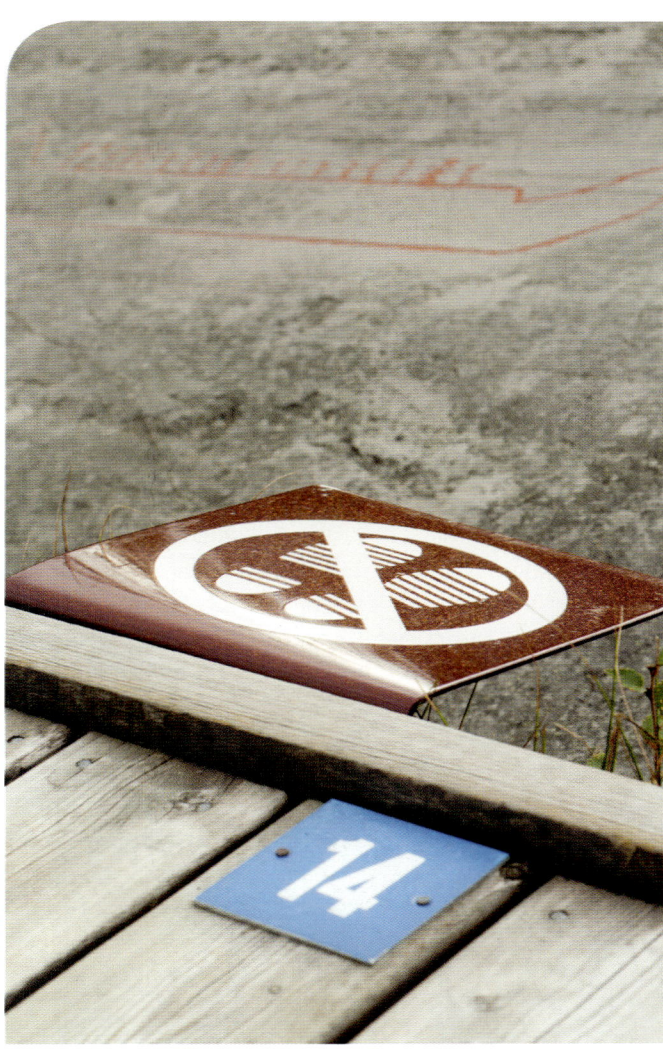

Figure 4
Prohibitory sign. It is prohibited to leave the walkways. The number 14 marks the last rock art panel made accessible to the public at Hjemmeluft. The boat figure in the background has been highlighted with red paint, a practice that has been discontinued.

Høgtun and photographers Adnan Icagic and Mari Karlstad of Tromsø University Museum – The University Museum for their contributions. The photos from the rock art panels taken by Adnan and the drawings done by Ernst, as well as Adnan's review of all photographs in this book and Ernst's graphic design, cannot be appreciated enough. I have learnt much from them.

Thanks to Arvid Petterson for his copy-edit of the manuscript and to Anne-Sophie Hygen for her constructive comments on the professional con-tent and writing. Many thanks also go to Vibeke Bårnes who did the final proofreading. Thanks to Ericka Engelstad, Jan Magne Gjerde and Bjørn Hebba Helberg for professional discussions and input, Johan Eilertsen Arntzen and Sveinulf Hegstad for technical assistance and Arvid Petterson for his many trips with me in the field.

The first draft of this book was written at the Department of Archaeology and Ancient History, Uppsala University, in spring 2005. I am very grateful for the support the department gave me. The last editing was begun during a research residency at Clare Hall in Cambridge, UK in autumn 2009 and at the University of Gothenburg in spring 2010, and the editing continued all the way up until the book went to print. To put ideas into words is a project that can never really be completed, because new knowledge and understanding emerges con-tinually; however, a limit had to be set, and the line is hereby, for the time being at least, drawn.

Many thanks to Sparebank 1 Nord-Norge and to Norwegian Literature Abroad (NORLA) for financial support for the English edition. Thanks also go to translator Tim Challman.

Knut Helskog

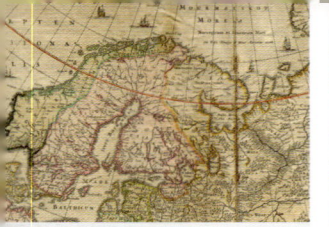

Figure 5
A right arm, a reindeer and a human-like figure pecked into the reddish-brown slate scoured with about 1–2 mm-wide glacial striations from the Last Ice Age. From period II.

Figure 6
Human-like figures lifting poles shaped at the top like the head of an elk cow. Both figures are men with phalluses, the clearest of these on the left. The placement in relation to the colours of the rock surface likely had a meaning, as well. From period II.

Figure 7
Human figure painted horizontally on a vertical rock surface in Transfarelvdalen.

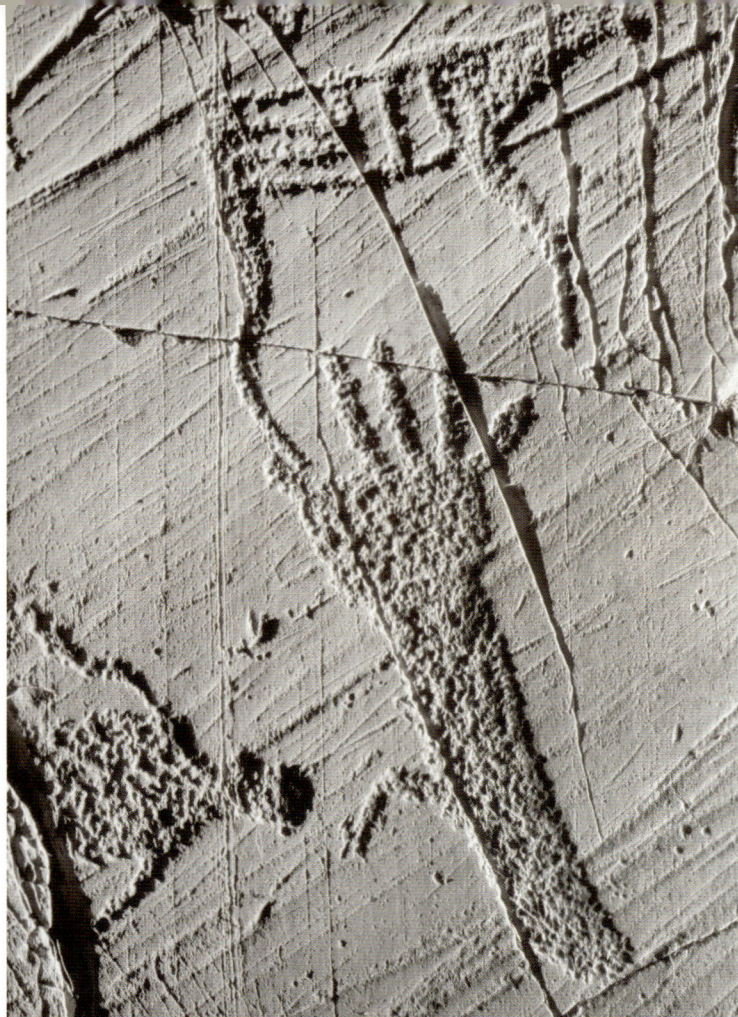
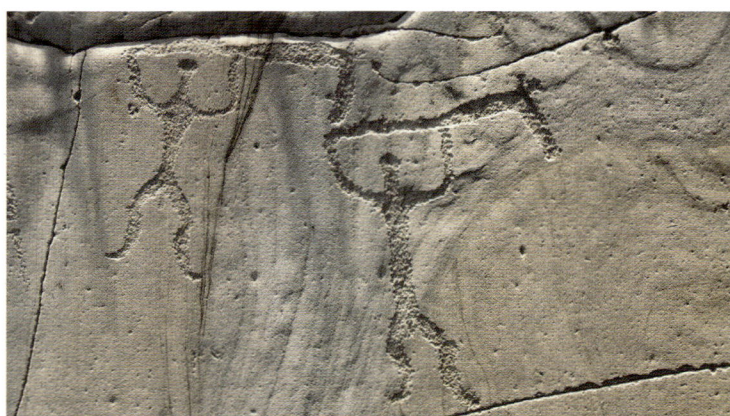

INTRODUCTION

Why was the title *Communicating with the world of beings* chosen for this book? What is communication, who are the beings and powers, and what function and meanings might the rock art have had? No simple and unequivocal answer can be given to these questions without a brief presentation of the natural surroundings and relation between these, the rock art and prehistoric settlement. This is needed in order to present the natural, physical framework to which people needed to relate, a natural environment that changed seasonally and over time. Some of the changes in nature, particularly land rise following the Ice Age, have provided important parameters for dating the images carved on the rocks. Without such dating, it is difficult to connect the rock art with specific prehistoric settlements. At the same time, the rock art can be better understood in relation to the natural environs, that is, life in the sea, on land and in the air, as well as the changes that occurred between the seasons. There are many traces of human settlement near the rock art in Alta – settlements that coincide in time with the rock art and the paintings and may therefore mirror some of the people who created and used these ritual sites.

The rock art comprises two main categories: 1) figures that have been pecked into the rock surface (Figures 5 and 6), and figures that have been painted on the rock surfaces in red ochre (Figure 7). The pecked figures are the most abundant materials. The scope of the paintings, by comparison, is very scant, although new panels have been discovered during the past ten years.

The presentation of the rock art follows a chronological division into time periods. Within each period, the primary motifs are presented individually: people, boats, reindeer, etc. The reason for this choice is that it is much more difficult to divide the figures into categories of what they symbolise or how they were used in social or religious contexts than it is to divide them into categories of animals or objects depicted, that is, the very physical models for the images. In most cases, the model is generally well-known and provides the basis for further subdivision of the figures. Moreover, the figures were made by prehistoric humans; these are their images of reindeer, elk, boats, people and tools that are easily recognizable to us, despite the fact that figures can also symbolise something quite different. For example, figures of people and animals can represent powers (other-than-human beings) in the form of a human or

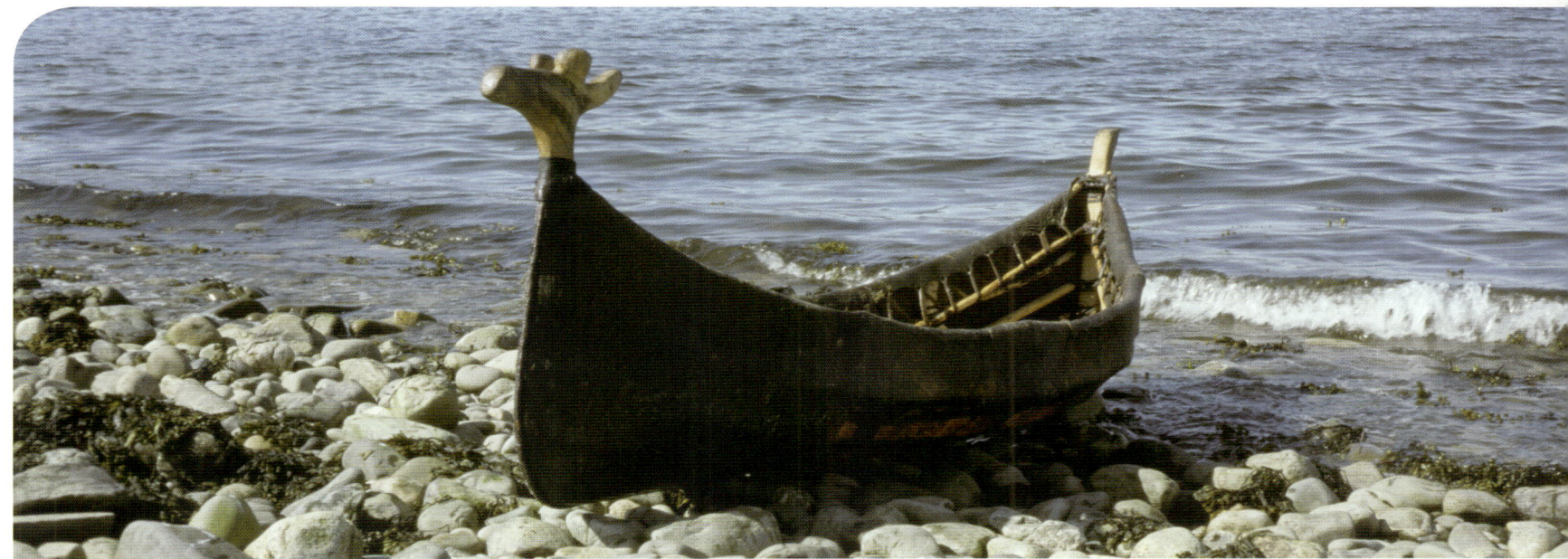

Figure 8
Our current knowledge about boat technology makes it relatively simple to construct a replica of what a rock art boat with an elk's head at the stem might have looked like. However, the details of the construction in a rock art boat are lacking to a great degree, so that one does not know if these details are correct. The boat is based on figures from Period II, 4800–4000 BC.

animal image. A division according to models gives us the opportunity to present variation in the material, along with an interpretation of what the figures might have meant across time. This subdivision should not give the impression that the different classes and types of figures are separate categories that have nothing to do with one another. On the contrary, the different figures have very much to do with each other, such as in compositions with human figures in boats, bears wandering between other figures and flocks of reindeer and elk. In addition, the colours, topographical features and minerals in the rock surfaces, especially quartz, appear to be a part of the compositions, representing, for example, mountains and valleys, caves, rivers and lakes, the sky and stars, light and darkness. In some of the panels, there are many colours in the rock that one can hardly conclude were completely ignored when the choice was made to carve figures. These features would have been distinctly visible when the rock surfaces lay along the shoreline and, conversely, invisible when covered with lichens or other vegetation.

Where many figures are comprised in a composition, the latter is described along with the type of figure that I perceive to be central in the tale being narrated. Thus, human figures in boats are categorised under boats, and not under the category of people, and humans spearing reindeer under the category of reindeer. In other words, the context in which the human figures are depicted is given precedence. This tells us something both about what people did and the relationship between other-than-human beings and humans, and about the relationship between mortal humans. The human figures are not always paramount; the central figures are at times animals, at times boats. The choice to begin presenting the figures in the category of humans is due to the fact that they represent how prehistoric producers used the human body as the basis for depicting themselves and, at the same time, as a symbol of something else. The goal is to try to approach as closely as possible the people behind the rock art and their understanding of the figures they created. Sometimes entire panels can be perceived as a single composition; at other times, the figures clearly stand alone.

The rock art was created over a period of about 5000 years. Within this long time span, one can trace both differences and continuity in the shape and content of the figures. The differences are relatively pronounced, and in this categorisation, the rock art is divided into six time periods. The figures in each period are assumed to have a relatively similar cultural affiliation, although variations in the composition of the figures on different panels suggest variations in the stories being told and in the rituals that were performed and depicted. In addition, it is also possible that contemporary panels, such as in Kåfjord and Hjemmeluft/Jiepmaluokta, can represent different groups of people.

The different periods are dated based on differences in the form and content in relation to shore

displacement, as well as association with other archaeological material. The dates are all in the calendric years before (BC) and after (AD) the birth of Christ. Without establishing the age of the rock art, it is impossible to study form, content and meaning in time and space in relation to the contemporary prehistoric settlements. Without any kind of dating, it is impossible to determine whether special techniques might be related to various norms or requirements over time.

The order of presentation for the main motifs is the same for each time period in order to illustrate the changes that took place both between and within the types of motif. The presentation is by no means objective. It is coloured by my own perspectives and conceptions. Perspectives and conceptions have always changed, and will continue to change with the acquisition of new data, methods and analyses. The goal is to bring out the diversity and the changes in the rock art throughout time.

From figures that we can recognize as boats, reindeer, elk and people, to a determination of what the they symbolised and meant is a far more difficult step to take; it involves conceptions of beliefs, spirits, powers, totem animals, spirit helpers, the universe, differences and similarities between groups of people, social structures, territories and territorial rights, various rituals and control of opinion and power. All rock art was, and still is, the bearer of meanings. The first thousand years illustrate this through the many compositions. Compositions or scenes are figures in interaction, such as in mythological stories, legends or historical events, and in some cases, in ritual events. To distinguish between these is difficult, but both ritual events and stories appear to be represented.

Considerably fewer paintings have been found than rock carvings. Thus, the presentation of the paintings is briefer and more simplified. The book has been given the title *Communicating with the world of beings* because the figures were carved or painted onto rock surfaces over a period of several thousands of years as a means of communication with other people and with the other-than-human beings. Communication with other people means that the figures were seen and experienced by people other than those who

Figure 9
Elk and reindeer figures, retouched in red and carved over dark striations in the rock. Portions of the figures appear to follow a striation extending up towards the left to the point where it meets another series of animals coming from the right. The figures in the two rows have different shapes, as if to reflect different identities. From period III.

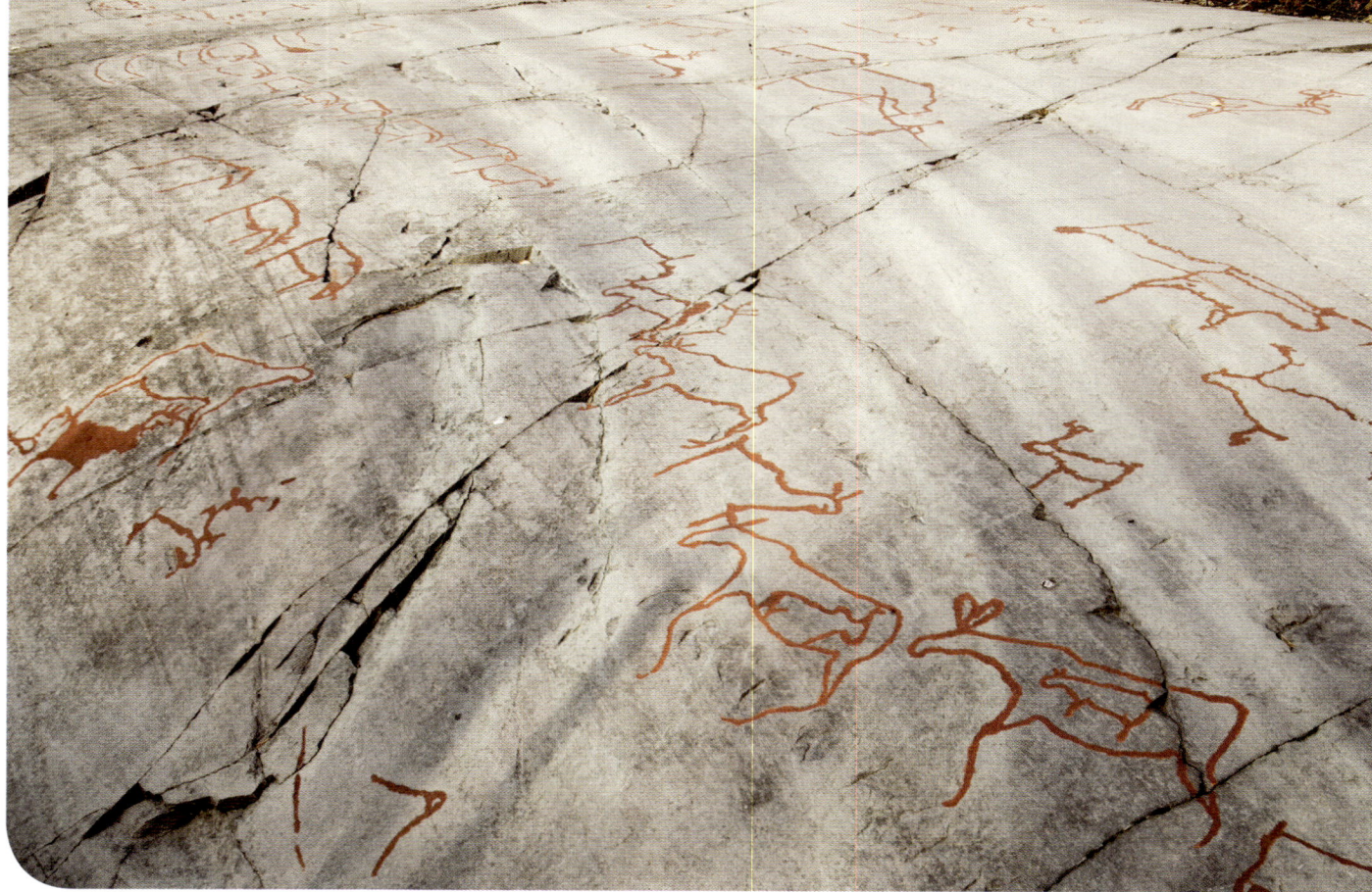

Figure 10
Human-like figure with physical traits beyond what we recognize as the human body itself. The figures very likely depict one of the powers to which humans related. From period IV.

created them, as symbols in rituals or as expressions of identity, position, power and rights. They can also illustrate concrete events, and some may have been used in teaching or telling about the figures that are depicted. At the same time, the figures show the animal life, objects and equipment that were a part of daily life at the time.

Communication with the other-than-human beings means that, by means of the figures, people addressed other-than-human beings who determined events in the environment – in order to petition favours for themselves or others, groups or the society as a whole. These other-than-human beings can be denoted as spirits, beings of the underworld, the dead or souls, which also included the animals depicted and represented by the figures. It is also possible that many of the figures not only represented, but were perceived, as other-than-human beings, and in the latter case, people appealed directly to the figures themselves.

This communication may have been based on a belief that both living beings and inert objects and natural phenomena had souls, and this belief may have existed ever since the earliest settlement. Such an animistic belief means that everything was seen as having a consciousness and identity of its own, independent and imbued with a will. Therefore, it was essential that the different participants communicated with one another as equal partners. Everyone could initiate the dialogue.

THE WORLD OF BEINGS

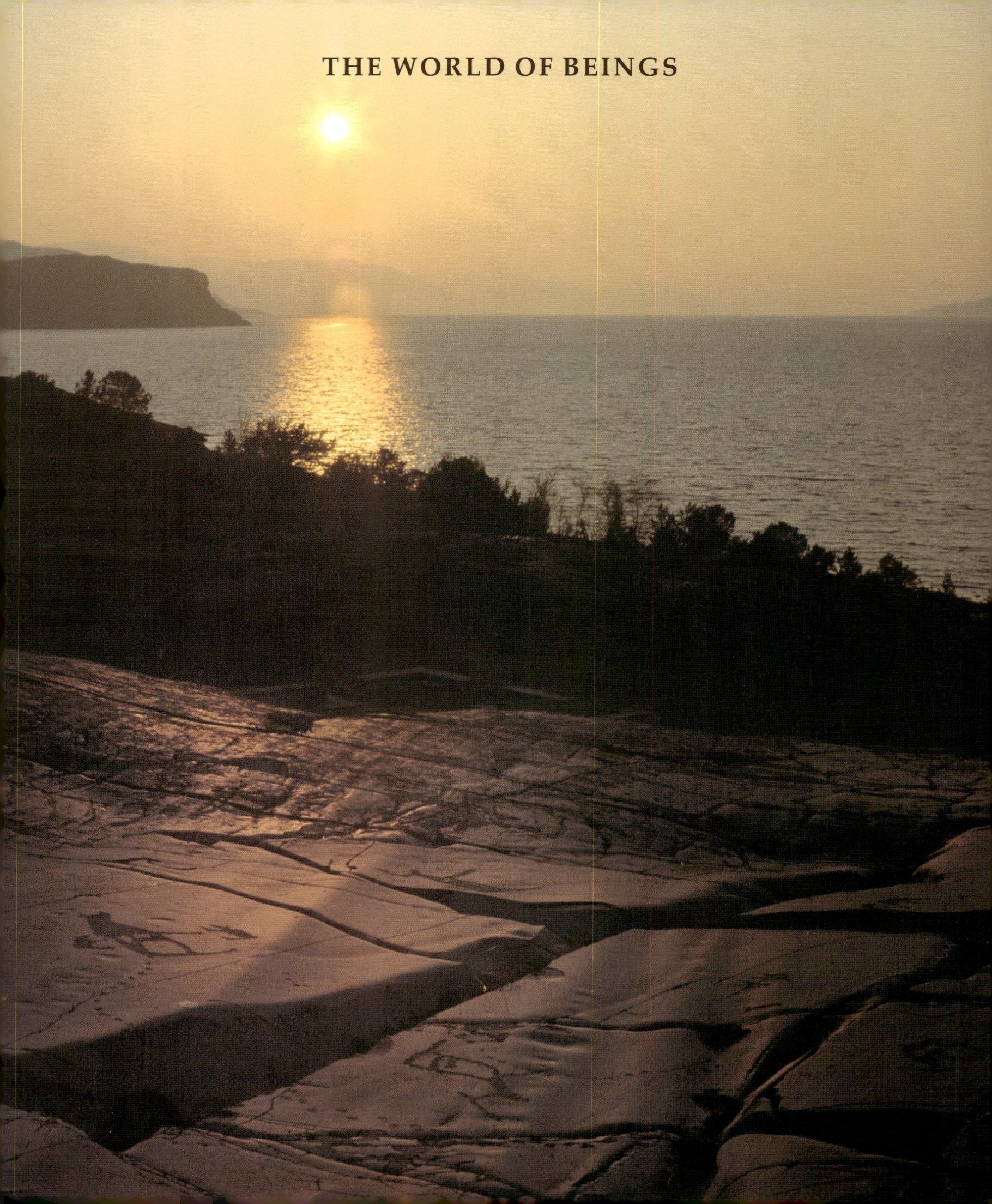

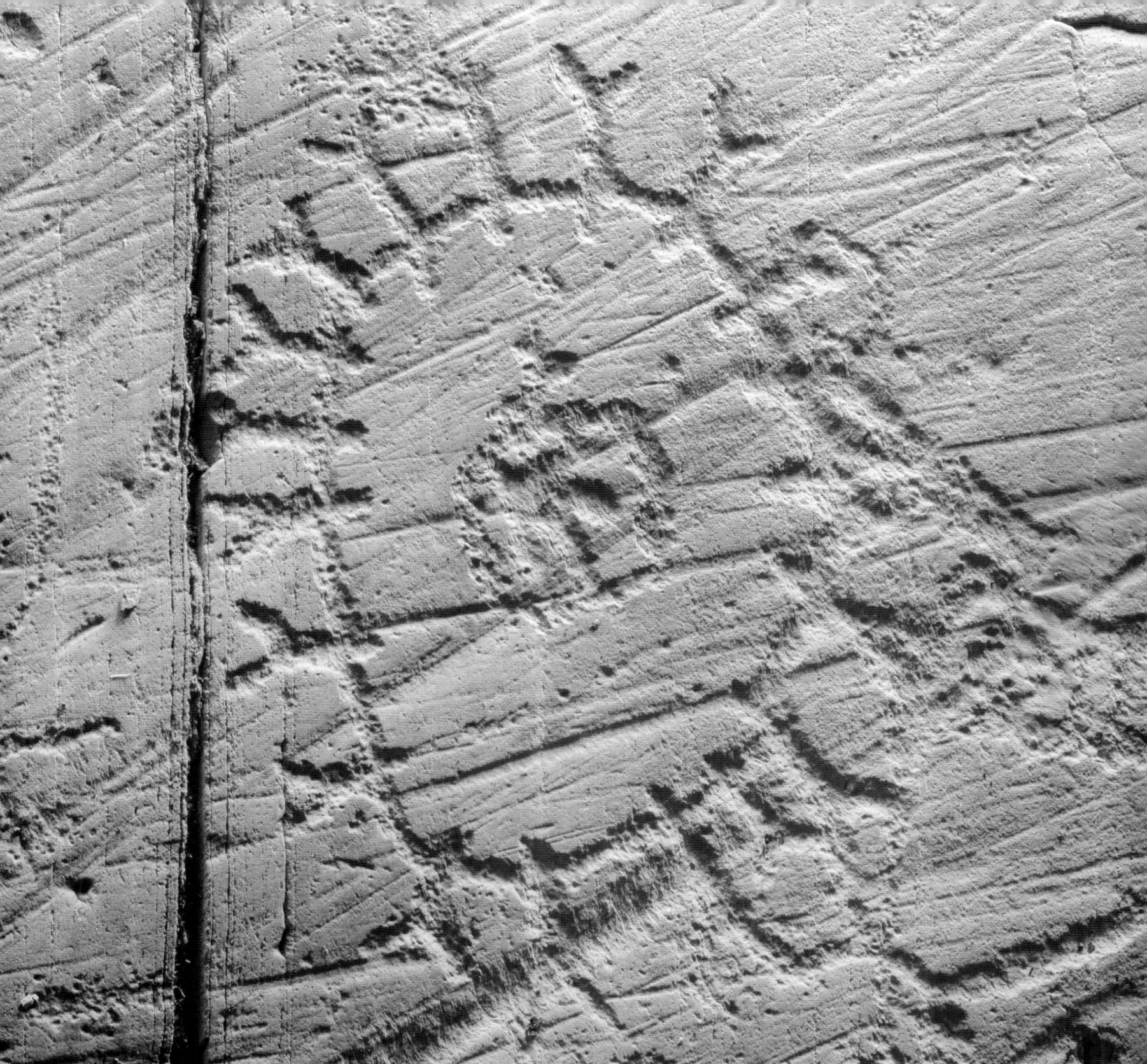

Figure 11 (p.14)
When the sun shines low on the rock surface, the figures emerge clearly. The seasons, as well as shifting weather and light, may have had a function of meaning in the communication between other-than-human beings and humans. The sun, source of light and warmth, was likely perceived as one of the powers. In the strip of sunlight, we see a female bear with cubs, a reindeer and human figures. The hour is almost midnight, and the atmosphere is magical.

Figure 12
A creature which may be part bear and part human, male and female, is standing inside a circle, perhaps representing the mouth of a den. Around this, 19 human-like figures stand holding hands, as if performing a ritual. From period II.

Figure 13
It is a rainy day, and the wet rock surface gives a special sheen to the reflected figures. This is how they would have looked when the sea washed up over the rock surface at the time when they lay on the waterline. We see a female bear and two cubs, and a reindeer. The bear had a special meaning for prehistoric hunter-gatherers in the high north, and this is also a well-known tradition in historical times. This knowledge provides a basis for understanding why the figures were pecked into the rocks as parts of stories, legends, myths and representations of powers linked with various rituals.

Who or what are these beings that maintained the order and content of the world and all its creatures, including human beings? Beings that decided over happiness and sorrow, births, illness, death, good or bad hunting and trapping, war and peace, lean or bountiful crops, fair or stormy weather and good or poor conditions for all animal life. It must have been important for people to be on good terms with these beings. When they respond to human supplications, or vice versa, a dialogue is initiated. As a part of communication with the world of beings – the images were given form and content.

People must have believed that other-than-human beings could influence them all, but we know too little about whether all humans were able to initiate the contact. Certain appointed persons might have led public rituals and performed rituals for either individual people or groups of people. These persons have been given many names. One example is the shaman (Sami noaide), who, by going into a trance, was able to contact the powers to heal the sick, ensure a good hunt, influence the future, etc. Others performed rituals by virtue of their status as leaders of households or larger settlements. At the same time, ordinary people may have performed rituals associated with special events or endeavours. In other words, there were many different purposes and occasions for communicating with the other-than-human beings. In some of these cases, rock carvings or paintings were used.

Another point of departure one might take is that there was no distinction made, as certain modern societies make, between the secular and the sacred. All life was interwoven with the natural surroundings (Ingold 2000), with people, animals, insects, vegetation, rivers and mountains, wind and weather and the other-than-human beings. At the same time, the surroundings and life changed between the seasons, offering changed circumstances to which humans had to relate. In other words, rock art not only had a meaning in itself, but the meaning was interwoven with the changes in nature, the features of the rock surface on which the figures were carved, the natural surroundings and the people who created and used the rock art.

INTERPRETATION

The interpretation of prehistoric rock art is complicated and must take account of many contexts; alternative interpretations are numerous. One problem is to determine how large the differences in rock art must be to enable one to say that they reflect differences in beliefs, rituals and myths. Do the differences have to be as clear as they are between Nordic egalitarian hunter-gatherer cultures and the socially stratified societies of the Bronze and Iron Ages based on agriculture and trade. The differences between these two types of societies are reflected in the rock art traditions, which are referred to respectively as veideristninger (hunter-gatherer rock carvings) and jorbruksristninger (agricultural rock carvings). The dividing line can be placed, at about 1700 BC, from Southern Scandinavia and northward to Trøndelag and the southern portion of Northern Sweden; however, this distinction is totally absent in the northernmost regions. Here, the hunter-gatherer cultures continued to exist into the first centuries AD. Therefore, to divide the rock art into a hunter-gatherer tradition and an agrarian tradition is quite meaningless when speaking about Northern Scandinavia, although it is clear that the people in the various areas did influence one another. There are, however, clear differences in the rock art of the northern areas, in terms of both space and time. In Finland, for example, only paintings have been found, in contrast to Sweden and Norway where both rock carvings and paintings have been found from the hunter-gatherer cultures existing during the same time period. At times, it is as if changes in rock art coincide with changes in material inventory, dwelling structures and settlement patterns, but there is no direct link that would indicate that the one is dependent on the other. But substantial changes in form and content in rock art as well as the other archaeological material considered together may suggest that there were changes in beliefs, rituals, myths and stories.

The High North was populated from about 9000 BC. People migrated back and forth from area to area; old and newer ideas and knowledge, beliefs, myths and rituals met one another and coexisted. Settlement as a whole gradually expanded; populations and ideas intermingled; some became extinct and others continued.

Who pecked the figures into the rocks in Alta? Why were they created, and why did people continue to carve images into the rock surfaces for approximately 5000 years? Why were some figures painted directly on the rock surfaces, and why are there so many more pecked images as opposed to painted images? Did the two types have different meanings? Were they associated with different beliefs and rituals? Did they serve different functions, and were they created by different people? These are some of the questions we will undoubtedly never be able to answer definitively without being able to go back in time, take part in what actually happened and live in these long-lost societies. Based on knowledge of people in hunter-trapper societies in both prehistoric and historical time, we can try to infer a notion of what life was like thousands of years ago. Rock art is a part of this background information. The figures alone are a form of expression; they are beautiful, living and thought-provoking. They resonate with the knowledge and notions we have about the prehistoric hunter-trapper societies and about the nature and fauna of the era. Nevertheless, the differences between us moderns and the prehistoric people are so great that we will

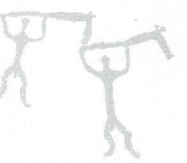

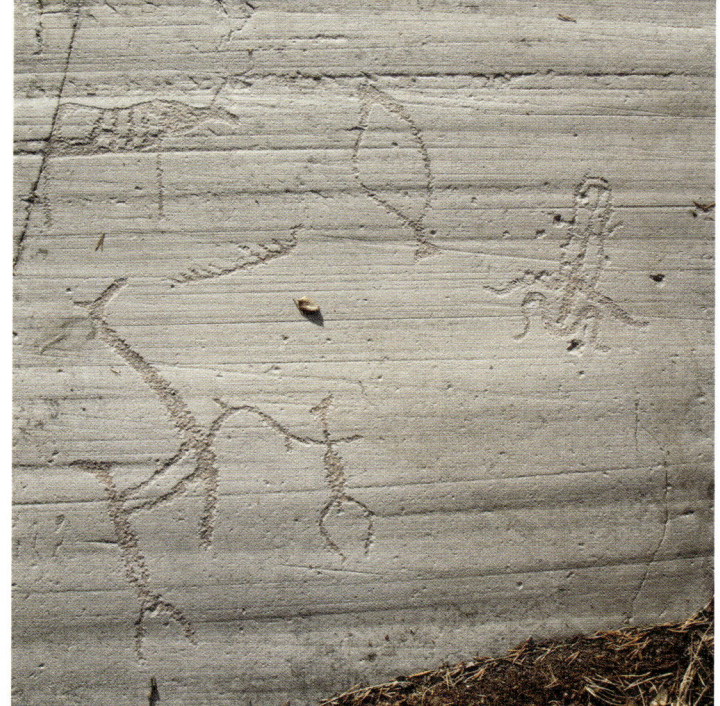

Figure 14
The elk, and particularly the elk cow, may represent something more than merely a prey. In some cases, they symbolize the powers, that is, the other-than-human beings associated with beliefs and rituals. The human-like figures are raising poles topped with or formed like an elk's head. The poles are characteristic of period II. In addition, there are figures of a boat, a halibut and, according to some older men, a squid (to the right) used for bait to catch halibut. Young people saw the figures to the right as having sexual intercourse/"haill", a practice of having intercourse in order to bring luck when fishing for halibut. This is one example illustrating that interpretation of what one sees is at the same time a reflection of who one is. From period II.

The reddish colour in the figures is a remnant of paint applied 24 years ago to highlight the figure for visitors – a practice that has been discontinued.

Figure 15
A reindeer and a goose. From period III.

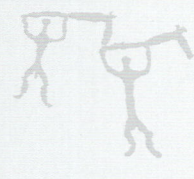

Figure 16
A high-angle photo of the Bergbukten I panel, towards the north. In the foreground, the expansive reindeer enclosure and, moving north, reindeer, bear, boats and people. The topography of the rock surface may have been understood as mountains and valleys, rivers and lakes in the tales relating to the figures.
Photo: Adnan Icagic

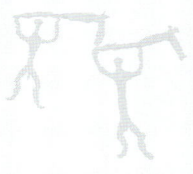
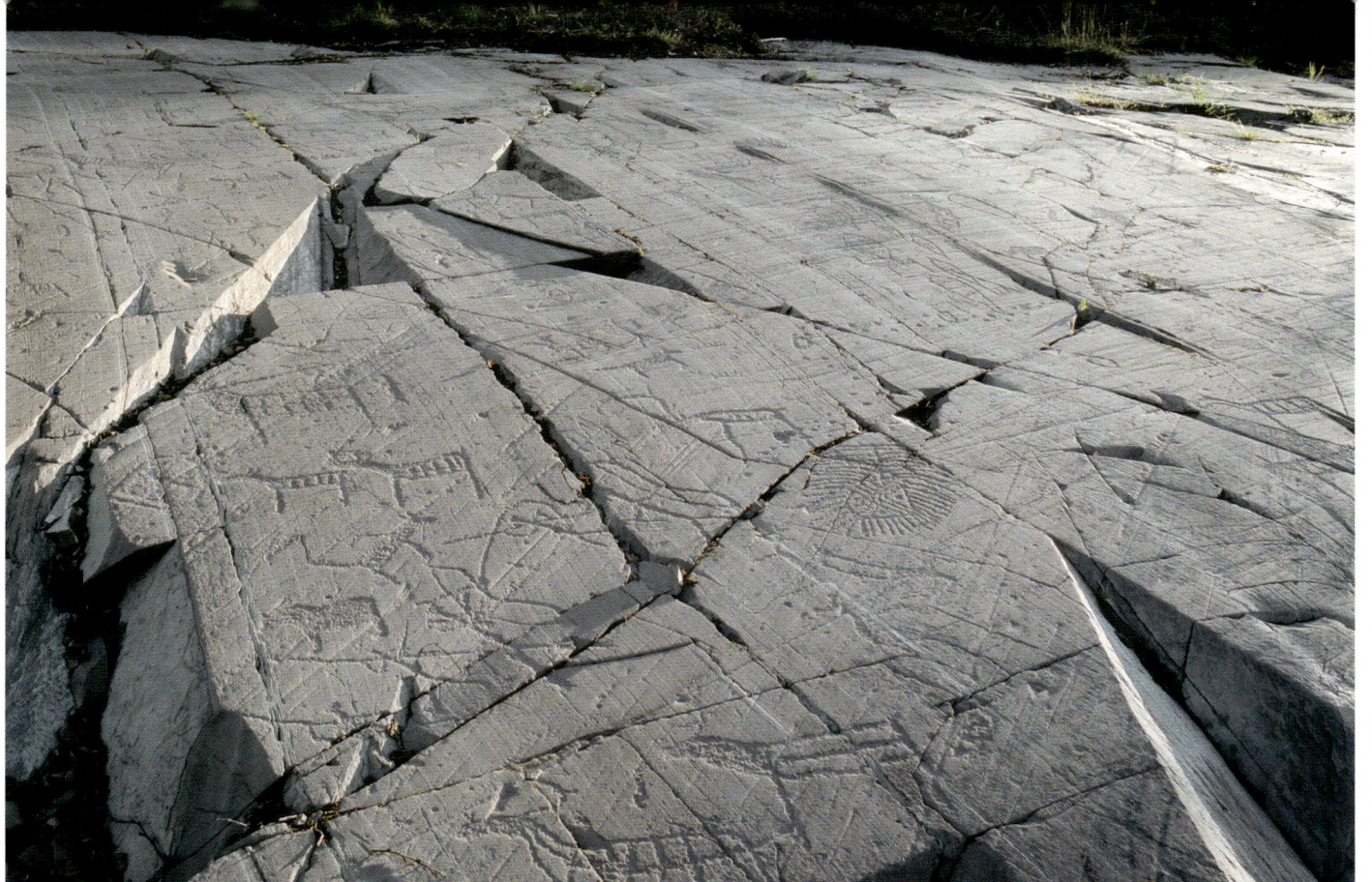

Figure 17
Faint low morning sunlight creates excellent contrast, and the panel have come to life with figures of people, reindeer, elk, bear, footprints from bear and humans, geometric patterns and much more. The colours and structures in the rock are clear and distinct, and this is a good time of day for photographing and documenting. In this photo, we can see depictions of reindeer and bear and bear tracks, hunters and a large abstract figure. In the upper right we see a long trail of snowshoes.

undoubtedly never be able to discern the complete and full meaning associated with the figures. We may be able to approach meaning, but without knowing how close or how far away from the truth we actually are.

At the present time there are many ways to approach understanding and insight, depending on one's point of departure, one's background, relationship with religion, interests, cultural background, life philosophy and the story one wishes to interpret. Interpretation, for example, can be channelled through perspectives on religious or secular leadership, on the rich and poor, on hunters, on men and women, or on society as a whole. In addition, understanding is dependent on the questions that are posed, the method applied in gathering and analysing data and, not least, the extent to which one believes it is possible at all to understand what rock art is all about. The credibility and probability of the interpretation is also dependent on the quality of the methods, analyses and argumentation applied. Not all interpretations are equally as good or probable. In the options and interpretations chosen, the author is a subjective interpreter, not an objective observer. The present work is my communication with the past, my story.

Rock art does not originate only from the people who created them, but is rooted, in a way, in the place itself, in the rock or rock surface. Why were these figures pecked and painted on such hard surfaces? The panels consist of various types of rock and minerals . They are oriented towards many different directions, are horizontal or vertical, are even and uneven fractured, full of striations, and they can be embedded with different colours. The people who created the figures may have perceived the colours and structures as meaningful, rather than merely meaningless surfaces on which to paint and peck. Are there patterns and structures in the rock surfaces themselves, or in the immediate locality, that might provide clues about the meanings of the figures in a larger, geographic perspective?

TIME AND CHANGE

The meaning that one attached to the figures must have changed over time. We know from other contemporary archaeological material that there were numerous and sometimes significant changes in artefacts, types of dwelling and use of resources, all of which suggest changes in how the societies were organised. There must have been regular contact between the populations of the coastal areas and the interior; people moved from one place to another, exploited different hunting and trapping areas as the supply of natural resources varied between seasons. There was bartering, cooperation, partnership in hunting and trapping, social intercommunication, intermarrying, conflicts of various kinds, etc. Contacts in the coastal areas were frequent, and new knowledge was exchanged.

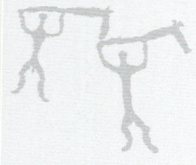

Figure 18
A location photo showing one of the uppermost panels with rock art panel from period II, on the rock surface to the right. When the figures were carved, the waves washed over the rock surface. The water was deep just off the edge of the outcrop, and very likely, therefore, most of the figures were located a safe distance from the steep ledge. The salt kept the rock surface clean, and the figures would have remained distinct long after they were carved into the rock. The figures were created in a zone in which water, land, air/sky and life therein were interconnected. The figures represent part of an ongoing communication between people and other forms of life. Perhaps there were places in the intermediate zones where figures were part of these dialogues.

Rock art was a part of this dynamic and these changes. In this sense, the meaning, stories and rituals associated with the individual figures and compositions in 4500 BC were not necessarily the same as those in 1000 BC. Knowledge, beliefs and the understanding of life and the world change over time, and this is suggested in the changes we see in the shape, content and composition of the figures across the 4500–5000 years during which the figures were created. To what extent do these differences reflect changes or continuity in beliefs, stories and identity? Can the differences reflect changes in communication between people and the other-than-human beings, such as, for example, between the established and the new? What happens when the beliefs and rituals of different groups of people come into contact with one another? On occasion, one thing brutally replaces the other, but more frequently there is a type of fusion or adaptation of the old to the new. At times, several systems of beliefs existed concurrently. All the various alternatives might have occurred in the course of the millennia during which people have lived in these northern regions.

IDENTITY

At the same time, figures can indicate who made and used the figures: from an individual, to ethnic groups, to entire societies and across several societies; identity in various contexts. Certain features may denote people and their affiliation with the same beliefs across national or ethnic boundaries. There is no doubt that there are features in rock art that indicate this. For example, there are elk-head poles (Figure 14) and strong similarities between the boat figures throughout all of northern Eurasia that identify a shared belief. At the same time there are unique features in Alta that might suggest an identity germane to the local societies. It is too early, however, to draw conclusions concerning whether differences in material culture and ethnicity coincide with differences in faith and rituals as expressed in the rock art. In sum, the archaeological material shows that there were cultural differences in beliefs, rituals, myths and legends between the various groups in the northern areas. At the same time, the animal and human figures also symbolise the most important powers with which people communicated and made covenants.

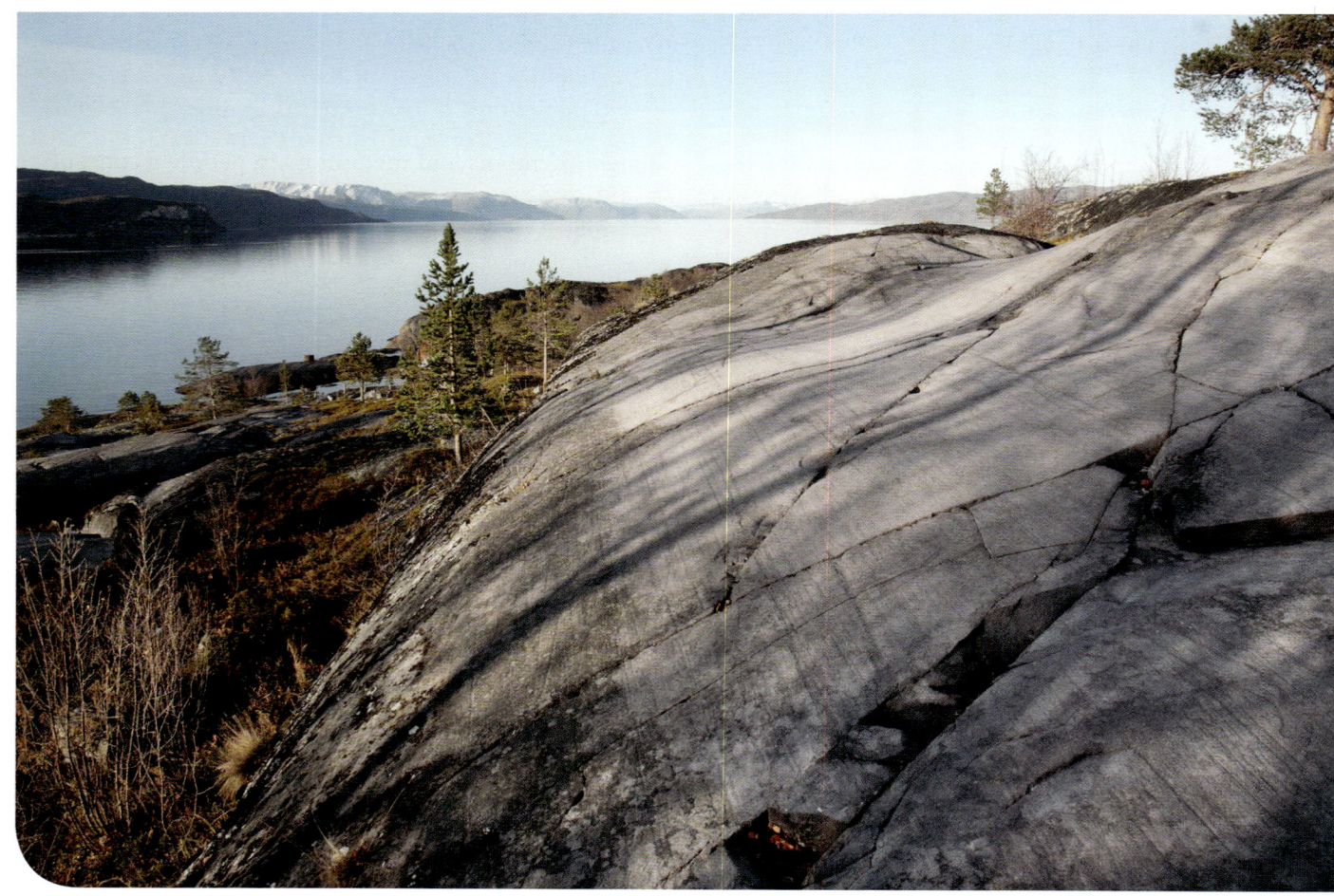

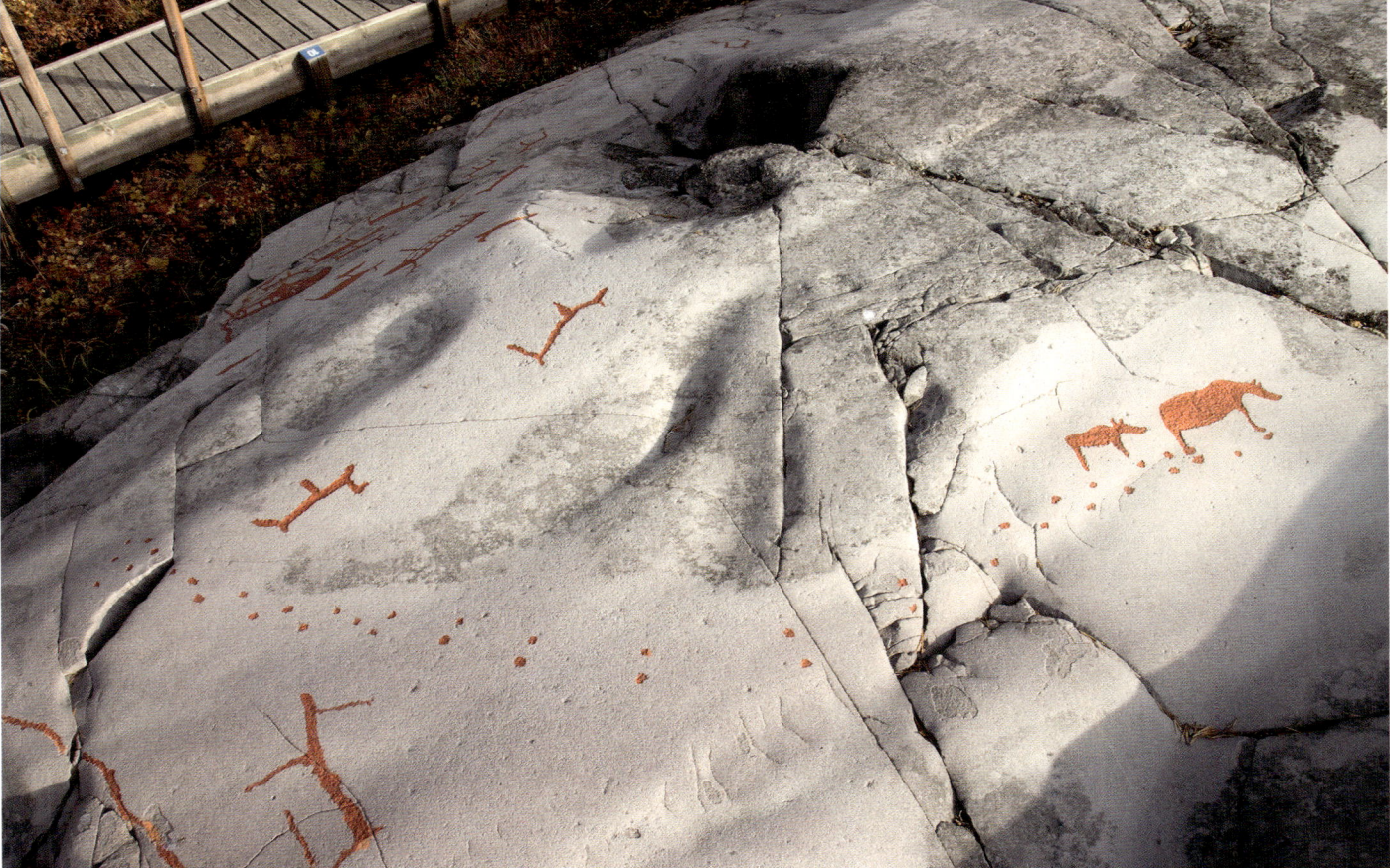
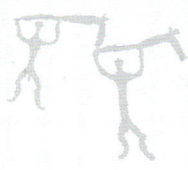

The figures may also reflect individual identity in their very design. Similarities and differences can reflect individuality, but the range of figures and similarities in form and content between relatively contemporary figures spanning large geographical areas suggest that there were some commonly shared norms that had to be observed.

The figures can also signal who and what they were, as well as the rights to hunting, trapping and dwelling places.

One relatively common interpretation is that the fauna are totem animals (Hesjedal 1994; Gjessing 1942; Gjessing 1945), that is, that the societal structure comprised territorial clans in which the members claimed they had a commonly shared, ancestral progenitor with the animals in the immediate area. The totem animal is also a power, and if this is reflected in the rock art in Alta, most of the humans were related to the larger animals – elk, reindeer, bear and halibut. There must also have been great variation through time, from numerous to few clans, and to the discontinuance of clans as a part of societal structure. However, these are ideas that are difficult to corroborate in the rock art and are yet another example of how difficult interpretation is.

Another interpretation is that the figures can be associated with hunting and trapping. Seen in relation to the resources that were exploited, the animals depicted in rock art reflect a limited and somewhat unrepresentative sample. There is no doubt that the animals were important resources and that the figures may have been created as a part of rituals to ensure a good hunt. The figures show some of the fauna, people and rituals, boats, weapons and hunting scenes. At the same time, the figures were elements in beliefs, rituals, myths, legends and stories; they were signs, symbols and metaphors in people's conception and description of the surroundings of which they themselves were a part. The figures themselves, and what they represented, possessed a power of their own. They were, and still are, reminders of events, perhaps even a type of guide for the content and performance of rituals. Perhaps part of the rituals entailed exploiting the power, strength and wisdom of the animals for the benefit of the performer of the ritual.

The figures represented not only a mode of communication between people and the other-than-human beings. They are also a visual rendering of some of the life enfolding in the different worlds. Because life in the worlds of the other-than-human beings was modelled on human conceptions of their own world, the figures are a key to knowledge and understanding of how humans perceived their own environment. It is important, however, to note that the figures represent merely a small and very special sample reflecting the natural surroundings and people's material and ritual culture.

Figure 19
Female bear with her cub emerging from a crack or recess in the rock, as if coming out of a den or an underground world. This is yet another example of how the structure of the rock surface is connected with the story being told.

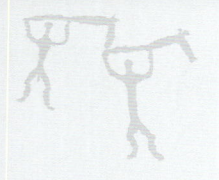

Figure 20
In contrast to the figures pecked into the rock surface, the paintings are on vertical, dry surfaces. This one is 50 metres above sea level in Transfarelvdalen. On the flat expanse to the right, there are human-like stick figures; some are standing upright, others are upside down, and one is in a horizontal position. A story or myth is told with a view towards the west, towards the setting sun and northward towards the mouth of the fjord.

At times it is possible to discern composite scenes, but at other times it is difficult to see a pattern providing a basis for concluding that the figures belong together as parts of a story or event. In order to fully know which elements belong together, we would have had to have the same knowledge as those who created the rock art. We do not have this knowledge, and therefore, the task of archaeology has always been, and remains, one of meticulous and exciting detective work. We can probably never claim that our interpretation reflects the full and complete truth, beyond banal facts, such as stating that a figure resembling an animal is probably modelled after precisely that animal. Nonetheless, we have much of the same knowledge and experience as that of people of the prehistoric era. We easily recognize some of the figures and scenes, but without being able to say with any certainty what deeper meaning they had and how the meaning changed through time and events.

THE MEANING OF LOCALITY

All rock carvings in northern Eurasia appear to be made on rock surfaces located on or just above the waterline (Simonsen 1958a; Sognnes 2003; Gjessing 1945; Gjessing). Due to the post-glacial shore displacement the rock art sites are located above the present shoreline. Therefore, it is logical that the oldest sites are those located on the uppermost rock surfaces. The reason why the images were made on the shoreline may be simple and of a practical nature. It was here that the rock was vegetation-free, and the surfaces were smooth and clear. But this does not explain why the rock carvings were made in certain places and not in others. Proximity to the settlement may be another reason. A third is that the shoreline, and certain parts of it, had a special significance in the communication that was associated with rock art.

An association with water emerges in some compositions showing bear wandering in and out of dens, up and down the rock surface and into the water. This is a story in which bear wander through the seasons, as an illustration of the cosmos as it was perceived by people. The association with water is a common trait of both the rock art's location and of the special compositions including bear as central subjects.

The surroundings may have been perceived as divided into several different worlds, a recurrent notion known to exist amongst historical hunter-trapper cultures: an upper-world and an underworld in which other-than-human beings lived, and an intermediate world inhabited by living people, animals and plants. These three worlds intersected in the shoreline, where there were special places where connections between these worlds were made. The

latter reason may be the rationale for the location of rock art.

Through the openings between the worlds, people and other-than-human beings could come into contact with one another. There may have been various reasons for certain sites being perceived as openings to other worlds, for example different colours, forms and structures in the rock surface, veins of quartz or fault lines and stratification forming different patterns, special stones or vegetation, or myths about the place and the landscape. At the rock art sites in Hjemmeluft and Kåfjord, there are many examples of rock features that may explain why the figures were created at exactly these spots. The Kåfjord sites, for example, are found on colourful reddish-brown, green-striped slate that is peculiar to this area, whilst those at Hjemmeluft are found on greyish, hard sandstone shaded with bluish, dark lines. Both rock surfaces are relatively easy to carve. Sometimes the panels with carvings are relatively horizontal. When it rains, all the hollows in the stone are filled with water; together with the elevated portions and the hollows, the overall impression is one of a landscape comprising mountains, valleys, lakes and rivers and in which the figures are a part. When the figures were pecked into the rock, between low and high tides, this landscape was regularly covered with water and just as regularly emerged out of the water.

These openings between worlds are found precisely where the panels meet the ocean, on the shoreline, where the sea washes over the rock surfaces between high and low tide, in stormy and calm weather (Helskog 1999). Based on descriptions from northern peoples, we know that openings of this kind could also be found in rapids and waterfalls; rivers running towards the cold North would carry the deceased into the icy realm of the dead (Anisimov 1963; Bogoras 1975). Certain lakes were perceived as being sacred, with openings to the underworld (Vorren & Manker 1976), and cracks in the rock surface can be perceived as openings between the world above and under the earth and inside mountains.

Perhaps a part of what the figures represented was perceived as a realm already existent inside the rock. People simply made this more visible. The first figures pecked into the rock established or marked the areas as special ritual sites where people would meet. These congregations may have been associated with seasonal migrations and various forms of resource exploitation in the area, or with major changes in the environment such as the return of the sun or the transition from winter to spring, the summer solstice, the autumn equinox and the darkest days of the dark season when the sun does not appear above the horizon. This was a land, then as now, with great changes in nature, changes that meant more to people than they do today, and that people tried to control. Rituals were also performed at other times and for other reasons than to observe the major changes in nature, such as when people needed to contact the other-than-human beings to invoke luck, order or chaos in their existence, to solicit healing, to observe births or deaths, to prevent accidents or ensure a good hunt and fair weather. Needs may have been numerous, perhaps many more than we are able to imagine today.

THE PAINTED FIGURES

On dry, vertical rock surfaces (Figure 20) at the bottom of Altafjord, there are six panels containing paintings. They are located between 18 and 50 metres above current sea level and at different sites than those with pecked images (Andreassen 2008, 2011). The figures are relatively small, mainly humanlike, in addition to a few figures of animals and geometric patterns. Painted and pecked figures are not found together anywhere, and the paintings appear to lack the close association with the shoreline that carved images have. Both are immobile, and if a visual or physical contact was part of the rituals, this would require that people would have to come to the site where the figures were visible. Their location on vertical surfaces gives more the impression of a wall with fissures, minerals and colours than does the topographical landscape on relatively horizontal rock surfaces containing rock carvings. This fact, in addition to the more limited choice of motifs, suggests that the stories and rituals linked with the paintings were fewer and perhaps different than those linked with the carved figures, although the other-than-human beings invoked may have been the same.

The paintings perhaps represented communication with powers behind the rock surface or with something inhabiting the rock itself. The numerous caves in Northern Norway containing humanlike figures in the transition between light and darkness may suggest that people believed in powers inside the mountain that one could encounter in the passage from light to darkness (Bjerk 1995, 2012).

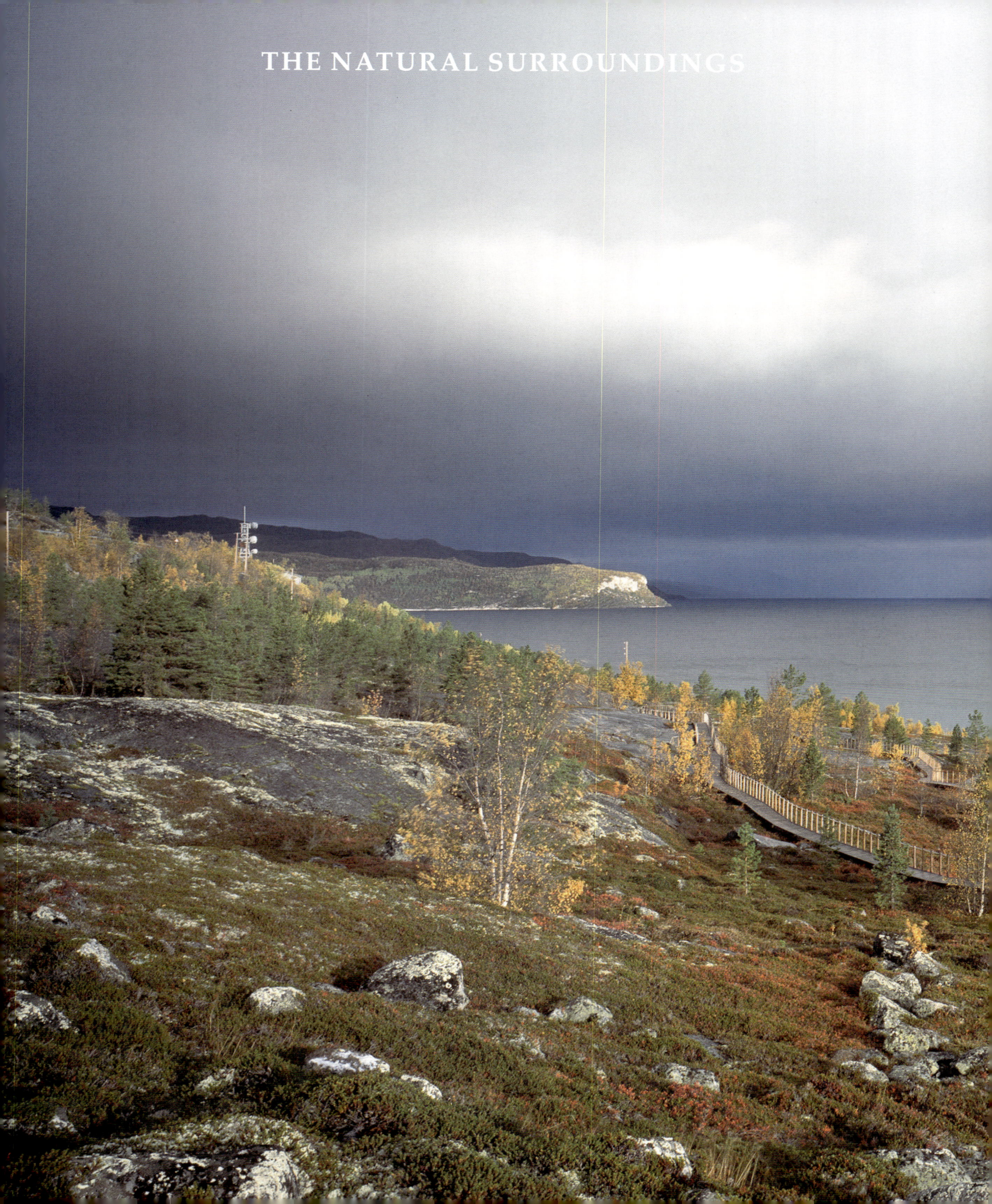

THE NATURAL SURROUNDINGS

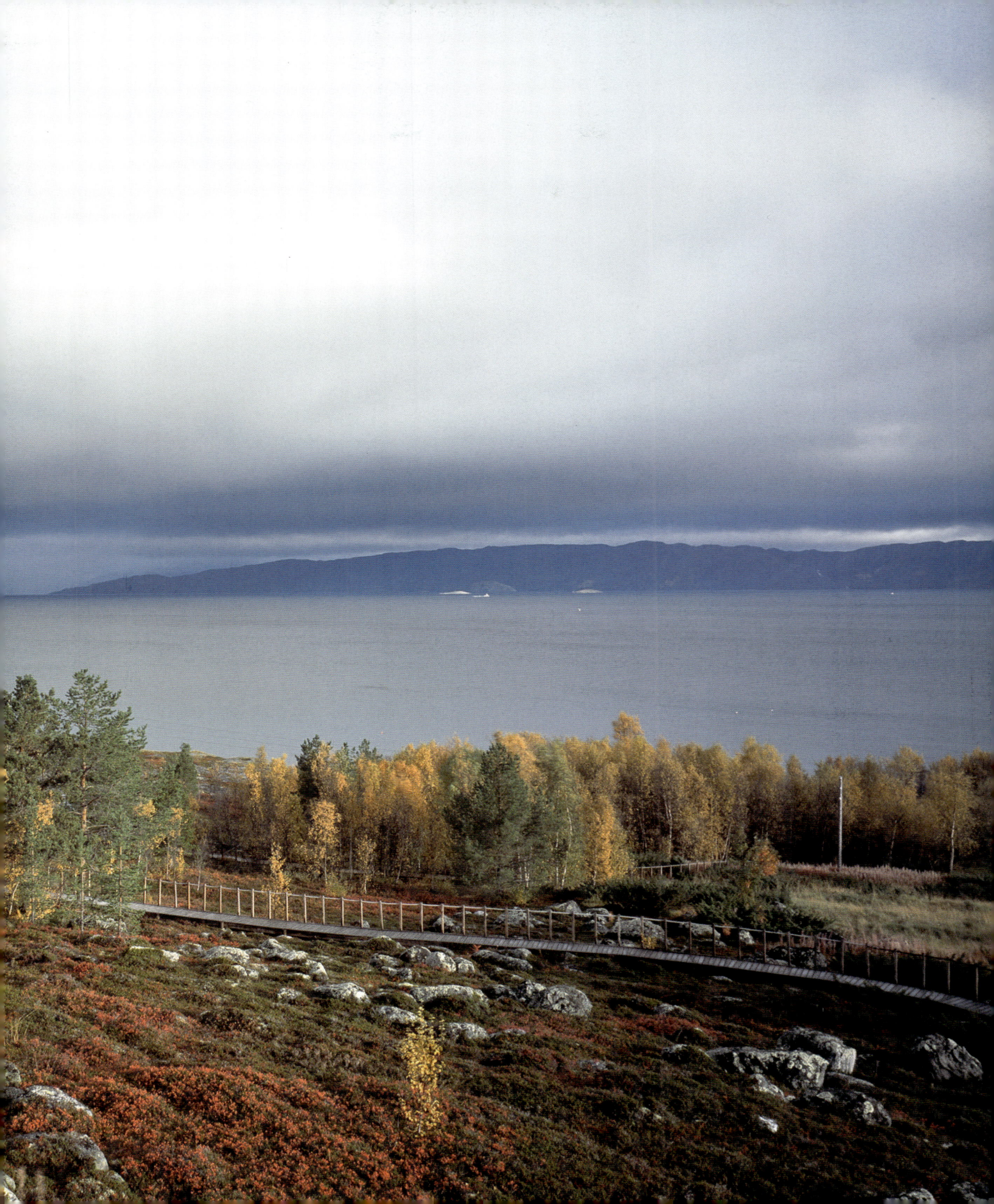

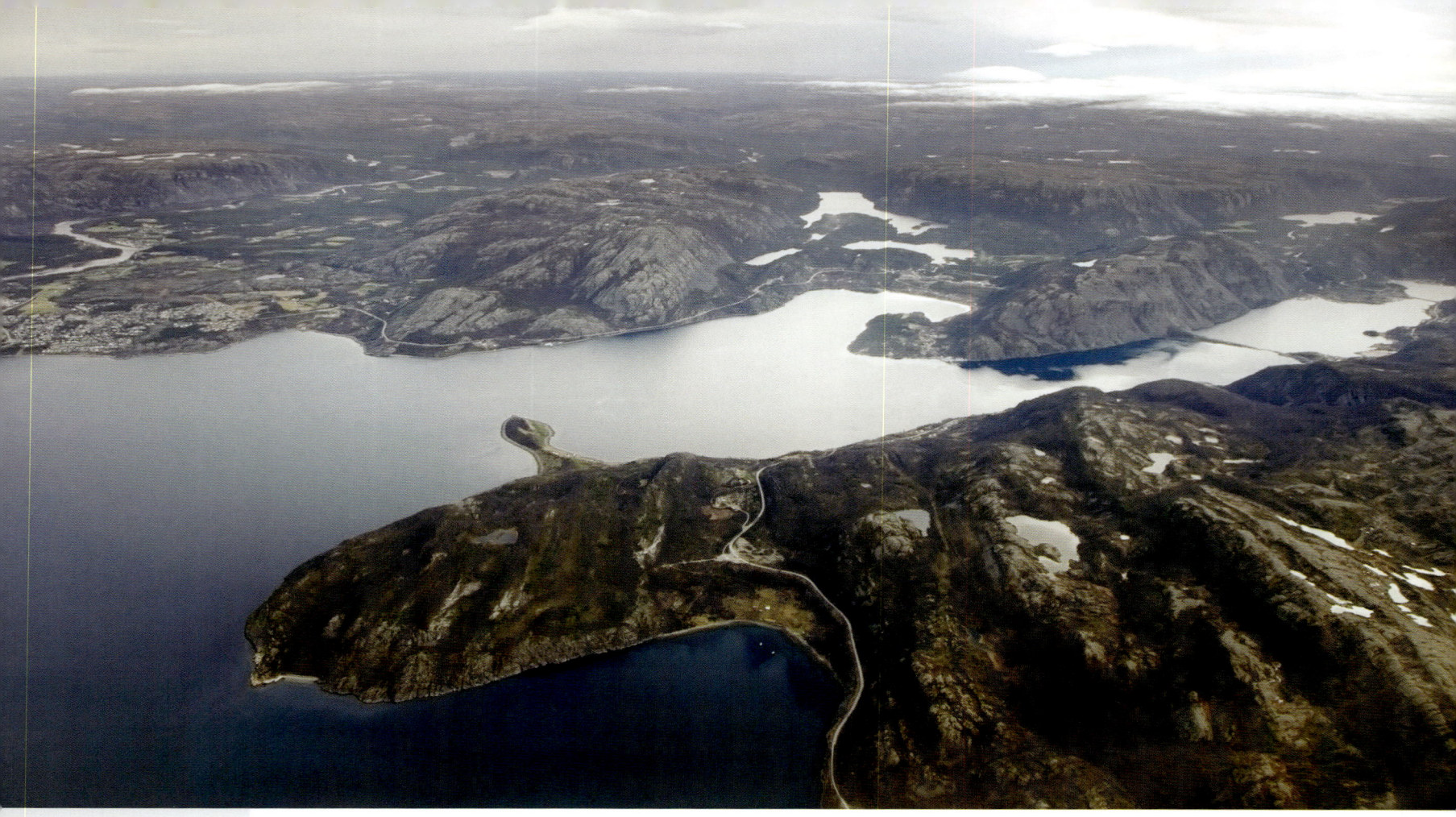

Figure 21 (p. 24–25) The walkway meanders through the colourful autumn landscape. The Bergbukten rock art panels are located on the outcrops by the loop to the left.

Figure 22 Towards the end of October. Hjemmeluft and Alta Museum, with the largest number of rock art sites, are located innermost in the fjord, and in the little bay just to the right of the community. On the left in the photo, one can see the lowermost portion of the Alta River. To the right, Kvænvika with the inland Storvannet Lake and Kåfjord on the far right. The Kåfjord site is located to the west of Auskarneset, the promontory jutting out into the fjord in the centre of the photo. The photo was taken facing south.

Alta's rock art site is located at 70° N and 23° E innermost in the Altafjord, in Finnmark County. The carved figures are located between 26.5 and 8.5 metres above sea level, in six different areas along the fjord, from Isnestoften in the north to Amtmannsnes in the south-east. The painted figures are located in two different areas deep inside the fjord, between 18 and 50 metres above sea level. The fjord is 40 km long south to north. South of the fjord, the terrain is relatively flat and wooded with birch and pine, and then rises towards a somewhat flat and undulating plateau – the Finnmark Plain – 400 to 500 metres above sea level. The forest line runs between 350 and 400 metres above sea level. On the western side, the terrain is relatively steep as it rises to the highest peak at 1149 m. On the eastern side, the terrain is less steep and easily accessible as it rises to the highest point at 700 metres. The wooded areas along the fjord consist mainly of birch, and the forest line towards the north sinks to 200 m at the outermost point of the fjord-mouth and continues to fall to sea level along the outer coast. The annual average temperature today is 1.3°C. The average temperature in July is 13.4°C, whilst January is the coldest month of the year with an average temperature of -8.7°C. Winters are quite long, lasting seven to eight months, followed by an abrupt transition from winter to summer and from summer to winter.

The fauna are well adapted to the yearly changes in climate and vegetation. In the Arctic latitudes, life on land and in the air is significantly reduced during the cold and snowy winter, with dormant vegetation and the exodus of migrating birds, which return to warmer weather and awakening vegetation in the springtime. A few birds remain over the winter, for example grouse and eider ducks. There are seasonal changes in the sea as well, but because the water in the Arctic fjords and coastal ocean does not freeze, there have always been sufficient resources to support a relatively stable settlement on land. It is likely that there have always been local species of fish and seals in the fjords. In spring, the reindeer migrate from the inland winter grazing lands to summer pastures along the coast and in the high mountains, whilst the spring migration of elk goes from inland towards the forested areas of the coast. Bears awaken from winter hibernation and leave their den in April/May, returning to hibernate for the winter in September/October.

At a time when hunting, trapping and fishing constituted almost the entire basis for human settlement, it is obvious that dependency on the natural surroundings was significantly more important than it is for today's society. It is no less doubtful that a large amount of knowledge that prehistoric humans had about animals and plants, and hunting and fishing techniques has been lost.

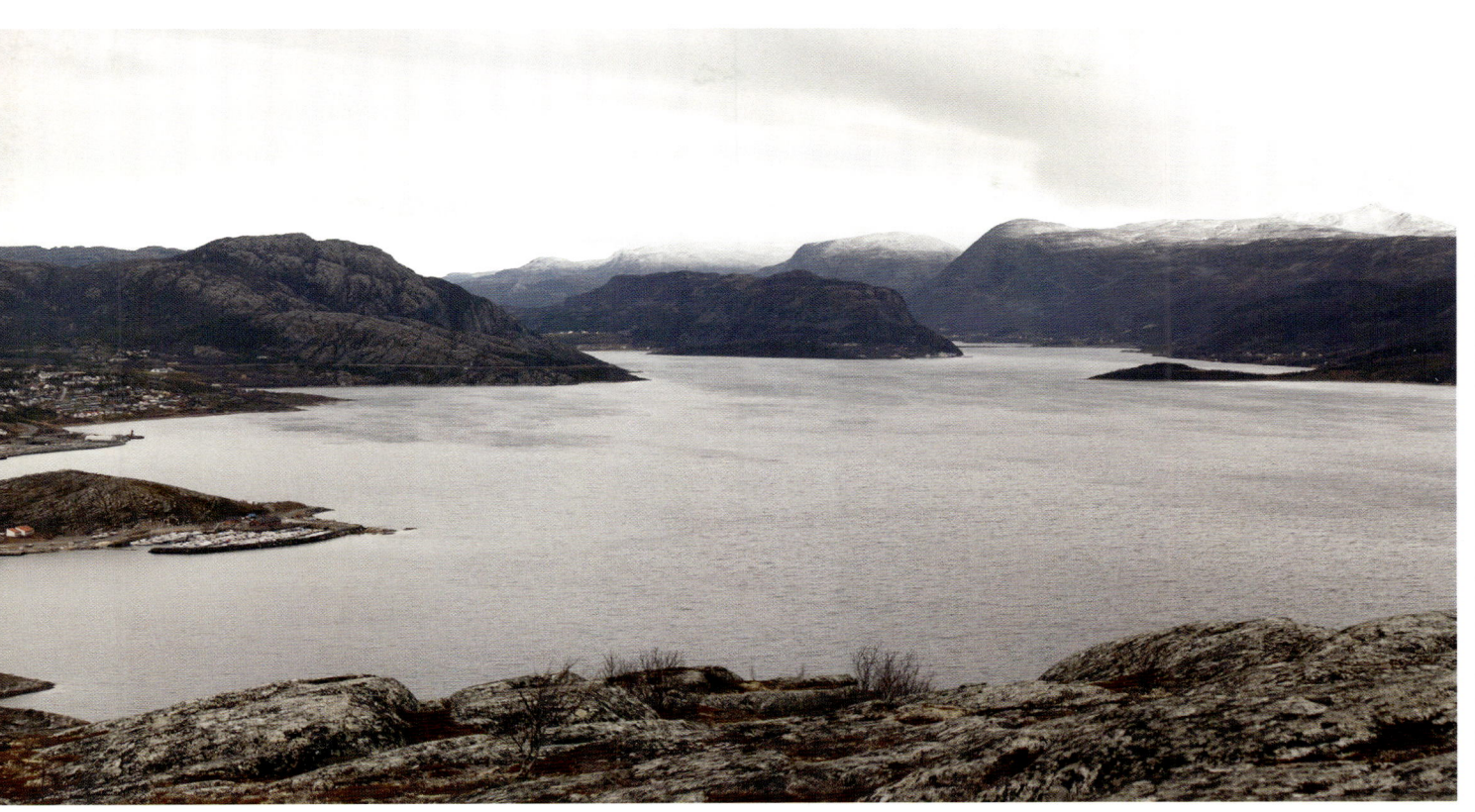

Figure 23
Fresh snow has fallen on the mountains, including the Haldde peak, the pointed summit to the right, where research on the northern lights was conducted between 1899 and 1926. It is cold; the leaves have fallen from the trees and all vegetation has gone into the winter resting period. The photo was taken facing west, with the buildings of Alta to the left. Hjemmeluft is located to the west under the mountain where Europe NR 6 runs towards the promontory, whilst the panels of the Kåfjord sites are found just inside the thin promontory – Auskarneset – on the other side of the fjord, to the right in the photograph.

From the time of the first settlements in Northern Scandinavia spanning some 9000 years BC and up until today, there were long periods of time marked by both colder and warmer climate. When the first rock carvings were made in the Alta area about 5000–4500 years BC, the average annual temperature was 2–3 degrees warmer than in modern times. The climate was more continental, characterized by warmer summers and colder winters, and the forest line was higher in the terrain and further out towards the coast. Although this does not mean that animal life was different from that of today, the extensiveness of fauna in the seasons was somewhat different, particularly given the fact that the forest and fauna living in it were more widespread. In terms of life in the sea, it is not possible to identify differences in species from those that exist today, although there was a greater abundance of sea life because fishing, hunting and trapping were small-scale and therefore could not exhaust resources to the same extent as is done with today's modern technology. In about 3000 BC, the average annual temperature dropped somewhat, but the modern climate period did not begin until about 500 BC. Some of the youngest rock art figures were created at this time.

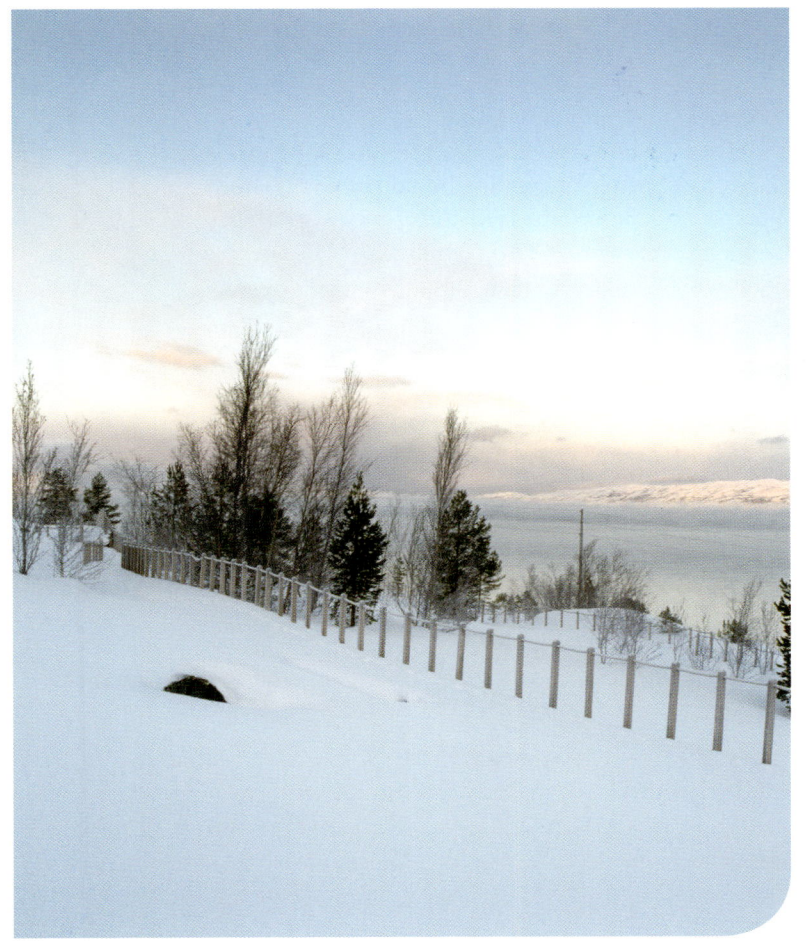

Figure 24
Early March. The sun shines warmly again in the mountains, and the snow covers the panels and walkways at Hjemmeluft. Pecking of rock art would have entailed removal of snow and ice, and this was of course feasible when necessary. Nevertheless, the topography, the structures and colours in the rock surface, which were often clearly an integrated part of the composition, would have been difficult to distinguish and include. Therefore, it is probable that the figures were pecked into the rock surfaces between mid- and high tide.

AGE

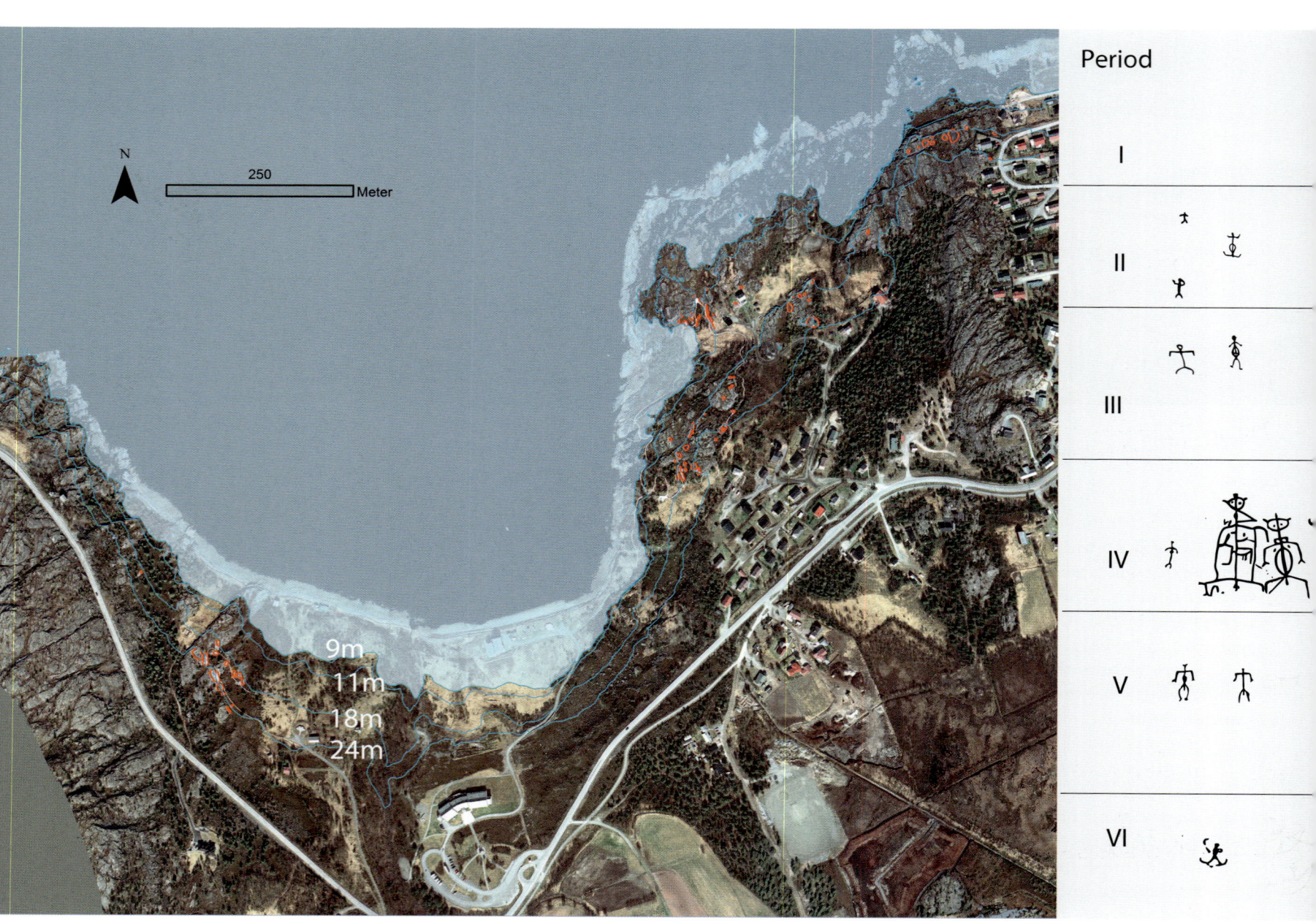

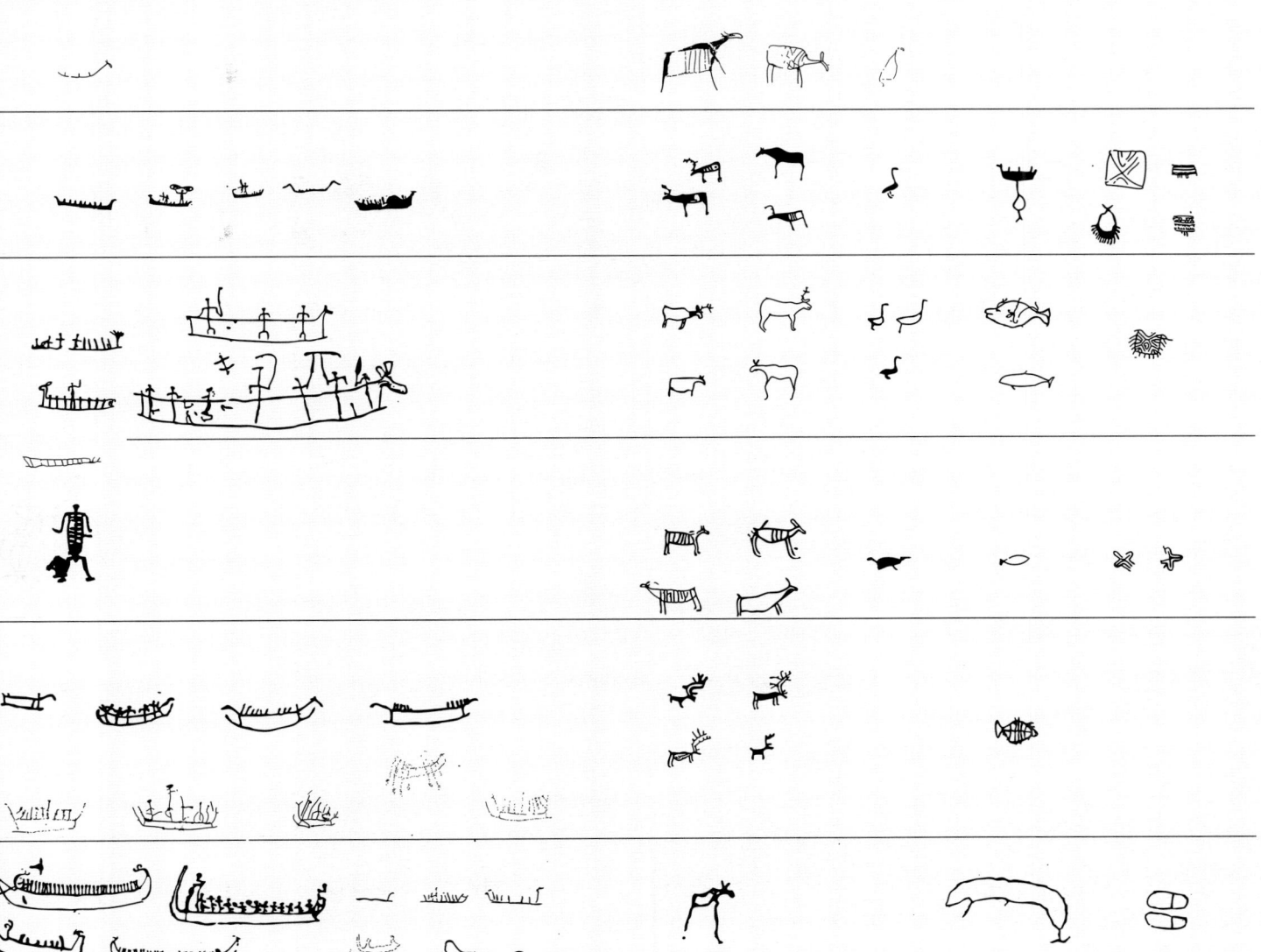

Figure 25
The blue lines show the mean water level when it was 9, 11, 18 and 24 metres higher than today's level. More elevated shorelines are older than lower ones, meaning that when the rock art were made along the shoreline, the more elevated ones will generally be older than those found at a lower level. This does not necessary mean that differences in height between individual figures in a panel reflect age differences The section below the nine-metre mean tidal line is marked as ocean, and one can see today's shoreline nine metres lower. The rock carvings, marked here in red, may have been made in the zone between the mean and high tide that was free of vegetation, but not under water.

When the mean waterline was 26 m higher than today, the rock surfaces with the highest elevated carvings were barely inside the zone between mean and high tide. When the mean water level was 23 m higher, all the rock surfaces with the oldest carvings were located above the mean tide level.

The diagram shows the main features of the figures in six periods spanning about 5000 years.

Period I: c. 5000–4800 BC.
Period II: c. 4800–4000 BC.
Period III: c. 4000–2700 BC.
Period IV: c. 2700–1700 BC.
Period V: c. 1700–500 BC.
Period VI: c. 500 BC–100 AD.

The time intervals are based on the age of the mean tide levels. The datings and demarcations between the periods are approximate and will undoubtedly be revised as we gain increased knowledge and understanding.

Aerial photo: © Geovekst

The first settlement in Finnmark was established in a coastal area about 9000 BC, and more than 3500 years would pass before the first rock art in Alta was created. The reason why we can be reasonably sure about this is that the location of the rock art in the old shoreline zone allows us to determine its maximum age. When the glacier that covered Scandinavia melted, the weight and pressure on the crust of the earth dissipated. Thus, land was released and rose, mostly in the centre where the ice had been thickest and heaviest, and least along the outskirts. The ice was thickest over the Bay of Bothnia, where the highest located shoreline, at Umeå, is 286 m above today's shoreline. On the Finnmark Plain, the corresponding shoreline is about 100 m elevation, and about 50 m on the outer side of Sørøya. No trace of any early settlement has been found on these ancient shorelines. The first settlement came several thousand years later and was located on the terraces just above sea level. The terraces cannot be older than the settlement itself, and based on radiocarbon dating of these hunting and trapping dwelling areas, it is possible to estimate approximately when the terraces were part of the shoreline, before they rose further above the water level.

This enables us to determine the approximate maximum age of the shoreline. Figures were pecked into some of the rock surfaces in the shore area, and as the surfaces with rock art gradually lost direct contact with the sea, new rock art was created on the newer, younger surfaces that emerged from the water. The rock carvings are hardly older than the mean water level, because if they were, they would have had to be made in the seaweed belt or under water, both of which are impossibilities. Figure 25 shows changes in mean water level in the Hjemmeluft area in relation to the rock art sites.

There is no doubt that many types of figures are associated with specific elevations. They do not exist at higher or lower levels. Thus the dating of the shoreline areas determines the maximal ages of the figures. Differences and similarities between the figures at the various altitudes suggest that figures were strongly associated with particular rock surfaces along the shoreline. The sequence of differences is most clearly found in the Hjemmeluft/ Jiepmaluokta area, because all of the periods are represented solely here, whereas occurrences are partially recurrent in other sites in the Alta area.

It is far from easy to use shore displacement and contact with the sea as the basis for dating, and it requires a detailed study of every single rock art site.

In slightly sloping terrain, only a one-metre rise can displace a shoreline by 50 metres horizontally. In very steep terrain, the distance will remain relatively unchanged. This means that one can expect local variations in size of the shore zone, depending on the angle of the rocks.

Another factor to be considered is the time of year when the figures were created and the degree of exposure of the rock surface to the elements. During summer, the rock surfaces from mean tide level to high tide level, as well as the areas that were not covered with heath and sod, would be exposed and available for making rock art. During the winter, only rock surfaces from the seaweed zone at medium tide up to the ice and snow at the upper edge of the high water mark would be exposed, unless of course the ice and snow were removed. One explanation for the strong shore connection can be that many figures were made during the winter, when access to the rock surfaces was limited precisely to the area between the mean and high water level , in addition to the area above the high water where waves were active. The height of this zone was the distance between the average mean and high water level, plus the wash-out zone. In Alta, this would amount to approximately 1.4 m plus a zone of 50–60 cm, depending on the shoreline's degree of exposure. The rock carvings could have been made along this entire zone, and as the land rose, new rocks could have been taken into use.

As the land rose, this zone was displaced downward at the same rate and along the same isobase (line between the points with the same rise or fall of the earth's crust). The rock art areas innermost in the Altafjord are associated with the 26–27 m isobase, whilst the Kåfjord sites a little further out in the fjord are at an isobase of about 26 meters. Shore displacement occurred somewhat more rapidly at the head of the fjord than farther out, where the ice had been somewhat thinner. On the outer side of Sørøya, shore displacement at the same time amounted to only 6–7 m. Maximal dating depends on geologists' and archaeologists' conception of how the shoreline was displaced. With an understanding of the variations in shore displacement and a certain degree of caution, it is possible to date the rock art found along the coast of Northern Norway and in Scandinavia generally, provided that the rock carvings were made along the shoreline. In several cases, radiocarbon analyses of prehistoric sites have resulted in dates older than the geological dates of the terraces on which the sites were found. Because the dwelling places obviously could not have been established below sea level, the understanding of shore displacement, and perhaps

also the isobases, needs to be adjusted somewhat. This kind of adjustment has to be made in relation to the inner regions of the Altafjord. The reason for this is that the radiocarbon dates of the dwelling features excavated in Tollevik in 2006 are about 500 years older than the dates geologists determined for the contemporaneous shoreline. The result of this adjustment increases the maximum dates for the mean water level and the surfaces where the figures were created. In this way, archaeological results contribute towards increasing our understanding of land emergence following the Last Ice Age.

The greater the difference in height between the uppermost and lowermost figures in a panel, the more probable it is that the rock art figures were created over longer periods of time than in areas where the differences in height are smaller. Therefore, one can also expect to find more temporal overlap in panels having large differences in height. It is also in the larger panels and adjacent smaller panels that a few figures have been observed which are typical of the younger, lower-lying panels. The opposite never seems to be the case. This can be interpreted as an indication that the lower-lying rock surfaces were covered with seaweed and ocean water. At the site with the largest difference in height, three parallel sets of foot soles were carved, ascending up over a large portion of the panel. Wherever they overlap other figures, they are always the youngest. The difference in age is difficult to determine, but the difference in height between the uppermost and lowermost figures suggests that they might have been made when more than merely the winter zones between mean and high tide were available, and that they are younger, because they are consistently pecked in over other, older figures. Most of the larger compositions have a height difference that would indicate that they did fit within the open rock surfaces between mean and high water level and the wash-out zone above this. However, to determine today what constitutes compositions amongst the figures in a panel is just as culturally dependent as when they were created thousands of years ago. We do not know the elements of the tales and rituals depicted, and thus any attempt to identify them will always be accompanied with uncertainty.

Besides Kåfjord, Storsteinen is a good example of a panel where figures were carved throughout at least two of the time periods. The panel is located at the 64 m² top surface of a giant block of stone. The boulder is more than 3 m tall, with vertical sides, and 99 per cent of the carvings are found on the top surface, 20–20.4 m above today's mean water level. Therefore, the

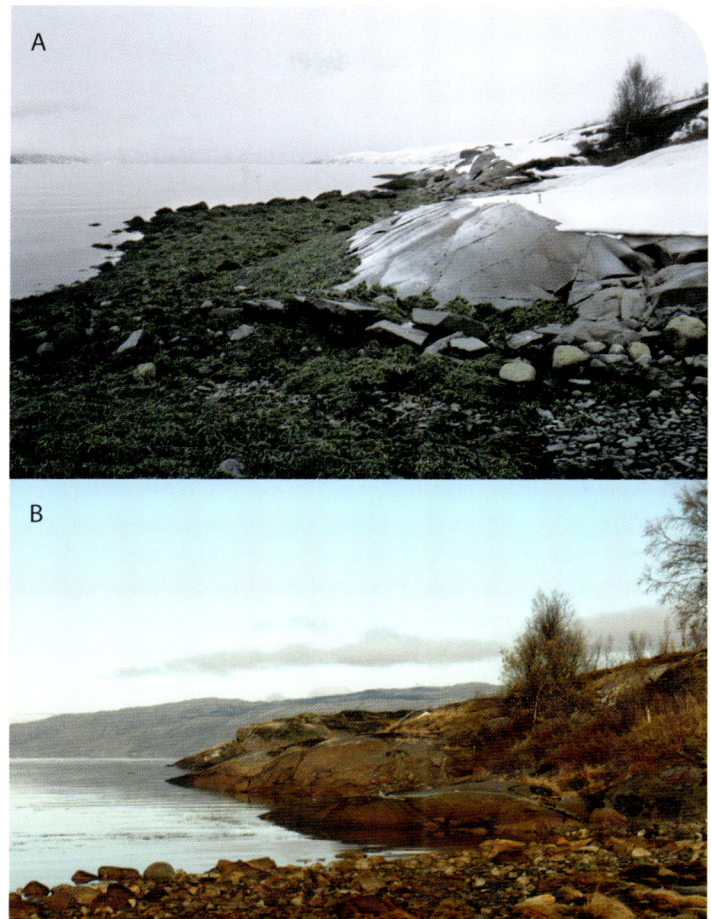

Figure 26
The shore zone where rock art could have been created during winter (A) and autumn (B). The zone between the mean and high water level is just as high, but the lack of snow and ice makes the wash-out zone somewhat larger.

figures cannot be much older than the time when the mean water level was about 20 metres above today's level. This would date the carvings at about 3300 BC. If direct contact between the stone and the sea was a requirement for creating and using the rock art, contact was no longer possible when the high tide level no longer reached the lowest part of the stone, that is, when the mean water level was about 1.4 m lower than the lower edge of the boulder. This yields a minimum dating of approximately 2000 years BC, which corresponds to a mean water level of 14.5 m higher than today's. This corresponds to the lowest portion of the Amtmannsnes panels, which can be used to date some of the figures on Storsteinen based on similarities of figures. If proximity to the ocean/water was an important factor for the place where rock art could be made, this factor denotes the youngest figures in the panel.

On some panels, certain figures are clearly eroded by water, which may mean that they are older than those that have not been water-eroded. As a result, they may be the oldest figures in the panel.

Figure 27
Figures that have been pecked in over others are youngest, although it is not possible to determine the difference in age between them. In this case, there are three parallel sets of footprints ascending from the lowermost to the uppermost part of the panel; all of these are pecked in over other figures, meaning that they might well be some of the youngest figures in the panel.

Another method is to base dating on objects that have been dated in another archaeological context. Some figures resemble large, flat spears or spearheads made of slate or sandstone from the Early Stone Age/Early Metal Age. The figures are not typical enough to allow more precise dating. In addition, there are three human figures carrying round shields (Figure 203) dating from the Bronze Age.

Some of the boat figures in Alta bear clear resemblances to rock art boats in Southern Scandinavia which have been dated from the Stone Age, Bronze Age and Early Iron Age. Few figures, however, can be dated based on their own characteristics alone. Dating is also based on the fact that figures carved over others are youngest, but it is impossible to determine the time difference between the two events. Again, the main basis for dividing rock art into periods of time is the dating of the shoreline with which the figures are associated. The presentation below of the rock art images will follow the divisions in time that are shown in Figure 25.

The painted rock art is much more difficult to date. Traditionally, it is dated from the last 1500–1800 years BC, mainly because they are regarded as part of a development in which the paintings in Northern Norway represent one of the final stages. This particular dating has never been properly challenged, and there is actually no statistical reason or other rationale for concluding that they could not be just as old as those found in Southern Norway or in neighbouring Russia, Finland and Sweden. In Finland, where only painted rock art has been found, amounting up until today to some 120 panels, the paintings have been dated from the Stone Age, from about 5000 to 1700 BC (Lahelma 2008). In Sweden they have been dated from the Mesolithic period and into the Early Metal Age (Gjerde 2010).

Neither the painted figures in Alta nor the rock panels themselves nor their location provide any clues to their age. There are no figures that can be dated with any certainty on the basis of motif and shape, and locality does not follow any spatial pattern corresponding to

that of the rock carvings, that is, to an association with the shore zone. The shorelines establish a maximum age for the individual panels from between 5000 BC to about year 0. If all the painted rock art were associated with the edge of the shoreline to the same degree as the rock carvings, the oldest in Alta may have been made as early as 7000 BC. Considerably more data is needed before a dating of the paintings to such an early time will gain general acceptance. Nevertheless, there are no grounds to claim that they cannot coincide with the same time span as that of the rock carvings.

Minimum age is based on the length of time it is estimated that the red ochre colour applied to the rock surfaces can last when exposed to the elements and potentially to salty ocean spray in cases where they are located near the water line. Since salt is an effective paint remover, it is less likely that the preserved figures were located near the water line, unless a natural varnish of silica was formed as a protective membrane covering the paintings. Such membranes have preserved paintings for thousands of years and probably also protected some of the paintings in the Alta area. We do not know how quickly the membranes were formed after the paintings were created. The shoreline at the time, in the steep terrain in front of the paintings, must have been significantly lower than the paintings if they were spared showers of salty ocean spray. There is no established minimum age and, in theory, the youngest may date from the Middle Ages or more modern times, and the oldest from perhaps a settlement sometime between 7000–5000 BC. There is a definite need for closer investigation concerning the age of the paintings along the entire coast, and concerning factors that can link them to a contemporary settlement.

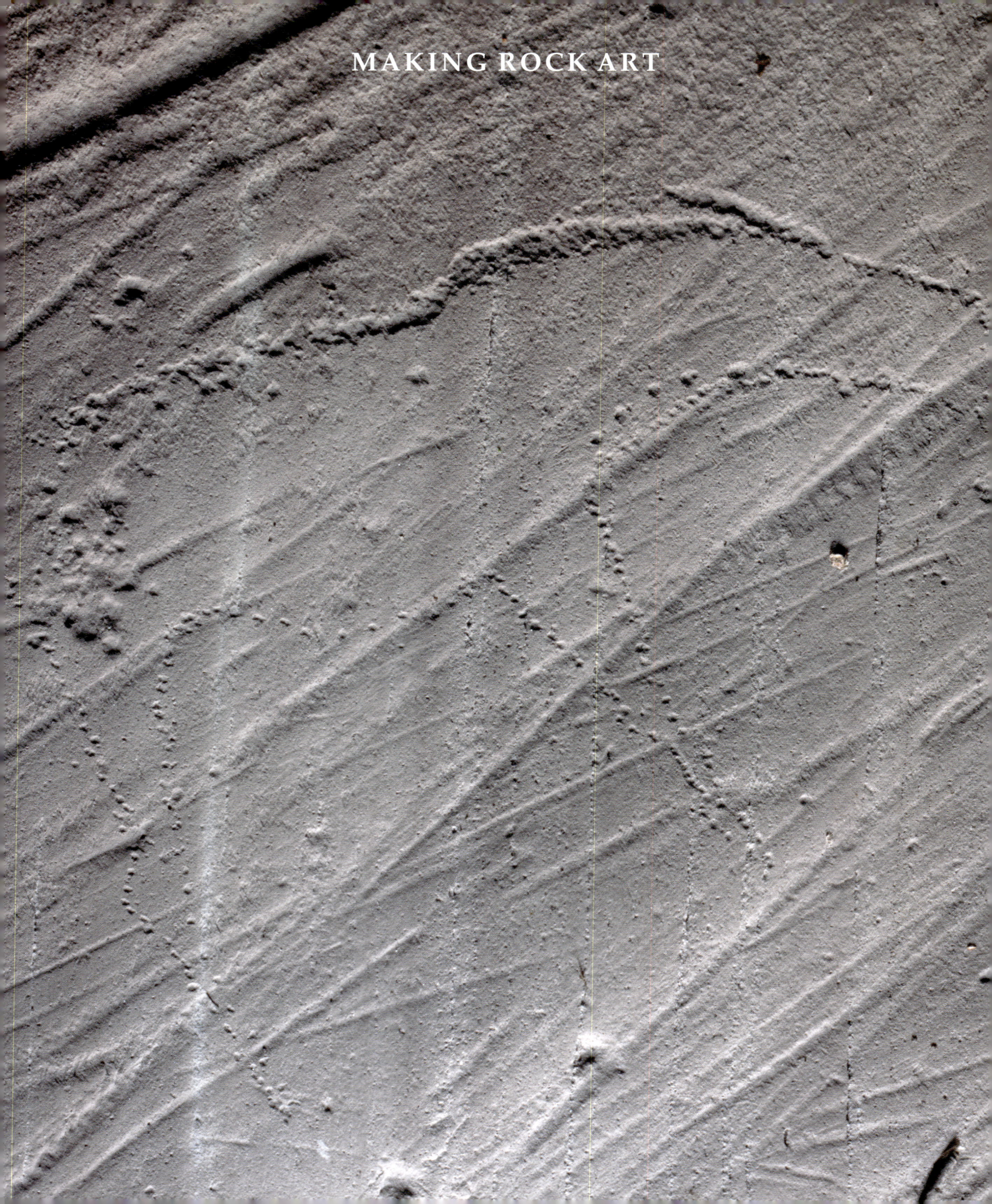

MAKING ROCK ART

Some 99.5 per cent of the rock art in Alta consists of figures carved into a rock surface. The rest of the figures are painted with reddish ochre. The differences in the figures reveal variations in individual skills as well as tools used and in the technique itself. The carved figures are created in two ways, namely by direct and indirect percussion. Direct percussion means that one uses a tool, for example a sharp stone, to strike the rock surface directly. This technique allows for a certain amount of wobbling, since it is very difficult to see and to hit the edge of a previously pecked mark. Lines made in this manner will be rough and uneven. In addition, the type of rock into which the figures is pecked will play a significant role. Indirect percussion means that one strikes the blunt end of a tool, for example a stone chisel held against the surface that is to be shaped or marked. This indirect technique has the advantage of full control over the point of impact and relatively little transfer of impact to the arm or shoulder. Therefore, the indirect technique is the gentler of the two, although both require relatively strong arms and a strong back, good muscle control and steadiness, as well as good vision. Compared with the direct percussion technique, the lines made will be considerably evener and often very clear and sharply defined. Neither chisel instruments nor hammers that could have been used for this work have been found in Alta. Chisel instruments may have been merely pieces of hard stone or minerals with sharp edges. The cutting edge used to strike the stone surface might have been fastened into a wooden handle which was pounded, or the carver may have directly struck the head of the chisel.

The softer slate in Kåfjord is easier to peck than the more compact sandstone in Hjemmeluft and the volcanite of Storsteinen. Likewise, tools with various degrees of hardness and structure will split and shatter differently when they impact with rock surfaces. The variation in the percussion marks within

Figure 28 (p. 34)
An elk, the outline of which was first made with millimetre-sized, rectangular peck marks before the lines were enlarged using a broader-edged tool. From period II.

Figure 29
The extremely even outer line is evidence of the steady and controlled hand of the chiseller. From period II.

and between figures suggests that both hard and soft cutting instruments/chisels were used.

The figures are shaped in several different ways. In certain instances, a preliminary outline is first cut with peck marks before the actual outline is broadened and deepened. Each blow is carefully placed (Figure 28), and the regularity in the size of the percussion marks suggest good control of both the blows of the chisel and of the shape of the figure. It is possible that the edge of a chisel changed shape due to chipping , and this would mean that it was important to watch carefully to control the direction of the incision.

In cases such as the one shown in Figure 29, the edges of the lines themselves are so even that there must have been very good control over both the impact and the pecking tool. The similarity in the way many of the figures on the panel are made suggests that they were made by the same person and that a special norm was followed.

In some figures, the percussion marks are large and deep, and it is clear that the tool used was relatively coarse (Figure 31). The fact that some percussion marks are deeper on one end indicates that the chisel was held at an angle and that the direction varied a little as the edge changed shape. The depth of some marks suggests that they were made with forceful blows using a hard type of stone.

In other instances, the percussion marks are relatively concave, as if a conical point was pounded or drilled (Figure 31) directly into the stone surface. Tools that might have produced marks of this type have not been found. Drill marks are the exception and are

Figure 30
When documenting and presenting rock art, many choices need to be taken, such as the level of detail and viewing angle or the choice of photography, scanning or drawing. Each gives a different impression, and each can influence interest in or interpretation of the object. Details in the figures were undoubtedly important, as was perhaps the viewing angle. Were the figures meant to be seen from a boat, from the side or from above, or do these factors make any difference at all? In this photo, graphic artist and illustrator Ernst Høgtun is drawing figures with an angle of sight from below, on the site of the waterline at a certain time in the past.

primarily associated with the oldest group of figures. However, a closer study of drilling as a production technique must be done before conclusions can be drawn.

In Figure 32, the percussion marks are relatively shallow, which indicates that the tool used was relatively soft or that the cutting edge was pulverized when it was struck against the hard and compact sandstone that is prevalent in Hjemmeluft.

In other cases, it seems as if one started with a broad line which was gradually lengthened. It is also evident that some of the differences that can be seen are due to individual pecking skills. At the same time, however, one cannot discount the hypothesis that the need for accuracy may have varied in terms of the figures being pecked, or their purpose, and that the requirement of accuracy may have varied through time. For example, the upper, and perhaps oldest figures in period I, are somewhat more coarsely carved than the group of lower-lying, younger figures. In the lowest group of figures, periods V and VI, many are more coarsely made.

Another problem is that erosion has expanded and worn away many of the percussion marks so that it is no longer possible to determine the kind of tool used to make them. Erosion has also widened some of the original lines. On some panels, a couple of the lower figures beneath a prominent vein of quartz show signs of little erosion, whilst the figures and the rock surface on the upper side of the quartz vein have been heavily eroded, and the lines appear to be smoother and almost twice as wide as those in the figures on the lower side. In terms of age, there does not appear to be any difference. In addition, there appear to be some differences in figures of different age, but the studies undertaken up until now are not sufficient to connect specific techniques with individual panels, types of figures or time periods.

The painted figures consist of red ochre, that is, pulverized iron oxide that must have been mixed with a binding agent to enable the paint to be applied to the rock surface. The binding agent has not been identified, but it may have been water, fat from animals or perhaps even blood. The only material still on the rock surfaces is the pigment iron oxide. If we are able to find traces of the organic binding agent, we will also have an opportunity to date it using radiocarbon analysis. The paint must have been thick enough to avoid running and was applied using the fingers, a flat stick or some form of brush. Figure 34 shows a painted figure from Transfarelvdalen.

Figure 31
In this figure, there are marks made by both percussion and drilling. The marks made by direct percussion vary in appearance and give the figure shape. Drill marks – round and conical in shape – are relatively few in number and can be seen, for example, in the space inside the amulet/symbol above the head of the human figure and in the right arm. The variations in technique used also suggest that this gave the figures meaning and identity. Period II.

Figure 32
The shallow peck marks were made with a relatively soft or fragile stone. Period III.

Figure 33
One of the youngest reindeer figures in Hjemmeluft, from period V. It is relatively indistinct, made with a thin, sharp-edged tool, and is difficult to see. The peck marks are from a thin, sharp and short cutting edge on a small chisel made of iron, bronze or a hard species of stone. Were the lines perhaps intended to be more distinct? Were they perhaps already present in the stone? The antlers are very large, like those of a buck. There are marks around the reindeer made by other, larger tools, and in the lower left there is a cross-shaped figure.

Figure 34
A geometric figure from Transfarelvdalen that was very likely painted with some sort of brush.

PERIOD I
5000–4800 BC

Figure 35
The figures were highlighted with chalk during the first documentation of the uppermost panel at Kåfjord. They were then copied onto plastic foil. Later, the panel was scanned. (Figure 37).

PERIOD I COMMUNICATING WITH THE WORLD OF BEINGS

Figure 36
It is possible that the first figures were pecked into the rock surfaces in Hjemmeluft when the mean water level was 26 metres higher than today's. They were possibly made a couple hundred years later than a matching surface in Kåfjord located a distance further out in the fjord.
Aerial photo: © Geovekst

When the first rock carvings in Alta were made, small groups of families had lived in the coastal area for approximately 4000 years. We are then in the end of an era called the Old Stone Age or the Mesolithic Period. People lived from hunting, trapping and fishing, gathering berries, roots and other plants, but because few remnants of animals and plants have been found, we know little about the connection between these. It is assumed that knowledge about animal and plant life was very comprehensive, with applications as both food and medicine.

Judging from the finds, population size was small. The dimensions of remnants from dwellings and dwelling sites that have been found suggest that the dwellings, and therefore the size of family units, were small. Finds in Sørøya, the Nordkynn peninsula and Varanger suggest that the dwellings were between 6–15 m^2 with space for 8–10 people, counting both children and adults. New finds in Tønsnes outside Tromsø show that people also lived in rectangular-shaped dwellings with a base area of 40 m^2 (Skandfer 2010). In this respect, one must also take into account that space requirements cannot be determined solely on the basis of the size of the dwelling, but also by the cultural perception of how space was used in various contests, including how space was perceived as a signal of wealth, power and status. It can therefore be very difficult to calculate how many persons a dwelling can accommodate, even if one subtracts from the area the space in which people could not have slept, such as the hearth or areas for commonly shared activities. The small dwellings may have belonged to core families, whilst larger dwellings may have accommodated several families or extended families (Simonsen 1962; Helskog 1984; Engelstad 1988; Schanche 1994).

If we proceed on the basis of the finds at dwelling sites, the need for contact between people in social and ritual contexts, as well as the seasonal variations in animal life, people were relatively mobile. This means that they lived temporarily in different places at different times of the year and migrated between inland and coastal areas, depending on changes in the scope of resources and in climate. Nor is it certain that settlement patterns were similar or invariable. We know that settlement was somewhat sparse inland but that at the time, as later, most people lived in the fjord – and coastal areas. Among the oldest traces of settlement at the head of Altafjord are the dwelling sites of Tollevik and Stensenget, located on the uppermost terraces at the Komsa mountain (Nummedal 1929). These dwelling sites are very likely

older than the rock art. The dwelling sites that are assumed to be associated with the people who created the rock art are those that are located in proximity to it, although at a slightly higher level above the sea. In Kåfjord, there are remnants from two dwelling sites. The largest of these is located above the rock carvings just below the road to Auskarnes. Over the years, a large number of objects made of dark, fine-grained quartzite/chert have been collected. The other dwelling site which may be contemporaneous with the oldest figures is located about 150 m to the west.

The level of the sea was higher at the time, and inhabitable areas were thus somewhat less than today. In about 5000 BC, the water level innermost in the fjord was 26–27 metres higher than today, and at Storekorsnes outermost in the fjord about 17–18 metres higher. The difference is due to the fact that the weight of the ice and the pressure on the depressed land mass subsided out across the fjord, which in turn resulted in the relatively greater degree of land rise in the inner sections of the fjord. The oldest rock carvings may have been made on rock surfaces in Kåfjord – on a shore that are currently 25.5–26.5 m above today's mean water level. This means that they were created maximally a couple hundred years earlier than the highest-lying figures in Hjemmeluft/Jiepmaluokta which are located at approximately the same height, given, as mentioned, that they were made between the medium and high water level.

The clean and smooth rock surfaces are only one of several reasons why the rock art was made in the shore zone. In this location, the figures were distinct. The rock surfaces in Kåfjord consist of brown-reddish brown, green-striped slate, lined with glacial striations running north-east to south-west. This is a vivid and colourful rock surface, and the colours, minerals and structures in them may have been one reason why certain surfaces were chosen over others. This connection between the rock carvings, the colours, the minerals and structures in the rock surface accounts for a part of the content in the tales and myths in memory and rituals.

It is not always easy to identify what the figures resemble, but often they are depicted with characteristic physical traits that are so distinct that identification is unambiguous. Problems arise when the figures display features that are nonexistent in the animal itself – some figures become inscrutable, and others represent a conception of reality that we no longer

Figure 37
Scanned image of the uppermost panel of rock art in Kåfjord and probably the oldest figures in the Alta area. At the earliest, the figures could have been pecked in when the rock surface was between mean and high water level, about 5000–4800 BC.
Scanning: Metimur AB

Figure 38
Boat with an elk's head above an elk cow's back.

Figure 39
The spear is firmly planted in the elk's chest. Is the figure a description of the hunt or a part of a ritual associated with an invocation for a good hunt? Can the figure beneath the muzzle represent blood dripping from the mouth of a dying animal?

recognize today. But based on the figures, conclusions regarding similarities and differences can be drawn. For example, some of the figures in Period I have stylistic features that suggest a connection with the Bukkhammar panel at Tennes in Balsfjord. Both panels share the same approximate maximum dating, about 5000 BC, when the high water washed over the rock surfaces. The similarities apply particularly to the large elk figures and their almost "square" bodies and characteristic long muzzle (Figure 37).

In Kåfjord, there are two single-lined boats with similar elk heads. These are the only known two boats with this shape in the entire northern region. The similarity applies to a lesser degree to figures of reindeer, but given the similarity and the coincidence in relative placement to shore displacement, it is possible that both panels are amongst the earliest rock art sites in Northern Troms and Finnmark.

The panel comprises 12 figures: Four elk, one reindeer, two boats, one bird and four figures that are difficult to identify. The four elks are all cows; three are depicted with full bodies, whilst only the neck, breast and head of the third are shown. All three differ from one another. On one, the body is somewhat rounded and the head bows towards the ground. In the front two-thirds of the body, there is a pattern of six vertical lines and three diagonal lines. Because of erosion, the pattern has been damaged and is difficult to make out. The animal is depicted with four legs, which is somewhat unusual in rock art. The body of the other elk is stouter than the first, more rectangular and sharp-edged and also has a pattern of vertical lines, like ribs, in the front two-thirds of the body. The head is raised, and there is a spear lodged in its breast (Figure 39). Under the muzzle, some small dots have been pecked, and a little further down is an unidentifiable figure. Could this represent blood that has dripped from the animal's mouth after it was speared?

Figure 40
A bear, likely a brown bear. The head is fully carved, and there are some peck marks in the body. The hind leg has been pecked over a line running into the bear's stomach area, perhaps representing a spear. A similar figure is found in a panel from Period II.

The third elk is depicted showing only the neck, chest and head. The shape is markedly different from the other animals, but all share a lack of antlers and dewlap. They appear to depict three different elk cows, as if they represent three distinctive identities.

To the right of these figures, the panel is highly eroded. This applies particularly to the upper section; figures that may have been present have been obliterated. To the far right we find a large web-footed bird; the head is damaged. Based on the beak and placement of the feet, we can conclude that this is very likely a depiction of a cormorant, and based on the shape of the body, a cormorant that has gorged itself and has lost its tail, or else it is depicted from a perspective where the tail cannot be seen. To the far right, outside the picture, there is yet another large animal resembling a reindeer or an elk. Four vertical lines mark the neck region and muzzle and give the animal an extra feature.

Both boats have a long prow capped with an elk's head (Figures 37–38). The hull itself is marked with a single line, and on the one boat, the sternpost curves upwards. The stern of the other boat has been obliterated by erosion. Three short lines extend upwards out of the hull; these are normally interpreted as representing crew members. The figures probably depict small boats used for traffic near the shore. The elk is an important symbol often associated with boats for almost 2000 years. This will be discussed in more detail in the chapter on the following period, when a much large number of rock carvings and compositions containing elk as central figures provide a broader basis for discussion.

In the upper portion there is a rhombic-like figure with two parallel lines running upward from the end; these are clearly the remnants of a larger figure. The immediate association one makes is to a paddling oar (and boat), but it is actually impossible to say with any certainty what the figure might represent because the rock surface has been obliterated by erosion. A little further down on the rock, there is a similar rhombic figure.

Still further below there are two more figures, a bear and a reindeer. Both held central roles in rock art and cosmology, also after rock art ceased to be made throughout the remaining part of prehistory and up until the modern era.

PERIOD II

4800–4000 BC

Figure 41 (p. 46)
The figures are compact down across the rock surface. The photo was taken facing east-southeast.
Photo: Adnan Icagic

Figure 42
There are an impressive number of figures in the panel, compactly grouped and seldom carved on top of one another. It is as if they are at one and the same time a large, complicated tableau as well as multiple small compositions and stories. The figures have been digitally enhanced to give them a darker contrast on the rock surface. The photo is the result of high resolution optical three-dimensional scanning, which does not record the colours of the rock surface. The topography of the rock and all the glacial striations from the Ice Age are very distinct.
Scanning: Metimur AB

PERIOD II COMMUNICATING WITH THE WORLD OF BEINGS

Figure 43
Perspective drawing of a section of the Bergbukten I panel showing the relationship between the rock's topography and the figures. Topography and colours were also integrated parts of some of the stories that were illustrated and told. Seen from the east.
Drawing: Ernst Høgtun

The population in the Alta area during this era still had hunting, trapping and fishing as the basis for their livelihood. It is difficult to estimate the size of the population, but it was very likely small, amounting altogether to only a few hundred people. Based on excavations on Sørøya and surveys and finds in the areas around the Altafjord and other places in Finnmark, we assume that people lived in turf hut-like dwellings that were few in number and located on the same promontory or in the same bay. We know little, however, about the building materials used. Dwelling features of huts like these have been found at the head of Altafjord including Hjemmeluft/Jiepmaluokta, and across to Storekornes on the eastern side of the fjord, as well as at Isnestoften on the western side. It is assumed that tents were used during the summer by people who migrated to the hunting and trapping places, such as, for example, the terraces above Savtĉo in the Alta River (Simonsen 1992, 2001). Based on the few excavations done in the Altafjord area, in the coastal and inland areas (Simonsen 1961; Simonsen & Odner 1963; Renouf 1981; Engelstad 1986; Hesjedal et al. 1996) and the inland (Simonsen 1979a,b; Simonsen & Odner 1963; Halinen 2005), as well as on our knowledge of seasonal changes in nature, we have a general understanding of the way seasonal exploitation of resources in the area may have been carried out. They hunted reindeer, European elk (Alces alces), seals, small whales and birds, and they must have fished extensively in both saltwater and fresh water. They picked berries and gathered roots. They undoubtedly had deep knowledge about animals and plants, weather conditions and life in general in the world they inhabited.

At the same time, the relations between people, between individuals as well as between families, groups and clans, were decisive for the choices they took, whom they could marry, where they could live

and with whom they could live, how they should behave, with whom they could hunt or pick berries, gather roots, etc. In many respects, this is not unlike relationships in many modern societies today. The knowledge they possessed was without a doubt vast and full of traditions. There were various types of specialists, a code of rules governing how tasks were to be accomplished and which other-than-human beings one should ally oneself with in every aspect of life. Some of the knowledge as well as the choices they made are expressed through the rock art.

The largest number of rock carvings and variations in motifs belong to this period. They are located at between 26.5 and 23 metres above today's mean water level (Figure 44).

Most of the figures are relatively naturalistic, that is, they are easy to recognize from the original physical model, the very prototype. Among the animal figures, reindeer and elk predominate, followed by bears. In addition, there are a large number of human-like figures and boat figures, as well as patterns or geometric figures for which no physical examples of a prototype have been found. Although it is easy to recognize boats, we do not know how representative they are, because no such boats have been preserved. The boats in the rock art represent the only direct knowledge in existence about boats in the north older than 2000 years.

Figure 44
The Hjemmeluft area. The transparent light blue layer shows a mean water level 23 m higher than today's. Marked here as red circles, the panels with figures from Period II lie just above this. The younger panels can be seen beneath the simulated waterline. As land emerged, the figures were pecked into the rock surfaces in the younger tidewater zones and the older rock panels were no longer used.
Aerial photo: © Geovekst

HUMAN FIGURES

Figure 45
The human-like figures are depicted performing various activities. For example, to the right are four people holding an oval figure; at the bottom, people are returning from bird hunting, and just behind them, there is a person beating a drum. In the middle of the picture, two figures are holding poles topped with elk's heads; another is brandishing a bow and arrow, and up to the left, there is some sort of procession. The panel is small, but full of content and focusing on human-like figures performing activities.

PERIOD II COMMUNICATING WITH THE WORLD OF BEINGS

Most of the human-like figures from this time period are depicted as line drawings with the body delineated by a thin or broad line. They are in boats; they fish, hunt, perform ceremonies and rituals. Human figures are central in all compositions in which they occur. Those in boats are discussed in the section on boats because it would be meaningless to separate one from the other. In a way, there is a distinction to be made between people performing activities in boats/on water and the rest of the human figures.

The figures brandishing bows and arrows at reindeer or spearing a bear in the chest describe humans in the act of hunting, whilst in some scenes, the figures have features indicating that they represent other-than-human beings, or humans masked as other-than-human beings. The problem is to distinguish between the three alternatives, if in fact there is a distinction to be made. Other than human life was shaped on models of mortal humans' experience and knowledge, despite the fact that the other-than-human beings took the form of European elk, reindeer, fish or humans. Based on descriptions of early and existing hunting and trapping societies, one expects the other-than-human beings to have human features, sometimes combined with features of other animals, and sometimes incarnated wholly as animals. In other words, there are many alternative interpretations.

In certain instances, the very composition or context in which the figures occur gives us an inkling of what the individual figures represent. But even if we are able to group certain figures and exclude others, there is still a long way to go in understanding what the figures and compositions really meant. In one case, it appears as if a woman is riding on a reindeer's back (Figure 58). Did people actually ride reindeer, or is this an illustration of a mythical event? In another instance, there is a scene with 11 human figures (Figures 45) in which one of them is holding a pole topped with an elk's head (?); two are holding a child between them, and all of them appear to be in motion along a carved line. Whereas one is left with the impression

Figure 46
Night photography using artificial light requires a lot of expertise and patience. The rock surfaces are never uniform and even, so that light sources and the photographer must constantly change angles in order to capture the targeted motifs. Photographer Adnan Icagic at work.

Figure 47
A ritual associated with giving birth?

Figure 48
Two human-like figures lifting a boat, delineated to the right by a cleft and, to the left, by a fissure in the rock. Below are human-like figures holding a rope.

that these are people performing some kind of ritual, one might also ask whether they represent different types of powers.

To the far right in the panel, four human figures are standing in a circle (Figures 45, 47). They are holding an oval figure between them. The human figure placed lowest is the smallest of the four, and the size of the others increases proportionally. The largest figure appears to be a woman squatting as if in a birthing position. This woman is grasping the opposite figure by the hands, whilst the other two opposite human figures are holding the wrists of their two counterparts. Perhaps all of these human figures are women, where the largest of them is giving birth and the three others are providing assistance during the birth. They are all holding an oval object during the birth, as if this is part of a ritual. What we see may also be a part of a narrative, a myth pertaining to a special birth and special humans or other-than-human beings. There is a reindeer bull and a cow turned

PERIOD II COMMUNICATING WITH THE WORLD OF BEINGS

Figure 49
The southern portion of one of the larger panels from Period II with an abundance of figures. In the upper left is a scene in which people are in the process of scuttling a boat (Figure 84). To the right of this, a "death ritual" (?), elk, reindeer, geometric figures, and below, human figures holding elk's head poles, a rare little whale, etc. To the far right: a depiction of sexual intercourse or a squid?
Photo: Adnan Icagic

Figure 50
Traditional sex position; to the left, two spears; to the right, a reindeer.

Figure 51
Sexual intercourse.

toward the birthing scene, as if they are watching the birth. The reindeer cow partially overlaps the birthing scene; the problem, of course, as in so many other instances, is to determine which figures belong in this composition. There is also a reindeer bull with its back turned to the scene.

On the lower right of the panel, there is a small scene in which two human figures are carrying a large bird between them. The figure on the left is holding a long pole in its left hand, topped with what appears to be a bird's head. On the left there are two additional human figures. One of them is holding a long pole in its right hand. It appears as if the figures are moving inwards in the panel. Behind them, there is another human figure carrying a circular object in its left hand and a short, straight object in its right hand, perhaps a drum and a drumstick, in a ritual associated with the hunting of the large bird being carried between the first two (Figure 45, 251)

The compact concentration of figures seems to be independent of the rock's surface dimension, which may mean that individual figures as well as the compositions are parts of a complicated narrative. Features of the rock panels also played a role in the choice of surface on which rock carvings were made. At the top of the panel, for example, there is a lighter, oblong section on which no carvings have been made. Perhaps features like these were subsections

Figure 52
A man wearing snowshoes. Notice the details of the snowshoes.

PERIOD II COMMUNICATING WITH THE WORLD OF BEINGS

of the narratives the figures were a part of, or had a special meaning associated with places where one could communicate with life in other worlds. The places themselves may have had great spiritual significance. It is impossible to know this, but since we find recurring patterns, a hypothesis of this kind is reinforced.

Another example: amongst the compositions, there is a scene with 19 human figures standing in a circle and holding hands (Figure 12). Another figure, which is part bear, part man and part woman, is standing inside the circle. The head is a bear, the body is human and it appears to have a large penis and two breasts as non-carved features. To the left of the penis is something resembling a vulva. The figure stands alone inside a circle. Based on many other scenes in which bear are depicted standing inside a den, it is tempting to interpret this circle as a den that the creature is either exiting or standing inside. This is perhaps a depiction of a power having several different capacities. It may portray a ritual leader wearing a special costume when he/she contacts the other-than-human beings, being transformed into a bear and changing sex, or it may be a power portrayed as a multi-gendered human-beast. Whatever the meaning was, it is clear that depictions of bears played a major role in people's beliefs and rituals.

Figures other than human-like figures also appear to represent a part of the context, such as for example in the case where ten human figures are holding a long line (Figure 48). Eight have horns, suggesting people wearing a headdress and performing a ritual. Above these are two human figures lifting a boat over their heads. Like most boats from this time period, it has the features of an elk. The entire scene is delimited by a crack in the rock on the left, and to the right, the rock plunges downward. Clearly, the topography and structure of the rock was used as part of the composition. It seems as if the boat, or what the boat symbolises, is the central focal point in the composition.

On another panel, five human figures stand around a boat, two in front, one on each side, and one in or over the boat (Figures 49, 84). The figure in the boat is holding a long pole and is piercing the hull with it, as if the figure is trying to destroy or scuttle the boat. Just above, there are some reindeer figures, and down towards the right, a fully carved human figure. A little further down to the right on the same panel, there is a circle formed by eight human figures performing some kind of ritualistic dance (Figure 49). They are holding hands, and on the outside to the right there is a somewhat peculiar human figure that is standing or lying outstretched. One interpretation is that this composition illustrates a death ritual (Evers 1988, 1991). The animal figures in the foreground are European elks, animals that may be more closely akin than any of the other animals with the powers associated with death and transport of the dead. In a context of this kind, the destruction of the boat perhaps illustrates a real or symbolic scuttling of a boat that belonged to a deceased person and which at the same time was meant to carry the deceased into the realm of the dead. The two compositions, in other words, may be part of the same ritual.

It seems easier to understand compositions suggesting that invocations for fertility, birth, renewal and rebirth were central in how people understood the world. It was important to communicate with the spirits that were the masters over various aspects of life and death. Human figures are portrayed five times in the act of sexual intercourse. Two of these are seen in the horizontal position from above (Figure 50) and in one instance, the partner lying beneath the other is the smaller of the two (Figure 42). The bodies of the two figures are fused, but there are clearly two heads, two pairs of legs and two pairs of arms, the woman lying beneath the man.

The third coitus is rear entry (Figure 51), whilst in the fourth, it appears that the woman is sitting astride the male figure (Figures 14, 49). The remaining scene is more ambiguous than the three previous ones. While we were working on this panel, visitors to the site had two different interpretations. One older man immediately saw a squid, because he associated the figure with the halibut-like figure to the left. Squid is a good bait used in halibut fishing. A younger couple saw this as sexual intercourse, or "haill" [intercourse to bring good luck when fishing halibut], which is at least as suitable a bait as squid is. This illustrates that interpretation is dependent on the context in which we see the figures, and on who we are.

The human figures from this period are often portrayed in some kind of activity with other people, such as in the scene where they stand practically in a circle around two mating dogs (Figure 79). At other times, the focus seems to be on individual figures. One example of this is human figures wearing snowshoes, a scene situated during winter (Figure 52).

Just below the large man wearing snowshoes, the bear tracks end (Figures 42, 96), as if the tracks are meant to

begin or end at this point. In another scene, a person wearing snowshoes walks along the back of a large bear, as if there is some connection between the two figures (Figure 90). The figures must have had great significance, because they are repeated several times. It also seems as though certain figures are associated with special rock surfaces and with other figures, simply because they are found in only one place. For example, there are human figures with semi-circular, fringed patterns above their heads (Figure 53) on only one part of the Kåfjord panel, whilst the fringed pattern in isolation appears on four panels. What these patterns symbolise is not known, but it is conjectured that they are amulets or sun symbols.

The last figure that should be mentioned in this connection is shaped like an oblong and complex face. It has only one eye and a triangular mouth, and the upper forehead tapers to a point. It does not appear to be a human face (uppermost, Figure 42).

Figure 53
Human-like figure with a fringed pattern around the neck and above the head, surrounded by reindeer and other figures.

REINDEER

Figure 54
The figures in one of the large panels that is substantial in content, Bergbukten I, with a reindeer enclosure and reindeer hunting, elk and boats, bear hunting and dens, people and droplet-shaped figures with fringed patterns. On this panel, as in all other panels, the meaning, stories and narratives are associated with content and the relationship between the figures, the topography and the colours of the rock surface.

BERGBUKTEN I

50 cm

PERIOD II COMMUNICATING WITH THE WORLD OF BEINGS

59

PERIOD II COMMUNICATING WITH THE WORLD OF BEINGS

Figure 55
A scanned part of a panel with depictions of bears and dens, bears wandering between different dimensions of the universe, two enclosures for trapping reindeer, "dancing" human figures, moon and sun figures, human-like figures lifting a boat inside a semicircle of other human-like figures, etc. Some are dancing or in procession, and uppermost, an elk and a reindeer standing upside down and facing one another, as if each belongs to a different dimension. The numerous figures reflect both activities and representations mirroring beliefs. The figures are digitally enhanced.
Scanning: Metimur AB

PERIOD II COMMUNICATING WITH THE WORLD OF BEINGS

Figure 56
Although reindeer were a very important resource, the animal is seldom depicted with arrows or spears embedded in its body. This may mean that communication between people and other-than-human beings pertained to the wish for a successful hunt, rather than the kill itself. It was more important that the animal would be restored to life to ensure continued meat supply and raw materials such as hides and sinews. To the left: a boat and a bird in flight.

The reindeer is the most common animal found in the rock carvings. They occur both as individual animals and in herds (Figures 54, 55) and are depicted together with people, elk (Alces alces), bears and boats. The meaning of similarities and differences between reindeer figures is not clear. Are they really animals, spirits, powers or totem animals? Or might they represent animals that relay communication between people and the powers? Did such a distinction exist? The differences in shape and body pattern are too systematic to be able to attribute them to individual "artists". They signalise differences and identities, their own as well as that of a group.

Many of the reindeer figures are associated with other figures, particularly with human figures performing some type of activity. Although they may be related to mythological tales and other narratives, they also reflect many activities rooted in human and animal behaviour. Perhaps the most unambiguous activities are those associated with reindeer migration. After a good grazing summer, well-nourished and shiny-coated reindeer move in herds from the coast to winter pasture lands inland. The many fences (Figure 55) show that people not only had the knowledge about reindeer behaviour that was vital to hunt the animals successfully, but also had the societal organisation necessary to cooperate and drive the reindeer into enclosures and to divide the spoils of the hunt amongst themselves. The question that arises, however, is whether this actually involves corralling reindeer behind fences to divide them between families as livestock, or isolating and killing the reindeer and distributing their meat amongst the participants in the hunt (Helskog 2011). We know from historical sources that wild reindeer were hunted extensively as late as the end of the 1800s in Finnmark using, amongst other methods, pitfall traps, where the gaps between the pits were obstructed with fences, or with lead lines to enclosures where the animals were trapped and killed (Vorren 1958; Vorren 1975; Vorren 1998; Vorren & Manker 1976). This method was used especially when the reindeer migrated between the coast and inland in autumn, but it was also used during spring. On the basis of radiocarbon dating of pitfall traps, we know that organised hunting of this type was common well over 4000 years ago (Furuset 1995). It is probable that organised drive hunting was practised ever since human settlement began in these northern areas.

Nothing has been found in other archaeological and historical sources from the northern areas that would suggest that large-scale reindeer herding associated with a market economy goes back further than 300–400 years at most. We do know that the trader Ottar, who lived north of Malangen in the 900s AD, owned a herd of about 600 animals and that he traded in meat and hides. Sami herdsmen tended the animals. He also had six tame reindeer, which were held to be particularly important. (Simonsen 1996). Knowledge about cows, horses, sheep and goats came to the country from further south, whilst knowledge about reindeer comes from the high northern regions. Because it is impossible to distinguish between bones from tame reindeer and those of wild reindeer, bone materials per se offer no direct clue as to when semi-domesticated reindeer herding began. However, DNA analyses suggest that the advent of domesticated herding may have come in southern and northern Fennoscandia during the course of the past 1500 or so years (Røed et al. 2011). Among Eastern Sami at the furthermost eastern point of Finnmark, on the Kola Peninsula, and the Nenets of westernmost Siberia, small-scale domesticated herding was combined with hunting, trapping and fishing and seasonal migrations (Khlobystin 2005). The practice likely goes back very far in time and may represent a continuation of the earliest form of tending reindeer in the northern regions.

It is possible that people kept reindeer already two thousand years ago, not only as decoy animals, but also as pack- and draught animals. At the Ust-Poloy settlement site in the Kama area west of the Urals and dated at about 300 BC, remnants have been found of halters associated with reindeer riding (Moshinskaia 1953). We know from archaeological finds that there was contact between east and west, and this may also have entailed exchange of knowledge. We have no finds from northern Fennoscandia that show controlled reindeer husbandry, except for two rock carvings depicting human figures riding a reindeer (Figure 58).

There is also a figure of a tethered reindeer, others caught and fenced in, as well as reindeer being shot with arrows. This variation in figures suggests that people of the Stone Age had sufficient knowledge to keep reindeer in captivity and to use them for simple, but important tasks, such as serving as decoys to attract other reindeer. Nevertheless, we do not have a basis to claim that organised reindeer husbandry

Figure 57
Tracks from a herd of reindeer go through an opening in the extensive reindeer enclosure. On either side of the opening, there is a human figure holding a spear or staff, and inside the fence there are 42 reindeer. There is also a bear that has entered to hibernate for the winter. It is late autumn, the time when reindeer are plumpest and their hides are best.

Figure 58
A female figure that appears to be riding on a reindeer. The photo shows that the female figure was carved later than the boat figure and that the contour line of the reindeer's back was pecked later than the female figure. The peck marks show the sequence but reveal nothing about the time intervals.

existed. The hide, meat and whatever else could be used from a reindeer's body were acquired by communal hunting during spring and autumn, in addition to reindeer hunted by individuals. The hides are best and the meat is most plentiful early in autumn, but when there was a need for fresh meat or other products from reindeer, the animals could be hunted at any time of the year in the areas where the reindeer grazed.

Reindeer fences, described in more detail below, open for a discussion concerning the reason why people built fences. To build a fence is an onerous task. Why build them when it was perhaps easier to herd reindeer into lakes or the ocean and then kill them from boats, or into rough terrain, over cliffs or into hunting nets? The best place for building fences was probably in the mountains, at the transition between coast and inland or at the head of the large fjords, where remnants of large hunting pit systems have been found. For the time being, no remnants have been found of fences from prehistoric time other than those depicted in the rock carvings.

We know very little about the scope of the hunt, how many animals were caught and how the spoils of the hunt were divided. It is certain, however, that the construction of fences required cooperation amongst many people, as well as organisation to divide up the game after the hunt. What we do not know is whether

people had some form of ownership rights to the animals. Construction of the extensive drive fences from the 1700s on the Varanger Peninsula was a joint project involving the people who lived around the Varanger Fjord (Vorren 1998). Trapping at the time was associated with trade or sale of hides and other products from reindeer, as well as products for the trapper's use.

Two of the enclosures pecked into the rock surface appear to resemble a rail fence or a picket fence (Figures 54, 55, 57). Both are long, with a circumference of 8–9 m. Both wind around in a "circle", as if the loops represent separate sections inside the fence. The loops reflect some sort of construction, because there is nothing in the structure of the rock surface that would lead to a shape of this kind. They may therefore represent a cordoning off of sections of the enclosure, which would make it easier to trap the reindeer to kill them or to sort them according to ownership, for example families or groups involved in driving the animals into the enclosure.

There are tracks from the herd of reindeer passing through the openings in two of the enclosures (Figure 55). On either side of the opening, there are two rows of figures forming a funnel leading the animals into the enclosure. In addition, there is a human figure holding a spear at the lower left inside the enclosure, and outside the opening another figure also carrying a spear. The fence is supported by bearing piles placed at somewhat regular intervals. Inside the enclosure, there are 42 reindeer (Figure 57). Most of the reindeer are depicted with their heads turned towards the fence, which is their instinctive stance when they are corralled. A couple of the reindeer resemble elk, and at times it is difficult to distinguish between them. In about the middle of the enclosure, there is a bear in its den, ready to hibernate for the winter. Both the bear and the communal hunt or corralling of reindeer inside the enclosure suggest that the season is autumn.

The other of the two large and complex reindeer enclosures (Figures 16, 43, 54) appears to be constructed somewhat like the first, but it lacks the distinctive bearing piles. The fence is open to the right, and a herd of reindeer are on their way in. This opening is clearly re-closable, and its counterpart on the other side of the enclosure is already closed. The ends of the fence on both sides of the two openings are identical, but on the outer side to the left (towards south) of the opening, a type of protruding barrier prevents the reindeer from running back along the fence. The opening to the north is oriented towards the coast; this perhaps suggests that it is placed so as to receive the reindeer as they move from the coast to the inland areas in autumn, whilst the closed opening on the other side may be associated with the spring hunt, when the animals migrate from inland to the coast. Inside the enclosure there are 29 reindeer, most of them turned towards the surrounding fence. There are two cows of European elk, and in the centre there are two small boat figures. On the lower right is a human figure brandishing a spear at a reindeer's chest. There is a corresponding figure in the previous enclosure. The two boat figures appear to be foreign elements in the context of the enclosure, but it is likely the connection was meaningful to the makers. The contrast between the marine environment reflected by the boats and the land represented by reindeer may symbolise various territorial rights and rights to resources amongst the coastal and inland dwellers, and perhaps negotiations pertaining to these rights (Hood 1988).

The other group of fences is outlined with a simple, broad line. Three of these combine to form an almost complete circle with an opening, and they are smaller when compared with the two larger fences. Inside one of these (Figure 55) there are two reindeer, and a third animal is seen coming in through the opening. This reindeer figure is standing at the end of a thick, carved line that begins at the point where the tracks of several reindeer converge on a path leading into the enclosure. On both sides of the opening, there are a number of oblong figures forming a funnel in front of the opening, and on the outside is a human figure carrying a spear or a pole, like a kind of guard. Although the size and complexity of these two fence compositions are different, there are clear common features – reindeer, tracks, guards and figures that herd the reindeer into the enclosure – all of these are identical. The human figures and their placement suggest that they represent special individuals, either humans or powers who had a particular function when the reindeer were herded into the enclosure and were sorted and/or killed.

In another fence installation, there are figures (Figure 59) which do not appear to belong in the enclosure. This figure has a diameter of 80–90 cm. Inside there are three reindeer, two shortlegged, stout creatures with tails, seen from above (wolves or bears?), and across the opening there is a relatively large figure that appears to depict a large member of the rodent family. With the exception of this one, no figure is in physical contact with the fence. To the right of the

Figure 59
The small reindeer enclosure in Kåfjord.

Figure 60
A possible reindeer enclosure at Bergbukten IVA. A long corridor leads to an enclosed space. Two reindeer figures are incorporated into the fence itself.

opening is a geometric figure that protrudes from the fence, perhaps a barrier to prevent the reindeer from running back along the outside.

The second enclosure of this type is round and has a diameter of 120 cm. To the right of the opening, a short, broad, protruding line meant to lead the reindeer in towards the opening and at the same time prevent it from running back along the fence. On the inside, there are six reindeer.

In addition to this, there is a carving (Figure 60) of a narrow corridor leading to an open space to the right. The figure is well integrated with the topography of the rock, and the corridor runs through a slight recess between two almost parallel quartz veins. In this instance, as in other cases, it appears that the rock surface and the quartz are integrated as part of the figure. On the outer side of the corridor, short, divergent lines protrude, possibly depicting a type of barrier or perhaps shoring supports for the piles. The corridor ends in an open space. To the far right, the upper line forms what resembles the foreparts of two large animals (reindeer?). The lowest line in this space runs through a small circle. The long opening, space and collocation with large animals may represent some form of enclosure into which the animals are herded, but the figure is different from the other enclosure installations. The figure is a good example of how difficult it is to identify what figures might portray, because we do not immediately recognise the form they were given.

In only a few instances are reindeer depicted with arrows or spears in their bodies (Figure 56). It is almost as if depiction of the actual kill was not important. What appears more important is to remain on good terms with the other-than-human beings that decide the fate of animals, so that

Figure 61
On the lower portion of this panel, figures of two reindeer and two bears have been pecked into the rock surface. They are considerably larger in size than the other figures. The reindeer with the fine, large antlers later had a fishing line from a boat carved over it, along with a cruciform figure and a small reindeer (?). The cross-shaped figure has been linked with a younger panel, which may suggest that certain figures in Period II are considerably younger than assumed, or that the cruciform figures are older than earlier interpretations.

the prey would not only submit to being killed, but would also return to life, ensuring continual renewal of the resources that humans needed for survival. Nevertheless, there are several human figures carrying bows and arrows, or spears, as if they are in the act of killing. Here, the focus is on the act of killing rather than on the animal itself. Like the other figures, these may depict both mortal humans in action and myths, as well as special powers associated with control over various animals, natural forces, people and/or human actions.

Many reindeer figures have different types of patterns carved into their bodies (Figures 54, 55). It has been suggested (Gjessing, 1945) that some of these represent the rib cage of the reindeer or its inner organs; others how the animals were butchered and parted after slaughter, or they identify special individuals and qualities. Based on the large variation of patterns, any conclusion drawn would be more ambivalent than certain.

Reindeer, as food, raw materials and symbols, were important to humans. The numerous reindeer enclosures illustrate an advanced form of drive hunting in which many hunters must have participated. The scenes in which reindeer are killed by arrows or spears, on land and from boats, illustrate other hunting methods. The fences may also suggest that there was a period during which people made more of an effort to control the reindeer than was the case in later hunting and trapping societies, where fences of this type do not occur in the rock carvings. Or do the differences in figures and compositions over time illustrate merely that there were changes in the content of rituals, stories, legends and myths, and that such changes also altered the content of the rock carvings?

ELK

Figure 62
This is a comprehensive panel containing reindeer and elk figures, human figures, poles with tops shaped like elks' heads, netlike patterns, snowshoes, two enclosures for reindeer hunting, one salmon and a boat, etc. The panel is very complex, and in several instances there are unambiguous compositions such as a long row of snowshoes, a herd of reindeer, human figures in procession and carrying poles topped with elks' heads (Helskog 2010, figure 10.5).

There is much here to suggest that people perceived the world as tripartite, with an upper, middle and lower realm. If one views the panel as a whole, the elk figures dominate the lower portion. Thus, if the placement of the figures on this and other similar panels bears any relation to the manner in which people perceived the world to be divided, the elk are linked with the lowest world. The power symbolised by the elk may therefore have held a prominent position in the connection between the living in the middle world and those residing in the lower world, the realm of the dead.

In another perspective, if one subscribes to the notion that the placement of the figures is merely a reflection of shore displacement, then the lower elk figures are younger than those higher up, but the true explanation is hardly this simplistic.

PERIOD II COMMUNICATING WITH THE WORLD OF BEINGS

Figure 63
The scene with the human and elk figures is at top left in the photo. The figures have been enhanced with paint to make them more visible.

There is much to suggest that elk (Alces alces) also symbolised a substantial power, both because they are the animals most often depicted as a part of rituals and because the elk's head is often featured at the top of poles and on the stems of boats. Elks' heads often adorn stone implements, poles made from horns and wood (Carpelan 1975).

At times, elks stand alone, but they are found most frequently in a context with other figures. There are few distinctive hunting and trapping scenes similar to those involving reindeer. There are scenes in which human-like figures hold poles topped with an elk's head. In one instance, two human figures, one on either side of an elk, hold poles like these (Figure 63). Both of these human figures have a carved indentation between their legs, rather than a penis line, and this suggests that the figures represent women. To the left, there is a third human figure holding a round, full-bodied carved figure in its hand, perhaps a drum. This figure, too, has a slit resembling a vulva between its legs, thus indicating a woman, and to the left is an elk. Yet another elk is standing just above these. To the left of the person holding the elk's head pole, we see a human figure with a bow and arrow, and just beneath it is a fifth person holding a short, curved object in one hand. To the right and below the small panel, most of the animals appear to be elk. All of these are not easily identifiable, but they appear to be elk, with the exception of the small animal to the right, carved upside down on the panel, as if its position represents another dimension at the top of the fissure in the rock. Elk without antlers and with small or missing dewlaps may represent females, and those with antlers and/or large dewlaps are most likely bulls. This means that the narrative addresses these, and in this case the rituals are performed by women.

In another composition (Figure 64), three human figures are lifting elks' head poles overhead whilst one is holding a short, curved object in its hands. A fourth figure is standing alone between a human figure and an animal with large and peculiar horns, and above this are four human figures raising their arms in a type of unified motion. To the right, there

70

PERIOD II COMMUNICATING WITH THE WORLD OF BEINGS

is a small, hornless animal, and on the left side are four larger animals, three with antlers; the lowermost figure may be an elk or a bear. To the right, there is a stick figure of an animal. The shapes of the larger animals' bodies give the impression that they are elk, as they resemble the possible elk figures in the panel described above, whereas the relatively tall antlers of two of the animals suggest that they are reindeer. All of the large animals are facing to the right, and their co-location with human figures carrying elk's head poles may suggest that they are part of a sequence of events, a story in which the elk, along with bear and reindeer, play a central role. The scenes perhaps represent a link between people and the other-than-human beings realized through rituals, where the powers are represented by the elk and where the participants control communication. Similar compositions are found on several other panels.

On a small, almost even and slightly sloping panel (Figure 45), two figures are lifting elks' head poles towards one another. The heads of the human figures are pointed ovals, as if they are wearing some kind of mask, unless the figures represent something other-than-human beings. Both have crooked penises curved in towards one another; they appear to be men. The elk headed pole on the right has ears and a relatively large dewlap such as elk bulls have, whilst the one on the left has no dewlap and likely represents an elk cow. Alternatively, both figures represent cows because they lack antlers. Between these two figures is a human figure lifting a spear, and beneath this is a bull carved upside down in relation to the others, as if it is lying on its back, is dying or already dead, or perhaps already in the underworld. Below this there is a large elk cow, and behind stands a human figure with bow and arrow. Here and there one sees several

Figure 64
Graphic representation of one of the panels. The broken line outlines a loose segment of the panel which was removed and is currently exhibited in Alta Museum.

other elk. In front of the bull lying on its back is a small hare, and above this is a male figure shooting an arrow into the back of the human figure on the left holding an elk's head pole.

Obviously, in ancient times as now, there were confrontations between people. Behind the archer, another figure, which appears to be a cross between an animal and a human, takes aim at the hare. It is as if a number of people armed with bows and arrows and spears are in the act of killing elk, a hare and a human being. This represents a complicated story in

which the elks' head carvings are an important part of the ritual. The figure that shares human and animal traits may symbolise a mortal human, a special deity or a power that is in the process of being transformed from one creature into another. A little higher up, there is a human figure with a spear. If one looks closely, a figure can be seen, a little to the right of the centre of the panel, that resembles a wolf on an elk cow's back.

The panel is located on a relatively flat section of rock that slopes downward towards west and south-west. This means that the figures in the upper left part of the panel are oriented in relation to the slope of the rock, in the same manner as the figures on the rest of the panel, and not upside-down in relation to one another. One gets this impression when comparing the image with a drawing that takes into account the structure and varying orientation of the rock.

In another panel, we see an entire procession of elk on the lower part of the panel (Figures 49, 62, 65). The figures are generally depicted in relation to the other figures and animals higher up on the panel. In two cases, one sees a tale of an elk cow defending its offspring against attacks by dogs or wolves (Figure 65). The calf is standing behind or beneath its mother, whilst the wolves or dogs attack from several sides and go for the elk's throat. In the one instance, the cow deals a crushing blow to one of the attackers with her front leg. This is a story which perhaps describes the use of dogs in elk hunting, as well as the cow's defence of her calf. The compositions and isolated elk figures can be interpreted in several ways. First of all, they represent rituals involving elk as a symbol of something other than mortal human power, an other-than-human power with which people communicated to invoke special objectives and desires. People tried to exercise control over the powers, so to speak, so that the elk would submit to being killed by humans for food and raw materials, and then be reborn. Secondly, the figures may illustrate parts of stories, legends and myths and thereby impart elements of popular shared history. The reconstruction may have served as an educational aid to impart stories, traditions and social behaviour, but also to teach specific hunting tactics. Perhaps some of the figures represent totem animals, that is, animals that a group of people – a clan – claim as their ancestor. Other figures may have been symbols of power or territorial rights. At the same time, the depictions may have a basis in real or mythological events, or a combination of rituals and the role of the elk in rituals. It is therefore difficult to offer an unequivocal interpretation of the figures.

Figure 65
An elk with its calf being attacked by dogs/wolves. The attackers go for the elk's throat whilst the elk tries to defend her calf. One of the attackers suffers a cruel fate under the elk's hoof.

Figure 66
Might this illustrate an elk cow protecting her calf, or are the two animals of equal status? Both have a dewlap, but only the larger animal has detailed hooves, and the smaller animal has a broad line down from the belly, as if it has been seriously wounded.

The impression given is that the two animals belong together and were carved by the same hand.

The many compositions and the relatively strong focus on elk, and particularly on the elk cow, suggest that she personified one of the most important symbols in the world in which people lived. Elk are sometimes depicted based on the animals' behaviour, such as moving in herds during winter, defending their offspring and swimming across bodies of water. At other times, elk are depicted together with people who seem to be performing a ritual directly associated with elk. Both the large and the small elk's head poles were very likely a reference to real poles, because specimens have been found in archaeological excavations in the Baltic and in Karelia. Axe-like sculptures have been found with elk's heads on the shafts (Carpelan, 1975), and in Rovaniemi in Northern Finland, a 40 × 15 cm elk's head in pine was discovered (Era-Esko, 1958); it was very likely fastened to the top of a pole or placed on the stem of a boat. Clearly, elk were strongly linked with water and boats, perhaps because the animal thrives in marshy terrain, eats reeds and rushes and is unafraid of swimming long distances. Behaviour may have been an influential factor in attributing to the elk the important role it had in popular beliefs and rituals. As we will see in the discussion about boats, the elk also emerges as a link between people, boats, water and activities associated with the use of boats.

BEAR

Figure 67
The hunter is driving a spear into the bear's chest, and the bear is gasping in pain and arching its back. It is standing in its den. Outside the entrance a dog attacks whilst a bear cub stands by watching its mother being killed. At the top is an unarmed person watching the scene; perhaps he/she is there to ensure that the hunt is carried out with the proper respect that is required when a bear is killed. The entire scene unfolds in the head of a large bear formed by the relief structure and colours in the rock.

It is spring when the female bear leaves its den with her cubs.

To the left are two bears watching the event. This is a classic example of how natural features in rock surfaces may have been perceived as living beings and a part of the story being told. Other parts were undoubtedly perceived as the environment in which people and animals live and roam. The bear tracks run in several directions on the rock surface (Figure 72). One set of tracks leads to another den (where the bears go into hibernation in the autumn?); two go upwards across the rock surface and one downward and into the sea which washed up over the rock surface during this time period.

PERIOD II COMMUNICATING WITH THE WORLD OF BEINGS

Figure 68
A gestating bear, geometrical patterns (amulets?), a small elk and, at top left, a bear with her cubs. In the middle of the striped pattern that meanders like a river down across the rock surface is a long, thin stick figure. The figures, rock surface and "river" are all part of the story being told.

We know from historical and ethnographic sources that in northern societies, the bear was perceived as a powerful animal that required special types of ritual performances. This notion is still found in some societies in the polar region. For example, amongst Samis and Karelians west of the Ural Mountains as well as Nenets, Khantis and Mansis in the east, beliefs and rituals pertaining to bears have been substantial and elaborate. Much has been written on this subject, and amongst the populations east of the Urals, the bear cult is still widely practised and is still visible in rituals observing the sequence of the hunt – from the moment the bear is discovered in its den to its being killed, skinned, eaten and its remains buried. Amongst the Khantis and Mansis, rituals associated with killing bears last for three days and 270 songs about the bear are sung in a specific sequence (Honko 1993 et al.). From the Samis, Finns and Karelians there is also extensive documentation of songs about bears, illustrated in Ossian Elgstrom's fine drawing from 1971 (Edsmann 1994; Elgstrom & Manker 1984). Bears were regarded as powerful and wise, and certain aspects of their behaviour are similar to human traits. It seems likely that bears were commonly referred to as 'the old man', or as 'grandmother' and 'woman'. Such forms of address denote not only great respect but also that people believed they were akin to bears.

Beliefs and rituals associated with bears go far back in time. It is possible that the very first people to settle in the northern regions had special notions about bears. The special role of the bear is known from finds of bear skulls some 30,000 years old (Palaeolithic) in caves on the European continent, particularly in France (Clottes & Arnold 2003), and it was without a doubt an animal that was both revered and feared throughout the millennia. The special role that the bear must have had can also be traced over thousands of years amongst the northern European hunting and trapping societies. We see this in the form of sculptures and, not least, in the frequent depictions in rock art, such as are found in Alta. No bones from bears have been found in prehistoric dwelling sites in Northern Norway. This may suggest that the bones were discarded or respectfully buried or placed elsewhere as described in historical and ethnographic sources. Bears' bones found in a few dwelling sites

Figure 69
The largest bear figure in Alta. Above its back, a human-like figure wearing snowshoes (Figure 90); inside the body, reindeer; and above the bear's muzzle, a boat. The two overlap one another, but we do not know if they are part of the same story or separate stories.
Photo: Adnan Icagic

on the Kola Peninsula, in northern Karelia and in Finland, however, do not necessarily indicate a lack of reverence for the animal.

In Northern Norway, 29 bear graves have been found, attributed to Samis. One has been dated at 300 AD, but most of them go back to the 1200s, that is, the Early Middle Ages (Zachrisson 1981; Zachrisson & Iregren 1974; Myrstad 1996). All of the bones are laid in correct anatomical order so as to enable the bear to be reborn without defects. This sign of respect may have existed throughout the polar areas and is still practised today amongst Ob-Ugric people, who hang the skulls of bears on sacred trees. Graves and sculptures of bears, their prominence in rock art and the geographic and cultural spread of beliefs and rituals associated with them all combine to make it likely that the historically and ethnographically described rituals are the end of a long tradition.

Taking some of the scenes associated with bears as a point of departure, one can recognize actions that reflect the notion of the world found in more modern accounts. This applies particularly to the very act of killing bears with spears whilst they are in the den, an act that must have been relatively similar 6000 years ago as it was 200 years ago. What may have changed are human conceptions and actions pertaining to the kill. However, one must be cautious about transferring historically established notions about bears back over thousands of years. Cultures and conceptions, legends, myths, beliefs and rituals are not static; they change over time. The myths and thoughts that were predominant 300–400 years ago have hardly remained unchanged over a period of 6000 years, even though it was believed that bears were, or represented, a power possessing special attributes. The many scenes in rock art in which the bear has a central role depict some of these qualities, some of the bear's natural behaviour, and hunting situations (Helskog 2009, 2012). The scenes are special and uncommon, and the richness of detail is important for understanding the role that bears had and the way they were hunted. Several of these are therefore described in detail in the following pages.

In some of the scenes in Alta, it appears that bears wander in time and space between different parts of

the universe. A good example of this is illustrated in a scene where a bear stands inside its den (Figure 55, 70). The tracks suggest that it has wandered around in the den and is standing facing the opening, ready to go outside. This must have been early spring, after winter hibernation. Following this, it wanders eight metres across the rock surface towards the east and enters another den, where it stands with its head turned inward. It is now autumn, when the bear enters the den for hibernation. The large reindeer enclosure that encircles this den also suggests that the season is autumn, because this is the time of year when drive hunting for reindeer took place. In autumn, the reindeer are plumpest and their hides are best. Further up on the rock towards the west (to the left in the photo, Figure 55) are images of a reindeer and an elk together; one of them is upside-down in relation to the incline of the rock. Beneath these there are two circular figures; the uppermost is fully carved and has eight fringe patterns running downward, whilst the other has a pattern consisting of two internal and gradually smaller circles. The gap between the circles is divided into eleven and seven rhombic segments respectively, and the inner space is open with a drilled indentation in the centre. To the left a vertical line of bear tracks run down to the set of tracks between the two dens, and onward down to a cleft or gulch in the rock. Beneath the two round figures, there are 33 human-like figures in some kind of motion – dancing or in procession. It appears as if the top figure to the left is standing inside a circle. Four reindeer figures, all facing to the right, are standing beneath these, and a fifth, also facing to the right, is standing in amongst the human figures. In addition, there is yet another round, fringed figure, and then a row of four reindeer, all except for one facing to the left, towards the inland. Below these is a row of eight stocky, oblong figures leading up to the reindeer fence to the right. Below these and the bear tracks are some large elk. A little further down, there is yet another row of eight stocky, oblong figures below the opening of the enclosure. The two rows together form a funnel that leads the reindeer into the opening of the enclosure. The panel continues downward, but the description

Figure 70
Bear in its den. Notice that the tracks go around inside the den, as if the animal is about to exit. A part of the large composition in which the bear wanders between dens from spring to winter; below human figures dancing (?), and the sun and moon (see Figure 55).

Figure 71
The large composition on one of the panels in Hjemmeluft. To the upper right in the photo, the bears have left their den, and to the left, they are attacked by humans carrying spears, bows and arrows. One set of tracks continues up along the rock, and another down to a natural opening (the den) in the rock. This is a clear example showing that the rock's topography is incorporated as the surroundings for the event/story narrated. The figures are enhanced with paint (see also Figures 43 and 54).

ends here. The sum of the composition shows parts of a narrative in which the bear plays a central role, a story that suggests people perceived their universe as tripartite, with an overworld, an earthly world and an underworld (Helskog 1999).

One might interpret the story being told in the following manner. The bear and the den on the left represent early spring when the bear leaves its den, but the bear facing towards the east represents autumn when the bear goes into its den for winter hibernation. This is why it is standing with its head turned inward towards the den, in contrast to the bear leaving the den early in the spring. After the bear begins to hibernate, its soul wanders into the other worlds of the universe (Two of the dens on one of the other rock art panels has an inner circle, as if it were an opening inside the den itself). The two round figures at the top of Figure 55 may depict the sun and the moon, and based on the shape of the figures, the homogeneously carved top figure with the fringe patterns represents the sun, whilst the figure with the inner structure is the moon. The sun is seen here as an even surface, whereas the moon's surface has visible relief structure, although not as regular as it appears in the photo. The people below these two figures are performing a ritual in spring, when the sun rises higher over the horizon than the moon after the spring equinox and all life returns to the earthly world; the bear is about to leave its den. It wanders from the overworld back to earth and walks around inside the den before finally leaving it. The line of footprints that begin/end at the basin a little farther down on the rock is a feature that recurs several times: the bear wanders between the earth and the world, passing through water. The topography of the rock and its orientation are active parts of this composition. The hollow filled with water represents the sea and lakes, and parts of the more elevated and lower-lying sections of the surface may represent the overworld and the lower world, respectively. The two animal figures (reindeer/elk) above the sun and moon at the top of the panel and which are facing one another in inverse position, one upside down and the other upright, may symbolise creatures standing each in their own universe. This means that the figures may have been placed in relation to people's perception of their own universe. Most of the figures nevertheless appear to represent life in the middle world, one which was also the basis for people's understanding of life in the other two worlds. This use of the rock's topography and the notion of the universe's subdivision is corroborated even further by the fact that the general features in this composition recur several times elsewhere. The stories are not identical, but they contain the same basic elements – bears, dens, bear tracks leading in various directions, and a hollow filled with water into and out of which runs a set of tracks.

Figure 72
The bear tracks go between two dens, from the one at top left to the one in the foreground, where a bear is being killed (see Figure 67). To the right below the den is a bear-like figure that has been given a shape different than that of the other. As in the other compositions, the rock's topography is a part of the story being told. It is hardly by chance that the hunting scene is carefully placed in area on the rock where the natural structure and colours resemble a bear's head, as an interplay between life in the rock and life in the exterior world.

On another panel (Figure 71) the bears have left their den. This den consists of an outer, almost closed circle, and an inner closed circle that may represent an inner opening into another season or another world. A set of footprints leads up from the den, another downward and into a basin that is filled with rainwater; one set leads to an open, rounded and fringed figure, and yet another set leads southward to the left through an indentation in the rock and to the point where three bears are being hunted by human figures carrying spears and bows and arrows. Here we see one figure holding a pole topped with an elk's head. Below this figure there is another human figure, upside down and foot-to-foot with the figure holding the elk's head pole, as if they are meeting, despite their belonging to different dimensions. The bears are standing just in front of the opening into a large and complex reindeer enclosure, and the trek from the den to the fence, as in the previous composition, gives a temporal dimension, from spring to autumn. The bear tracks then curve at an angle down across the rock and back towards the first den, ending in a round, marked indentation which closely resembles the opening of a cave, or a den. The bears appear to migrate from den to den, from spring to autumn.

On a much smaller panel we see a natural dark structure in the rock that is shaped like the forepart of a bear's body (Figures 67, 72). Inside this is a bear in its den, its body raised as if it is arching its back. A human figure is spearing the bear in the chest through the opening of the den. A bear cub is standing in the opening; above the cub, a dog, and then an unarmed human figure. The tracks coming out of the den lead towards the south, and we find two bears, both turned towards what is happening. The tracks continue and meander up across the rock to an empty den. In addition, another set of tracks go downward across the rock to the sea, which has washed up against the rock surface. Two sets go up across a small, steep rock surface as if they are on the way to the upper world. To the right of the den is a figure that appears to be yet another bear. Higher up on the rock there are a number of figures that are different, both in context and composition, from the other bear scenes.

In the last large composition in which the bear is the central figure, it wanders across the entire rock surface (Figures 74, 75, 76). At the den are two human figures thrusting spears in through the opening. There is also a third person with a spear, two archers and an unarmed dancer. The latter is performing a ritual showing respect for the bear so that the other-than-human beings will allow the animal to be reborn and return to life. A little farther to the right, a human figure is holding a spear and another has a bow and arrow, and there are two bears, both facing the den. The goose and reindeer to the right are facing away from the den, and it appears that they have a less active role than the figures in front of the den. The bear tracks run in a circle in front of the den, and then one set of tracks descends into a hollow filled with water and three sets run upward to the top of the panel. The tracks towards the left and up across the rock pass by a very large bear figure. It has a line – a lifeline – from the mouth and inward to an oval circle representing the stomach or perhaps the heart. The bear with the long muzzle resembles more a polar bear than a brown bear, and the front and hind legs resemble the tale and flippers of a seal. This may be a creature that is a cross between two animals, or an animal changing from one shape into another. Above this there is an elk, whilst all figures farther up on the rock are bears and their footprints. From the den and the bears at the top, the tracks run down across the rock all the way to a row of five oblong figures which may represent whales. The uppermost one has two relatively long lines extending downward, like the fins of a humpback whale. Just below the third of these "whale figures", the footprints seem to stop, but they appear again a little farther down on the rock. Here they emerge out of a fissure and continue towards a bear standing on the head of a humpback whale (Figures 74, 75).

Standing in front of the humpback are two bears; two more are standing on its back, another two beneath the head and belly, and yet another behind the whale, for a total of seven bears. Bear tracks run between a fissure in the rock 2.5 m from the hind end of the whale and the whale itself, and a bear stands midway along this trajectory. Two strong lines run across the rock surface; these may be some type of delineation or fence. The humpback and the bears appear to block the opening. The line to the left ends at two human figures holding an unidentifiable oblong figure

Figure 73
These are the same figures as in Figure 11 but photographed towards the west. One can clearly see the tracks of the bear and her cubs going into/out of both sides of the cleft-like fissure, as if going from/to a den or entering a world below the ground. The cubs indicate that the season is spring. Around these are reindeer, perhaps an elk and, down to the right, another bear.

PERIOD II COMMUNICATING WITH THE WORLD OF BEINGS

Figure 74
Graphic copy of one of the large panels with several compositions in which bears and bear tracks (highlighted in red) are an integral part. The bears appear to wander between the seasons and events, out of dens and fissures in the rock. Some are being hunted and others stand around a humpback whale, perhaps a carcass that they are devouring.

Ole Pedersen I, Alta County, Norge

PERIOD II COMMUNICATING WITH THE WORLD OF BEINGS

associated with the broad line, whilst the line to the left ends in an "oblong" figure.

The opening can possibly be closed from both sides. The figures between and outside the lines are clearly different in composition. Between the two long lines there is a relatively large herd of reindeer and perhaps an elk, as well as a halibut on a fishing line. The rock surface in this area is heavily weathered and the figures are indistinct.

Down to the left of the panel, outside the long lines, there is a large boat figure with a reindeer's head on the stem. Reindeer heads on boat stems occur very rarely; normally, elk figures and the bodies of elks are chosen as symbols. The hull of the boat is typical of younger and more low-lying figures, and because this is the only specimen of this type of boat at this level above the water line, it was very likely carved later than the other figures. In addition, in the lower portion of the panel there is a large figure of a boy or a man shown from the hips down, a figure that is unique in and of itself (Søborg 2008). If one considers the panel as a whole (Figure 74), one will notice that the reindeer are in the centre, whilst the elk, save one up to the left, are placed lowermost in the panel. The human figures are in the middle, except for the special figure at the bottom, whilst bears occur over the entire panel and particularly in the left portion. Similar placement of figures occurs on three other panels that are contemporary in age, which may suggest that this placement is not entirely incidental. All these panels are found on slightly slanting rock surfaces. When seen in terms of the idea that people may have considered the natural surroundings as comprising three basic worlds – one above, one in the middle, and one below – the positioning of the figures may be related to this. The upper part of the panel can be more closely associated with the overworld, and the lower portion with the underworld.

Another example is the panel in Kåfjord, which features more bears than any other panel, many of them with bear tracks indicating how they moved in the context of the tale being told. The bears wander inside and between all of the different worlds to a greater extent than do the other animals. The elk appears to be somewhat linked with the underworld, whereas the reindeer is active primarily in the middle world. At times the combination of figures seems to

Figure 75
Photo of a humpback whale "surrounded" by seven bears. Is this a mythological narrative or an image of bears devouring a stranded whale, or perhaps both?

Figure 76
Two human-like figures thrust spears into a den; a third stands with its spear at the ready. Two take aim with bows and arrows, whilst one is unarmed. Just to the right of this are two humans, bears and one large goose. On the left, a large bear above a natural basin filled with water. One set of bear tracks leaving a den run up across the rock; another set goes down into the basin on the left. To the right in the photo are whales, the first of which resembles a humpback, whilst the "diving" figures appear to portray another type of whale such as North-capers or sperm whales. The panel is very complex and rich in content.

point directly towards another dimension than the one normally frequented by people. One example is the humpback whale and the bears; another is the bear standing opposite a halibut hanging from a fishing line extending down from a boat (Figure 77). Encounters of this kind take place in a dimension other than the realm of mortal humans.

Four of the bear and reindeer figures on another panel are considerably larger than the other animal figures higher up on the rock. Clearly, the size of the figures played a role in the portrayal of the stories being narrated. Two of these are found at the lowermost section of the panel. Here we see a very angry bear arching its back and growling at a reindeer which is fleeing (Figure 78). The bear has a bulging belly, as if she is pregnant, and perhaps the figures illustrate a mother protecting her soon-to-be-born offspring.

The figures and compositions show bears in situations that have been particularly important in the societies and environments to which creators of the rock art belonged and in which they lived. Respect and reverence for bears was substantial, from the time a bear was discovered until its bones were ceremoniously and respectfully buried. Rituals have varied, but common features include deep respect and the desire for the bear to be reborn and to roam the earth, and for it to willingly submit to being killed by people. The many rock art figures from this period showing pregnant bears or bears with cubs suggest that there was a constant wish to perpetuate the existence of bears. Seen from the perspective of bears' wanderings in the rock art and their link with other animals, it appears that power was represented in the image of the bear, an allegorical figure to which all humans had to relate. Bears were amongst the powers that decided over life and death.

Figure 77
A bear stands facing a halibut hooked by a fisherman.
Photo: Adnan Icagic

Figure 78
An angry, pregnant bear growling at a reindeer in flight (?).

PERIOD II COMMUNICATING WITH THE WORLD OF BEINGS

OTHER LAND ANIMALS AND BIRDS

Figure 79
Two dogs mate inside a circle formed by nine human-like figures. Above one of the dogs is a third dog, and from below, one of the human figures is poking a pole at the genitals of one of the two animals. The animals are clearly the central focus in the story and ritual.

There are relatively few animals depicted in rock art other than reindeer, elk and bears. This does not mean that there was any less respect for other animal species. It is possible that certain rituals and ceremonies associated with other animals were performed in a different way than through the use of rock art. Still another possibility is that the other-than-human beings that assumed the form of elks, bears and reindeer also represented other animal life. The latter were perhaps more of a profane nature and were given less attention in the rituals and in mythology.

Amongst other, less frequently depicted animals are those with powerful chests and bushy tails, perhaps wolves or dogs. Dogs are portrayed twice in the act of mating; in one instance, they are inside a circle of human figures (Figure 79), and in another, they are relatively alone.

There is a fox with a long, thin body, short legs and a long, straight tail (Figure 80). Hares are even rarer than foxes and are found only on one small panel (Figure 45). One is standing whilst the other is lying with its legs folded under its body, and both have long ears pointing straight up. In addition, there is a series of small animal figures that resemble stretched hides of small animals, or animals seen from an aerial perspective, with all limbs showing. In the small reindeer enclosure at the top of the Kåfjord panel, we see three of these.

If we move from animal life on earth to birds, we find that birds are almost totally absent. In proportion to the rest of the fauna in rock art, birds account for less than 0.1 per cent. On one panel we find a handsome goose (Figure 76), and on another, there are figures resembling birds in flight (Figure 56). It is as if rituals and stories associated with birds occur to a very small extent in rock art from this time period and in mythology.

Figure 80
Two foxes, a spear and a reindeer. Photographed under artificial light in late August.

Figure 81
Lower left: a large goose. Centre: a duck next to two whales. Far right: Tracks of a bear that has wandered down across the rock. To the left of the ducks, a small figure and a flatfish – flounder or halibut (detail from the panel Figure 74). Erosion of the rock surface has made it difficult to see the figures clearly.

Figure 82
(A) Porpoises or springers and (B) a springer with her calf.

Figure 83
(A) A small whale, (B) and the only salmon depicted in the rock art in Alta.

FISH AND SEA MAMMALS

Life in the sea is almost as rarely depicted as life in the air. Fish motifs include a spiny dogfish, a salmon and eight halibut. Halibut, the largest fish in the sea, is normally portrayed hanging from a fishing line, sometimes from a boat carrying human figures (Figures 77, 85) and sometimes not. In only one instance is a halibut depicted without being hooked. It was clearly important to depict fishing, and particularly the catch itself. Sea mammals are even less frequent. On one panel, a set of figures may represent a pod of five "diving" whales (Figures 74, 76); another example is the handsome humpback whale surrounded by seven bears (Figures 74, 75), and a small whale on a third panel (Figure 83). There is also a large porpoise (Figure 52), dolphins (Figure 82A), and a dolphin with a calf.(Figure 82B).

From the perspective of quantity of figures, it is obvious that birds and marine life played a lesser role in rock art than did reindeer, elk and bears. One should nevertheless exercise caution in equating quantity with importance, because there is nothing to rule out the possibility that a relatively infrequent figure may have been the most important of them all. One interpretation is that some of the figures were associated with an invocation for a good hunt or catch and that the animals would be reborn so that there would always be an abundance of game. This was undoubtedly very important, but at the same time one should bear in mind that the figures do not reflect a complete prehistoric menu, but rather only a part of the fauna. Fish, which was the most stable resource, is found depicted only sparsely (five times); birds occur very infrequently, and edible plants are totally absent. The very limited variety in motifs suggests that they were more associated with the stories, myths and rituals, as well as with communication with the other-than-human beings, than they were an inventory of various available resources.

BOATS

Figure 84
A boat is sacrificed. A narrative or ritual in which the human-like figure in the boat thrusts a pole through the hull, whilst two others hold on to the stem and stern and two individuals holding circular objects in their hands perform a dance (?) in the foreground.

PERIOD II COMMUNICATING WITH THE WORLD OF BEINGS

Figure 85
Boats with an elk's head on the stem and a hooked halibut. Between the halibut and the boat are a few small figures that possibly represent other sea life.

Although no remnants from Stone Age boats have been found in the northern area, there is little doubt that people had boats. Boats were an essential means of transportation in conjunction with hunting, trapping and fishing in lakes, rivers and the ocean, for transport of people and goods, but also in connection with rituals, for travel between the different worlds. It goes without saying that without a boat it would have been impossible to survive in the coastal regions. Traces of prehistoric boat technology and use are indirect. Settlement on the islands necessarily requires the use of boats; likewise, fish hooks, sinkers, harpoons and in some cases, fishing line "spools" to protect the line from chafing on the gunwale. The boat figures chiselled into the rock surfaces represent the most direct knowledge we have about the oldest prehistoric boats in northern Scandinavia and northern Eurasia in general. Farther south in Scandinavia, in Denmark, remnants have been found of early log-boats, but we have no knowledge about the associated rules and taboos, about who fished and hunted from boats or whether/how this was organised.

All boat figures depict open boats. Shape and relative size in relation to the number of people represented suggests that they were relatively small craft. Crews varied from two to eight members, that is, from small open boats about three to five metres long for use in relatively calm water, to the somewhat larger,

Figure 86
A human-like figure is standing in the boat harpooning a seal.

perhaps seven to eight-metre-long craft, which could handle more choppy water and carry more people (Helskog 1985). In all probability, the boats were of rib-frame construction and covered with stretched hide, like the Inuits' open boats. Hides may have come from seals, elk or maybe reindeer. In the High North and Karelia, based on the presence of elk's heads on the stems of boats, it is clear that land life is integrated with maritime life. In some cases, human figures aboard boats are shown fishing for halibut; in others, the human figures stand and hunt using bows and arrows or spears. In some boat figures, we find humans engaged in no other activity than being transported.

Boats and their sizes and use in historical time, particularly in the Arctic areas having comparable or identical materials available, give us an idea of construction techniques and use in prehistoric times. The Inuits' skin-covered boats, umiaks, were built to carry many people as well as equipment and goods. They were used to move between dwelling sites, to visit other people or to hunt and trap larger mammals such as small whales, walruses and seals, or to fish. It is probable that amongst the prehistoric people in Finnmark there was comparable variation in open, skin-covered boats, but nothing suggests that there were boats that could compare to the Inuits' elegant kayaks. Deep inside the fjord there were probably pine trees with trunks large enough to be dug out to make log-boats. These boats would have been heavier and would lie lower in the water than skin-covered boats, and they would have been more suitable to navigation in the calm waters of the fjords and inland than on the open ocean. It is also possible that smaller boats existed, such as birch bark canoes, but to draw distinctions between these boat types based solely on the rock art is impossible.

Then as now, strong gales and storms were never welcome weather conditions. The larger craft could have been used for longer journeys and for transporting people and goods, but also for hunting and trapping, which required larger crews. The many scenes on the Kanozero rock art panels on the southern Kola Peninsula (Kolpakov & Shumkin 2012; Gjerde 2010) and in New Zalavruga (Savvatejev 1970, 1984) in the south-western corner of the White Sea in Russian Karelia show that beluga (white whale) hunting was carried out through collaboration between several boat crews. One must nevertheless be cautious when using boat size and crew numbers to deduce possible usage, because one cannot be certain that everything seen in the rock art reflects physical reality.

Figure 87
A composition showing hunting and fishing from boats.

Are there any features of the boats indicating that they belong to other or different dimensions than those frequented by living mortals? A common interpretation is that boats transported the departed into the realm of the dead. This notion is known from historical time amongst certain northern populations, and in Karelia some were buried in boats all the way up until the turn of the previous century. Boat graves are known from the Iron Age in the Nordic countries, although not in conjunction with the northern hunter-gatherer cultures. However, in a cemetery on Bolshe Oleni Ostrov Island on the western side of Kolafjord, items were found buried in chests that may represent either boats, small sledges or pulkas (Shumkin et al. 2009).

All the boat figures dating from Period II have fully carved hulls, and most of the boats have an elk's head on the stem. Some of the boat figures from this era do not have animal heads. How can this be explained? The female elk may have been a totem animal, one to which a family or clan claimed kinship by descent, and which would protect its descendants. If this were the case, then only members of this particular clan would have depicted the boats in rock art. Another explanation may be that the elk had a wider meaning that associated them to people throughout all of northern Fennoscandia. Elk thrive in lowland areas with lots of water, woodland and marshes; elk are good swimmers and thrive on rushes and reeds. Perhaps people drew the conclusion that the elk's ability to move about between these different elements was also transferable to the various worlds comprising the environment of humans. This was why, perhaps, a power assumed the shape of an elk, and the boats with elk's heads symbolise a link between life in the water and life on land – a power, in brief, that could travel in several dimensions.

Thus, a power taking the form of an elk , and particularly a cow, might have been associated with transport on sea, rivers and lakes. The head on the prow of the boat, the hull, the ribs and stern extension were seen as metaphors for the elk's body and organs. The scenes in which these boats take part in hunting, trapping and fishing suggest that this power might be associated with the transition between life and death. On one of the panels there is a collection of boats with vertical lines that may symbolise crews, and on the foresection of each boat there is a raised part, as if something is being transported (Figure 88). All the boats have elks' heads on the stem, and in the boat to the left there is a small animal, a reindeer or an elk with small antlers. Bear tracks run from the left to the relatively small boat just below, and it appears as if there is a bear in the boat. In both the real and the mythological world, one of the many tasks of the boats is to carry the dead to their final destination. Both elk and bear symbolise powers that humans must respect, so that when animals are killed, new ones will be born and animal resources will be replenished. The same rule might also have applied

to humans. Perhaps the raised part on the bow of the boat depicted deceased on their way to the realm of the dead. The collection of boats is unique in itself for this period; it appears as if an entire small fleet has been portrayed, whereas boats otherwise stand alone. Quite obviously, boats have always been an important means of transport for hunting, trapping and fishing in the northern regions. What is worth noticing is that the shape of the boats depicted in the rock art changes over the several thousands of years that followed. One type of elk symbolism associated with boats in the rock art continues until about 2700 BC, whilst the boat as a symbol is still depicted in the rock art throughout the entire millennium preceding the birth of Christ.

Figure 88
Nine boats with elks' heads on the stem. In each boat there is a raised part, as if they are all transporting the same thing, for example the body of a deceased person to be buried at sea. In all the boats there are vertical lines indicating human figures, and in one at the lower left, there is a small animal (a bear?). Up to the right we see four leaping dolphins. Night photo under artificial light.

Photographer: Adnan Icagic

EQUIPMENT

Figure 89
Human-like figures holding composite bows. The one on the left is drawing an arrow, whilst the one to the right holds four arrows in his right hand. Between them is a figure holding a long pole, probably a spear.

Figure 90
Detail showing a person wearing snowshoes and moving westward.

Tools and weapons must have been numerous and specialised, but surprisingly few of them have been depicted in rock art. The focus is on living animals, rather than objects. Implements are normally featured together with people performing some kind of activity; only rarely are they depicted alone. This suggests that tools and weapons were relatively unimportant in the type of communication of which rock art was a part.

The most common weapons are the bow and arrow and the spear – weapons for taking life. The most common is the composite bow (Figures 87, 89) made by placing wood under pressure or by laminating two layers of wood. The other type of bow is formed from a single long piece of wood. Along with the spear, the bow and arrow (Figure 80) were the most important and most common weapons used to hunt game. Based on artefacts that have been found, the arrowheads were normally made of quartzite, chert, slate or sandstone.

Among other items are the oblong snowshoes, depicted both as isolated figures and as equipment in use by people. In one instance, we see snowshoe tracks carved across the rock surface. They end with a human figure trekking forward (Figure 90). In most instances, the snowshoes are pecked into the rock without any direct link to human figures. The most impressive is a series of eight snowshoes carved up across a rock surface (Figure 97). The most handsome depiction is that of snowshoes worn by a large male figure. The snowshoes are so wide that the person is portrayed as bow-legged (Figure 52). The internal portion of the snowshoes shows a distinct, fine latticework stretched inside a strong wooden frame. The types of wood and parts of the tree that were used are impossible to identify based only on the rock art.

ABSTRACT FIGURES

Figure 91
A droplet-shaped, fringed pattern. The pattern inside the fringed portion varies from full-body, filled-in area to a a net-like pattern such as is the case in this figure. In some instances, fringes are found around the neck and above the head of human figures.

In addition to the few weapons and tools, there are figures that are not easily identifiable because we have no clear prototypes. The figure that has been the object of most discussion is the droplet-shaped figure with fringes below the broadest, lower part (Figure 91). The patterns are relatively rare and are found on only four panels. In instances where they are not directly associated with people, the broad, fringed part is normally oriented downwards across the rock. Seen in relation to the fact that practically all human, animal and boat figures are oriented with the feet/keel at the bottom in relation to the slant of the rock, this is the natural orientation of the patterns. In some cases the lower portion is full-bodied; in others, it is outlined in a chequered pattern.

It has been suggested that these figures, when considered in isolation, may represent the sun or the moon, a tent or an amulet to be worn around the neck. If the latter is the case, then it is tempting to see the fringes as representing objects having some magical significance such as the teeth of bears, elk or seals. When they are depicted around the neck of a human figure (Figures 31, 53), the fringed portion is oriented in the opposite direction from the way they are normally depicted when they occur alone on the rock surface. The explanation may be that a fringe figure carved with the fringe portion downward would hide the human figure or be disproportionately large in relation to the human. When carved with the fringes oriented upwards, the relation between the figures

Figure 92
A chequered pattern, with a female reindeer to the left. The lines in the forepart of the reindeer's body coincide closely with the lines to the right, as if they represent the foreparts of eleven more reindeer. At the same time, the horizontal lines give an impression of a net pattern, perhaps as an expression of the desire for a good hunt. The use of nets as barriers for trapping or stopping reindeer in flight is a well known trapping technique. The figure also shows the artist's ability to depict a three-dimensional impression of depth. The light reddish colour in the figure is a remnant of modern-day retouching.

Figure 93
In the upper part of the photo is a zigzag pattern with fringes as well as a nearly square figure with two crossed lines and a filled-in circular section in the centre. It is impossible to draw any conclusion as to what these depict or symbolise. In the lower portion of the panel we find a large human figure with a bow and arrow.
Photo: Adnan Icagic

We find grid-like patterns of horizontal and vertical lines on several panels. On two of these, the horizontal lines stick out like fringes on both sides. In the one figure, a reindeer (female) can be seen to the left (Figure 92), and the outline of the forepart of the body coincides with the vertical lines in the pattern. It seems as though the figure in its entirety depicts a row of reindeer from left to right, or a reindeer that has been trapped in a net. In the other instances, there is no direct association to other figures (Figure 94). In another net-like pattern there are fringes only on the lower edge, and in one case there are no fringes at all. On a third panel, there is only one such figure, and it resembles a net more than any of the others, whilst on a fourth, there are five net-like patterns. All of the figures differ from one another, and seen as a whole, the variation suggests that the reference is to something other than nets. One would expect more uniformity of design based on the construction of nets, and the figures also lack both floats and weights. Perhaps some illustrate nets for trapping animals and birds, whilst others represent fishing nets? On one panel there is a salmon placed just next to one of the patterns. The patterns show differences in the number of horizontal and vertical lines and in the geometric shapes made between them. The patterns perhaps represent the patterns found on items of clothing or personal items and thereby signal identity, tell a story, or are meant to bring good fortune. We simply do not know.

is more clearly seen. They "hover" in the air above the head of the human figure with the fringes rising towards the sky and the overworld. This is a question of meaning and perspective. Regardless of whether the fringe patterns represent the sun, an amulet or something else, this complex figure identifies a special person, power or divinity as well as a special event.

In addition to these two types of patterns, there are some that are illustrated only once, such as the large, complex pattern with long fringes resembling an elaborate leather embossing on a skin pouch (Figure 95), and five parallel zigzag lines that crisscross one another.

The geometric figures are without a doubt the ones that are most difficult to interpret, mainly because we have no clear and unambiguous prototypes. Some perhaps illustrate concrete objects such as amulets, nets or decorated skin pouches. Other patterns may have been meant to bring good fortune or to symbolise ownership or identity. Possibly we will be able to narrow down the more plausible interpretations as additional patterns are discovered and we gain better insight and information about the various contexts in which they occur.

Figure 94
Rectangular, net-like pattern. None of these patterns are identical, and they are found on only four of the panels. In other words, they are of a special nature associated, for example, with groups of people or stories retold through rituals.

Figure 95
Pouch-like patterns with fringes. The figure is unique.

PERIOD II COMMUNICATING WITH THE WORLD OF BEINGS

SUMMARY

This second oldest period of rock art in Alta is the era with the largest number of figures and has the greatest variation of individual figures and compositions.

Human figures, boats and large land animals such as elk, reindeer and bears are the central elements and are frequently featured together in scenes. Many of these show humans in various types of activity that we know or assume must have taken place. Examples are hunting reindeer, elk and bears with bows and arrows, drive hunting of reindeer, fishing from boats, and rituals. There are also scenes depicting intercourse, as well as human figures wearing snowshoes. In addition, some of the compositions contain elements suggesting depictions of events or stories as a combination of mythology and rituals. A good example of this is the bear wandering between the seasons and different dens, and between different parts of the universe. It appears that people performed rituals when the sun and moon were simultaneously visible in the sky.

Other compositions such as those featuring reindeer enclosures and drive fences bear witness to an important exploitation of resources, but lack certain items that must necessarily have been associated with the hunt. Where are all the people who must have participated in the hunt? In several of the enclosures fence scenes there are no human figures at all, whilst in the two largest fence scenes we find only one person carrying a spear; in other instances the person carrying a spear is outside the entrance to the enclosure. This choice may suggest that the human figures represent both mortal humans who kill and the other-than-human beings.

The human figures portrayed on dry land have all the limbs of the body, whilst variations in the human figures in boats are often shown only by simple, vertical lines. Why these simplest of stick figures are chosen to denote people in boats is unknown, but one explanation may be that the upper torso, when seen from a distance, resembles only a vertical line above the rail of the boat, whilst the boat's shape in profile is distinct. It seems less probable that some of the vertical lines may represent extensions of the ribs of the boat. The elk's head on the stem – probably a cow because it lacks antlers and a dewlap – is a common trait of most boat figures. Why was an elk chosen, and more particularly, a female elk? Perhaps the choice reflects the fact that elks thrive in marshy habitats to a greater degree than do other large land mammals, and they are a connection between life in the water and on land. In addition, the females are the animals that bring new life into the world.

Figure 96
The largest portion of the panel in Kåfjord, reconstructed by means of scanned sections and sections drawn on plastic foil.

Figure 97
Section from Kåfjord photographed in soft, morning sunlight when the light strikes the rock at a low angle. The rock is teeming with figures. In the foreground: bear tracks and a bear; in the centre: snowshoes trekking up across the rock. To the right we see foot soles, as if left by people who have wandered up across the rock.

Amongst hunters and trappers in the Arctic region, great emphasis is placed on rituals associated with the rebirth of animals. Can the preponderance of elk cows in rock art be linked with these rituals? Is it possible that the power that gives live may also be the power that allows life to be taken and requires that the dead animal be buried in a proper manner so that it can be born anew? It is tempting to infer that the elk – the largest of animals in the northern regions, and the one most frequently linked with water and boats – represents and connects land and water through rock art. In certain mythologies, the dead are carried by boat into the realm of the dead, or the deceased finds the path to the realm of the dead in a river. Perhaps some of the boats depicted in rock art are precisely such vessels, particularly those with a raised feature on board symbolising the deceased being carried into the realm of the dead?

Elk cows are also associated with human figures lifting poles topped with an elk's head in activities that clearly take place on land. Some of these activities can be interpreted as a celebration of the kill, as well as rituals performed as invocations to the other-than-human beings for permission to take the life of an animal, so that they might later be reborn. In certain of the largest panels in Hjemmeluft/Jiepmaluokta, the elk is placed primarily in the lower sections of the panel, down towards the world of the dead, underground or under water (Helskog 2009, 2004). In a way, these panels can be interpreted as reflecting a map on which figures are positioned in accordance with people's perception of their surroundings. The latter possibly consisted of a middle world inhabited by people, animals, plants, mountains and lakes, and an underworld and overworld populated by the powers, spirits and the dead co-existing in a society and in surroundings mirroring the world of mortals. However, not all elks are placed in the lower sections of the panels. A few are also found high on the panels and may be associated with life in the overworld. In mythological accounts from northern hunting and trapping cultures, Mother Earth takes the form of an elk dashing across the stellar vault. Myths of this type may be based on beliefs from far back in prehistory.

In the rock art, rituals and other acts are performed by both men and women. Based on strict evidence seen in the human figures themselves, there are no physical features signalling that any single type of activity was reserved for one or the other gender, but in all likelihood there were certain forms of role division.

Figure 98
Backlight emphasizes the role that topography of the rock may have had; the indentations may have represented valleys, and the water may have been construed as rivers and lakes, etc. The entrance to the large reindeer enclosure in the foreground.

Fertility, pregnancy and gestation are motifs that are frequently depicted. Both people and animals are depicted having sexual intercourse; gestating animals and animals with offspring are also portrayed. Gestating animals and those shown with offspring are females, as a rule, whilst scenes showing sexual intercourse involve both sexes.

The fact that female animals are predominant in rock art can be interpreted in many different ways; amongst others, female animals had a more prominent role than male animals at the time in the rituals, stories and myths related through rock art. It is difficult to determine the extent to which this emphasis reflects social structures in the hunter-gatherer societies. At the same time, we recognize figures and scenes that are familiar from other contexts. The scenes showing bear hunting are not linked only with stories and myths pertaining to people and their relationship to bears and to rituals involving bears. They are also reminiscent of rituals and beliefs associated with bears in the Sami and other societies throughout the circumpolar region. This suggests a degree of continuity as we move towards our own era, although there are perceptible changes in the rock art during the course of the millennia.

In terms of reindeer hunting, the figures show that already 6000 to 7000 years ago people not only had developed advanced methods of drive hunting, but maybe also had decoy animals and tamed animals for transport. In addition, the rock art suggests that there were forms of social organisation for the purpose of dividing the game amongst the hunters.

The rock carvings should not be regarded as a collection of figures that are independent of the stone surface on which they are incised, just as the rock art panels are not independent of the natural surroundings in which they are found. The surroundings also have a meaning, and the figures and panels were not randomly chosen. The rock art

Figure 99
Rock art showing reindeer, a boat with two human figures who have hooked a halibut, a person holding a staff with a top shaped like an elk's head, other people and an abstract pattern (amulet?). Is it possible that these figures represent some form of integral composition based on the fact that they were created on a single, isolated boulder? Do they relate one connected story or several stories and rituals? Were they associated with a special group of people?

What was the relationship between these and the three figures pecked into the bedrock in the background?

There are more questions than there are answers.
Drawing: Ernst Høgtun

panels lie in the shoreline zone because this was the place for communication with the other-than-human beings. One reason for this may be that the shoreline zone is a juncture where the different worlds meet. Certain places were attributed special significance because of the structural factors in the rock, such as colours, deposits of quartz and topographic traits. In these places there were openings enabling the inhabitants of the different realms – those of the spirits, mortal humans and the dead – to communicate with one another. In three of the scenes showing bears wandering between the worlds, the shoreline zone is represented as having a separate zone within it. The question to be answered is whether all the figures and compositions have a relationship within the panel similar to the relationship the rock art panels have to their natural surroundings. Logic would dictate that this should be true if life in the other worlds were shaped in the image of the world that people knew and used as a model.

Figure 100
The middle section of a panel photographed facing north. A bear and her cub in the foreground.

We do not know if all the inhabitants of the northern regions used rock art or paintings in their rituals or if such rituals were performed during all seasons. It is probable that many were not performed during each season. The question then is whether rituals and ritual sites varied according to the seasons. There is much to suggest that people migrated seasonally in order to take advantage of climate, vegetation and fauna. It is possible that the other-than-human beings may have been contacted through rituals during precisely these changes of place and circumstances. Some rituals were associated with the rock carvings, but rock art has been found in only a few places and near only a few dwelling sites. The few rock art sites found in areas out towards the coast are all, with one exception, located on loose blocks of stone on the outermost

western side of Altafjord in Kvalsund and on Sørøya, and in Skjervøy on bedrock. No panel has been found in inland areas. Variations suggest that seasons were just as important as places. But the relatively few finds made may also reflect the random nature of sites chosen, or the fact that they are simply difficult to find.

Rock art is not portable, and the sites represent places to which people returned year after year, season after season. The numerous panels in Alta, along with the substantial dwelling and activity areas, particularly in Hjemmeluft, suggest this. There is nothing in the other archaeological material that can positively indicate that the settlement at the head of Altafjord was inhabited all year round, or only seasonally. Since the rock art could have been created between the mean and high water mark, the rock art sites were open and accessible during both summer and winter. Ethnographic and historical sources reveal that people from the coastal and inland areas met during winter at the markets at the head of Altafjord. Agreements were made, and marriages were celebrated. Midwinter, the darkest and coldest time of the year, was traditionally the time when Sami families gathered to make agreements, to negotiate and to socialise with one another; when sunlight began to return, they

Figure 101
Upper left: two round figures, very likely representing the sun and the moon. Below these are human figures depicted in a type of procession. Tracks lead in several directions starting from the bear in its den – towards the east, northward to the human figures and downward to the south, to an indentation that would be filled with rainwater.

The composition may allude to springtime, when the sun is highest in the sky and nature comes back to life after a long winter. People celebrate this major seasonal change with a ritual and festive dance, and the bears leave their dens.

would go their separate ways. This was the time of year when it was possible to make one's way through the terrain on skis or with reindeer-drawn sledges.

If figures were made during winter, only the section between the mean water mark and high water mark would have been free of snow and vegetation and would have been readily accessible. The evidence of a winter gathering not only strengthens the argument that the rock art was created along the shoreline, but it also partially explains why the rock art that is similar in form and content is associated with specific shorelines. At the same time, however, many of the scenes and figures depicted are also linked with other times of the year than mid-winter. That is to say, the choice of figures and scenes does not necessarily reflect the season during which the figures were pecked into the rock, but rather the season with which the events, meaningful narratives, rituals and figures are associated. Once the figures were made, they remained visible and accessible during all seasons, regardless of their connection.

Figure 102
Human-like figure with wings and a head, the left part of which resembles a beak and the right part a rounded, small head. The figure perhaps depicts one of the powers to which humans related.

PERIOD II COMMUNICATING WITH THE WORLD OF BEINGS

Figure 103
The innermost area of Hjemmeluft before the walkways were constructed and the museum was built on the soccer field on the upper right.
Photo: Arvid Petterson

PERIOD III
4000–2700 BC

Figure 104 (p. 108)
It is late afternoon, and the shadow of the walkway railings falls on the rock surface. The figures of reindeer, elk, boats, etc. have been highlighted in red paint in recent time in order to make them more visible, but there is no evidence that they originally had colour added to them. Provided the rock was clean and was located in the intertidal zone, both the figures and the natural colours in the rock were visible, and both the locality and the colours may have given meaning to the stories and rituals.

Figure 105
The mean tide level when it was 17 m above the present-day water level. The rock art panels are marked in red. The areas where the younger panels were created are still below the water surface.

Aerial photo: © Geovekst

During this period people lived scattered along the entire coast, on the islands and along the fjords; they survived, as people did earlier, on hunting, trapping and fishing as well as plants and roots that they gathered. The remains of houses are seen as relatively shallow, oblong or round depressions on promontories and inside bays, at places such as Isnestoften and Storekorsnes as well as in Hjemmeluft/Jiepmaluokta. The largest group of dwelling sites in the nearby coastal areas is found on the inner side of the island Sørøya.

The rock carvings from this period are located in the same area as the older panels, but between 17 and 21 meters above the present-day mean tide level (Figure 104), that is, two to six metres lower than during the previous period. The appearance of the animal and boat figures differs somewhat from the figures on higher ground; there are fewer of them and there is far less variation. The many scenes that are typical for rock art in higher terrain, such as the reindeer enclosures, the bear scenes and the rituals involving poles topped with elks' heads are not present here. This does not mean, however, that the rock carvings higher above the sea level were not seen and used by the people who created and used the more low-lying rock art. We can be quite certain that the people saw the older rock carvings, and that they were perceived as having meaning. The new figures represent, at the same time, continuity as well as an introduction of new meanings. A different view on this is that there was no continuity at all; a new group of people with other stories, other symbols of identity and other rituals came to settle in the same area. But the latter is less probable, because the continuity in the choice of what was and was not depicted suggests that the old and the new meanings and stories were commixed.

If the rock carvings were not covered by vegetation – first lichens and then more profuse vegetation – they would have been visible for a long period of time during the snow-free seasons of the year. Under today's conditions, snow and ice cover the ground down to the upper water mark and a little higher in open areas, depending on how steep the terrain is and how high the waves wash up over the rocks. The situation was the same in prehistoric time as well, meaning that the older and higher located rock art panels were inaccessible during winter, unless of course the snow and the thin layer of ice between the snow and the rock surface were removed. There is only one example from Hjemmeluft/Jiepmaluokta which shows a boat, typical for Period III, carved on an older panel at a higher altitude. On the panel at the top surface of Storsteinen at Bossekop, we find figures dating from the end of Period I until the end of Period III.

On the rock surface near the residence on Apana Farm, there are three boat figures and one reindeer at about 16 m above the present-day mean water level. If the figures were made in the zone between the mean and the high water mark, they are younger than the lowest-lying figures of the Bergheim panels, and older than the dwelling site on the plateau 14 meters above sea level. This places them at the end of Period III or at the transition to Period IV, which will be described later.

The following describes the figures and scenes in the same sequence used for the rock art from Period II, thereby allowing a comparison to be made between the figures.

Figure 106
Graphic drawing of the largest panel of rock art from Period III. The figures at the top are found on a relatively flat section, whilst the rock surface on which the lowermost figures were carved is relatively vertical. Beneath the turf and the upper platform (Figure 104), there are figures that have not yet been uncovered.

PERIOD III COMMUNICATING WITH THE WORLD OF BEINGS

111

Figure 107
Perspective drawing showing the relationship between the figures and the rock's topography – the local landscape of the figures. When the intertidal water mark was at the lower end of the rock, water washed up over the figures in both calm and stormy weather. The integration of figures, locality and season combined to give meaning to the stories and rituals.
Drawing: Ernst Høgtun

Figure 108
In the first documentation in 1976, the figures were marked off with chalk and then traced onto plastic foil. The foil was later photographed using high contrast film, and the end product was a drawing that shows only the placement of the figures in relation to one another, but without including various features of the rock surface. Our current notion that features in the rock surface are an integral part of the story being illustrated has made documentation of rock art substantially more demanding than earlier.

PERIOD III COMMUNICATING WITH THE WORLD OF BEINGS

113

Figure 109
Drawing of one part of a panel where the large fissures are indicated by dotted lines. The arrows point to indentations where "major" pieces of the rock are missing, and the slant varies from between 10 and 17 degrees. At the top is the inscription "19.23 meters above sea level" (today's mean tide level). This is included as an example of a field drawing.

Figure 110
Section of the same panel as above. In the upper left and far right there are two relatively large bears. In addition, we find reindeer and elk figures. The panel has been scanned, but because the figures are not digitally enhanced, they may be difficult to make out. The scan, which provides very precise documentation of the surface's topography, was done by Metimur AB.

PERIOD III COMMUNICATING WITH THE WORLD OF BEINGS

HUMAN FIGURES

Figure 111
Human-like figures, a man and a woman, in intercourse or perhaps as a celebration of potency and strength?

Figure 112
The three figures on the front edge of the panel (Figure 106).

Figure 113
Ritual intercourse (?) with the man holding the woman by the ankles. On the upper right, two reindeer looking backwards.

There is now a stronger focus on people in boats than on activities taking place on land. In most instances, the figures are standing in boats; they differ from one another either in size and position, or by the fact that they are holding an implement or a weapon. In certain cases there are also features alluding to gender differences.

Most of the human figures outside boats are depicted in some sort of activity. The single instance where a human figure is thrusting a spear into the chest of a bear is the only direct reference to hunting on land, in contrast to earlier periods when portrayals of this kind were more common. The other activities appear to be far more peaceful. Human figures are normally illustrated using simple, straight lines, such as in the "intercourse scene" in Figure 111. This is incised inside a small arch-like section of pale quartz and, as in many other cases, it seems that the quartz itself had a meaning, in this case perhaps as a medium to strengthen fertility and the sex act. It is worthwhile to note that the male figure has a round bulge at the waist which might otherwise be interpreted as a feature indicating a pregnant woman.

On another panel there are three human figures with their arms bent downwards. All have a round expansion on the upper torso like an enlarged belly (Figure 112), perhaps indicating three pregnant women. Weathering of the rock surface, however, has made the figures indistinct, and it appears that the hip region is characterised by stronger lines, perhaps penises. What is the sex of these figures, then, and are they in fact people? It is complicated to identify figures based on existent or absent physical features because we lack knowledge about the criteria that were once the basis for their creation.

In a few cases, the outline of the body comprises two lines. The largest of these (Figure 113) shows a man and a woman in profile. The woman appears to be naked, and the man is holding her around the knees from behind. He may be wearing footwear and clothing, his penis is erect, and he is wearing a pointed mask over his face. We do not know what this is meant to depict, whether it is an allusion to a myth or a specific event or whether it is associated with the figures immediately surrounding it.

In another example, two human figures are standing together, the figure at the top having a round body and outstretched arms and the one below, a man in profile holding an axe-like implement above his head (Figure 114). In contrast to the male figure, the one at the top may be a woman.

Simple line figures are still predominant in Period III. However, human figures are associated to a greater extent than earlier with activities involving boats, and some figures carry various objects in their hands. Not one human figure carrying a bow and arrow has been found, a depiction that was relatively common earlier. These differences in and of themselves are not particularly significant, perhaps, but in comparison with Period II, the sum total of the differences in figure types, scenes, activities and the other archaeological material is relatively large.

Figure 114
The two figures stand together as shown in the photograph. The lower one is a man seen in profile and the upper figure seen from the font may depict a woman. See Figure 106.

PERIOD III COMMUNICATING WITH THE WORLD OF BEINGS

117

Figure 115
In this period, many of the human-like figures are portrayed in boats. The photo shows different human figures in one of the largest boats with an elk-head stem.

REINDEER

Figure 116
A herd of reindeer moving forward. The antlers are large, like those of bulls; this suggests that it is summer, when the bulls are gathered in small herds. Once again, the figures are carved besides a vein of quartz, as if the quartz may have had a specific association with the animals. The large reindeer at the bottom contrasts in size and shape with the animals above it, and it is uncertain whether the lower figure, either a bull or a female, is part of the composition.

Reindeer bones found in refuse from prehistoric dwelling sites in Finnmark show that reindeer have always been an important resource, perhaps the most important source of meat and raw materials amongst the land animals. Reindeer hunting was extensive, involving both drive hunting and killing of individual animals. But this alone is not an explanation for the predominance of reindeer figures in rock art. They are illustrated as isolated animals, as members of herds and in combination with other figures. Sometimes it is difficult to ascertain which combinations of figures are scenes because, amongst other reasons, there is no clear reiteration. The very variations in shape of the reindeer figures are different from the older figures, and they are generally larger than earlier, as if they are given different identities or affinity with a clan.

The occurrence of a few gestating animals suggests that one of the purposes for people's ritual communication with the other-than-human beings was to express a desire for animals to be reborn. The largest of these gestating reindeer is 1 m long and has large antlers, perhaps an older female (Figure 117). In one case, two reindeer appear to be mating (Figure 118); the one with the smaller antlers is mounting the other. Neither has antlers of the size that a bull reindeer would normally be expected to have. There may be several explanations for this, but based on observed behaviour, these may be two females. This small scene cannot be linked only with the human desire that reindeer should produce calves, but with the reindeer's own instinct to perpetuate the species. Another behavioural trait that is depicted here is reindeer looking backward, as if they are instinctively on the watch and ready to flee, or simply curious about something going on behind them (Figure 113).

There are also herds of reindeer, such as, for example, a small panel with 12 reindeer (Figure 116). The animals are 20–25 cm long and have large antlers, and ten of them are moving towards the right (south). The

Figure 117
Large gestating reindeer.

animals are similar in appearance and seem to have been created at approximately the same time and by the same hand.

Just below are three reindeer that are twice as large, and beneath these, two boats with elk's heads, a human figure and a swimming reindeer. One meter to the right is a boat with an elk's head and human figures.

Hunting fences and other scenes in which reindeer are driven, gathered, hunted and killed are not represented in this period. Although such figures are no longer carved, this does not mean that hunting and trapping became any less important or that reindeer were no longer hunted or trapped. If earlier attention to reindeer and lead fences may have been associated with control over reindeer, as a form of animal husbandry, the change may mean that this was now less important or common, or simply that depictions of this kind were no longer important. A figure of a large bull (Figure 12) with a halter (?) suggests that some type of domestication of reindeer existed, perhaps to use them as decoy animals or pack animals. We get the same impression from the human figure placing its hands on a tethered reindeer's back, at the panel on Storsteinen (Figure 152).

Figure 118
Reindeer and elk in low-angle, soft sunlight. Upper right: a spearhead. Lower left: a mating scene.

Figure 119
The relatively rectangular shape of the body and the fully carved neck region give a distinct identity to some of the reindeer figures from this period. The figure is in the lowermost portion of the panel Figure 106.

Figure 120
Around the muzzle of the reindeer are lines that resemble some type of halter. If this is indeed a halter, then it shows that people kept reindeer as decoy animals and perhaps also as pack animals.

Figure 121
(+ enlargement) A talented artist has created a reindeer that is bellowing.

Figure 122
Beneath the shadow from the walkway railing is a large bear, and on the lower right are two reindeer figures about 1m long. In the centre of the photo are the faint traces of what may be the initial carvings of a boat figure.

122 PERIOD III COMMUNICATING WITH THE WORLD OF BEINGS

Figure 123
A reindeer, standing tall and majestic amongst the other animals. Upper right: a boat with an elk-head stem.

ELK

Figure 124
An elk cow licking her newborn calf, still unsteady on its legs.

Figure 125
This is the only scene in which an elk, a shag and a human with a hooked halibut are all depicted together. Here life on land, in the sea and in the air is interassociated and linked with fishing, as if in a narrative serving to connect three dimensions of the world.

PERIOD III COMMUNICATING WITH THE WORLD OF BEINGS

Although one can imagine that elk were important animals in terms of resources, no bones from elks have been found in the cultural deposits at dwelling sites from this period that have been excavated in Northern Norway; the same is true of the two previous periods. One explanation may be that the bones of elk were treated in a special way. In historical time, for example, certain Ob-Ugric peoples placed bones in rivers, believing that the animal would be resurrected.

In contrast to previous periods, there is now a lack of scenes in which elk and human figures are depicted in some kind of interaction. Individual animals and herds are depicted, and a few reindeer are gestating, but not one illustration has been found in which the animals are being killed by bow and arrow or spear, or in which the animals are part of a ritual performed by human figures. The animals appear instead to be featured in interaction with other elk or other animals. A fantastic composition is the large elk cow licking its newborn calf wobbling on unsteady legs (Figure 124). The carving is almost a tribute to life itself. Individual scenes like this are rare. Two metres east of this is an elk that seems to have a head on both ends of its body. The heads share the same body and legs and are turned backwards as if they are looking at one another. It is almost as if the elements of the body form a circle. An alternative interpretation is that they are two animals standing next to one another, but the perspective is difficult to comprehend (Figure 126).

Figure 126
Two elk stand against and facing opposite one another, or perhaps a single elk with a head on both ends of its body?

Another elk has a distinct line going from the mouth into the body, ending at a circular figure probably meant to represent the stomach or the heart. Yet another figure is depicted as swimming. In other instances, elk occur in herds, and on panel Figure 9 one can see two rows of animals, all of which seem to represent elk, one group of eight and another of three, and all are turned facing to the right. The lack of antlers and a dewlap suggests that these are elk cows. To the right is a row of six reindeer, four turned towards the left and two towards the right. The two in front have large antlers, likely indicating that they are bulls, whilst two of the reindeer in the rear are gestating. The herd comprises both bulls and cows. It appears almost as if the two herds are interacting in some way, partially turned towards one another.

Although it is sometimes difficult to distinguish figures representing reindeer from those representing elk, it is nonetheless clear that the elk figures are less commonly featured than other large land mammals.

Figure 127
Elk cow with a lifeline and stomach/heart. Similar lines are found on one of the large bear images in Period II (Figures 74, 76).

BEAR

Figure 128
A small bear cub beneath two elk. See Figure 154.

Figure 129
A bear is killed with a spear.

Just as in the previous period, bears' bones have not been found in the middens excavated in Northern Norway. This may suggest that the bones from bears, like elk bones, were discarded or deposited other places. This special treatment of bears is a continuation of earlier practice. The overall impression is that bears continued to be treated with great respect, much like the reverence that is still practised today in some societies in Siberia.

Figure 106 shows one of the largest panels dating from Period III. The upper portion of the panel is relatively flat and then declines towards the west. Two bears are depicted here. The largest one is standing in front of some elk and reindeer in the left part of the panel, but it is impossible to determine whether this is an intended composition or an arbitrary placement. The other bear is being killed by a human figure thrusting a spear into the bear's chest (Figure 129). As in the older rock art, relatively few bears are depicted in situations where they are killed. The other bear, large and powerful, appears to be standing practically alone. On another small panel, a bear is standing behind a reindeer, whilst on a third, the bear is clearly gestating; there is a smaller bear visible in the stomach (Figure 131).

Possibly the most expressive bear figure in the rock art of this period is a cub standing with its back arched (Figure 128). On a fourth panel, a female is roaming with her cub (Figure 130).

As in the previous period, the size of bears varies from quite small to large and dominating in relation to the surrounding figures. The proportionally larger size may denote physical and/or psychological dominance. The meaning that these size proportions may have had, however, cannot be ascertained. Perhaps meaning was attributed to the figure itself without regard to the surrounding figures.

None of the bears are identical, and the variation in shape and size suggests that the figures depict different bears. (They may also reflect different actors in the scene.) As a whole, the scenes are less complicated than those of the previous period. The large narrative compositions featuring bears wandering across the rock surfaces do not exist in Period III. This does not necessarily mean that bears as a representation of non-human power were less important or that the stories and rituals were less meaningful than they were previously. If the figures can be seen as a supplement to those found higher up on the rock, they add and strengthen meaning in relation to the older figures. But this can also mean that the stronger symbolic role that bears had earlier, that of powers in the dimensions of the universe, had changed with time. Even if its role became more limited, however, it can still have symbolized one of the powers that governed aspects of life in the universe.

The figure showing bears being killed with a spear or as gestating females or with cubs suggests not only that people petitioned the powers to allow bears to be killed; it may also mean that people, by following the rules requiring respect for the animals, wished to ensure that the powers would allow new bears to be born. This type of respect was very likely shown to all living creatures.

PERIOD III COMMUNICATING WITH THE WORLD OF BEINGS

Figure 130
A bear with her cub.

Figure 131
A gestating bear, perhaps an expression of the desire that bears must always exist, as well as the power they symbolise?

130 **PERIOD III** COMMUNICATING WITH THE WORLD OF BEINGS

Figure 132
A large bear amongst a herd of reindeer and two boats. Although there is ample space on the rock surface, the figures are pecked close together as if they might be part of one or several stories and rituals associated with a special group of people. Or is there something in the surface of the rock that attracted focus to precisely this area? The visibility of structures and colours on rock surfaces change depending on whether they are wet or dry and whether skies are overcast or clear and sunny. Light and shadows move, and in a way, it is as if the figures and the rock come alive. These phenomena may have played an active role in the stories and rituals, including the circumstances under which they were told and performed.

In the photo, the surface is wet and masks some of the nuances in the panel. The sun is trying to break through the cloud cover, and the figures are seen best under natural backlight, as here. When the surface is dry and the sky is heavily overcast, the figures are very difficult to make out.

PERIOD III COMMUNICATING WITH THE WORLD OF BEINGS

BIRDS

Figure 133
A European shag clutches a fish in its beak; the fish wriggles in a desperate attempt to free itself.

Bird figures are few and comprise primarily swimming birds such as cormorants, swans, geese and ducks. There are found on only a few of the panels. On one panel there is a cormorant, more specifically a shag (Figure 133), perhaps with a fish in its beak. There are geese, a swimming duck (Figure 134) and another aquatic bird together with a reindeer.

On another small panel, a cormorant stands with outstretched wings as if it is drying its feathers (Figure 135). Beside it are several other birds. A human figure is holding one bird, probably a goose (?), by the neck. There are also birds seen swimming. Only one bird is depicted in flight, and birds appear to be swimming in only four instances (Figure 134). The largest of the bird figures is a goose carved above a large boat (Figure 144).

Based on the small number of figures, we can conclude generally that little attention was given to life in the sea and air, just as in the older periods. We cannot, however, conclude that birds were not important in myths and stories, or as symbols in rituals. The small number of figures does not necessarily reflect lower status or power, but instead perhaps that communication with the other-than-human beings through rock art pertaining to birds, just as with fish and sea mammals, was more limited than with elk, reindeer and bears.

Figure 134
Figures including three geese and a duck (upper right in the photo) (see Figure 106). We also see boats with elk-head stems and with the head of a bird, reindeer and two human-like figures. The placement of these is hardly arbitrary, and the people who created and used the figures associated them with stories and rituals in their communication with other-than-human beings.

Figure 135
This small panel shows yet another constellation of birds, a boat, a reindeer and a human-like figure holding a large goose (?) by the neck. All the birds are aquatic fowl; one appears to be a cormorant flexing its wings, and on the far left, a swan.

PERIOD III COMMUNICATING WITH THE WORLD OF BEINGS

FISH AND SEA MAMMALS

Figure 136
Orca (killer) whale with her young swimming above her back (?). Through rubbing onto paper, details such as glacial striations and defoliations on the figures and rock surface become distinctly visible.

Figure 137
The largest halibut figure (110 cm long) in Alta. Four reindeer are carved above the upper part of the body.

Like in the previous period, life in the sea is rarely depicted in rock art. In one instance there is a whale, possibly an orca, together with a calf (Figure 136), and in two instances, halibut figures. One halibut is hooked at the end of a line that rises to a human figure (Figure 125), whilst the other is carved together with a reindeer and an elk. The other halibut figure is 110 cm long and is the largest of all the halibut figures in Alta (Figure 137). In two depictions, sea mammals – probably seals and a whale – are being harpooned from a boat (Figure 142). The infrequency of sea mammal and fish figures suggests that rituals associated with life in the sea were performed other places and on other occasions, or perhaps that they were associated with other figures, such as the boats having elk-head stems. Alternatively, animal life in the sea played a minor role in the stories, myths and rituals, despite the fact that fish was the most stable source of food that humans had. This suggests in turn that the communication of which rock art was a part, also encompassed other aspects of existence, not only exploitation of the resources in the environment.

BOATS

Figure 138 (p. 135)
In contrast to the boats in Period II, there are now several boats with what appears to be a stem shaped like a bird's head. The beak is slightly curved like that of wading birds, and it seems that a new concept – a connection between boats and aquatic birds – has become a feature of the rock art in Alta.

In Period III there are more bird figures than in any of the other periods. This does not necessarily mean that birds in general had become more important as symbols.

The predominant position of the elk is underscored by the fact that most boats have elk-head stems and an extension of the stern that may represent an elk's tail, as was found in the previous period. It can sometimes be difficult to tell whether the animal's head on the stem is that of an elk or a reindeer, but the overall impression is that elk are mainly represented. Like the boats at a higher altitude, the heads here also lack antlers and a dewlap. In all likelihood, the figure depicts an elk cow. The connection with boats derives from notions of the elk's role and power. But why an elk, and why a cow? As pointed out earlier, the elk's "water-related behaviour" and size may be factors. Perhaps another rationale was that the elk cow gives birth to calves and thereby serves to restock the elk population. Maybe it was logical that those who give life are also those who take life. Symbolism associated with boats can thus be said to be relatively unchanged from earlier periods.

In this period there are some boats carrying a stem figure that resembles a bird's head. This is a new feature in relation to the boat figures from the two previous time periods. Closer identification is difficult, but based on the birds that are depicted elsewhere, these are likely swimming birds or wading birds. This means that individual birds, for one reason or another, have now become an identity marker for specific boats. The question is: Why birds, and what does their relationship with boats mean? Are they really boats? One plausible response is that these are special boats with special qualities linked with beliefs, rituals and mythological stories. In other words, they are used in certain special events. Certain birds may also symbolize a power associated with boats and related activities that corresponds with the role the elk seems to have had over a long period of time. There may also have been groups of people who attributed their origins to birds, in the same manner as other groups believed they were the descendants of elk or reindeer. The animal's head thereby identifies the boat and the people in it. Whatever the case may be, the choice of a figure for the stem is hardly arbitrary. A third possibility is that the figures were merely decorative; however, given the seemingly conscious choice of stem figures, this alternative seems unlikely.

In contrast to the older boats, most of the hulls are now carved in outline. In some few instances, the hull is clearly shown by a single line. The boat figures are

larger than earlier, and they are depicted singly or in groups, with and without crews. In a 2.2-metre-long boat, the longest of all boat figures amongst the rock carvings that have been found at this level above the sea, are two human figures (Figure 141). Off the stern there are three additional boats. Only one of these has a distinct animal's head, whereas the other two have heads summarily represented with simple lines. The forms of expression are very different. Two small panels are dominated by boat figures, as if the boat were a central element in the stories or rituals being performed.

If we look at the situations in which boats are depicted, they vary between a connection to fishing/trapping and figures having no content at all. In one instance, three boats are found together on a slightly slanting surface of a larger panel. All have two human figures each on board. From one of them, a line runs out to an animal that is swimming in front of the boat (Figure 142). The animal is relatively thin and has flippers like a seal. The line is hooked to the rear portion of the swimming animal. It is reasonable to conclude that this is an animal that has been harpooned, a seal, a white whale or a porpoise. Another line goes from the other boat out to a small, harpooned whale, and just below this is a third boat with a crew that has harpooned a seal. A reindeer stands by and observes (Figure 143).

In a 175-cm-long boat to the right in the same panel are seven or eight human figures in two groups (Figure 115). They are simple line figures, and the differences in shape, position and content show that they represent different individuals. Each of the four figures in front is lifting an object overhead. The first is holding a kind of spear; the next two are lifting poles that end in a horizontal line, perhaps representing an axe; and the last one is raising an object that curves over the human figure's head. If all these figures are viewed from the same angle, the objects are being lifted with both hands, right and left. The four human figures in the far rear are also different from one another, but in contrast to the figures in front, their differences are found in the bodies themselves rather than in the objects. Each human figure has an identity of its own, and the four in front are the most "warlike". At the top right is a boat with three human figures, and to the left above this are some reindeer figures (Figure 106).

A boat carrying three persons is a combination that is repeated several times. In one instance (Figure 140) three human figures are standing in a boat and the one

Figure 139
The fjord and the open ocean was rich in fish and sea mammals, and exploitation of these was of crucial importance for the settlement. Some 5000 years ago, the high water mark stood approximately at the platform to the left and across the rocks to the right. The fjord was wider and deeper than today, and the lowermost part of the Alta River comprised the innermost portion of the fjord. Weather conditions were just as severe as they are today. Most of the boats were probably of light construction and hide-covered; perhaps people made log boats as well. Both types of craft are best suited to navigating the fjords and inner coastal areas. No remnants from these boats have been found in northern regions, but the rock art reveals very clearly that boat technology was advanced. The fjord and the sea were the life nerve then as now, and without good boat technology, settlements in the coastal area would not have had the scope that dwelling features seem to suggest.

However, boats were important not only for hunting, trapping, fishing, transportation and travel. The many boats depicted in the rock art bear witness to the fact that they were also part of the communication, through belief and rituals, with the other-than-human beings.

Figure 140
In contrast to earlier periods, boats are now carved in outline/contour. The stem is still shaped with a elk's head, although at times it is difficult to distinguish between elk and reindeer. In the upper boat there are three standing human figures, two men and a woman in the middle holding a T-shaped implement. Behind them are three swimming reindeer, as if the scene describes reindeer hunting from boats.

Below this we see a smaller boat with three human figures and the T-shaped object being held by one of the men. The scenes may suggest that the implement was used by both men and women when they were in boats, and perhaps also in hunting reindeer.

in the middle is holding a T-shaped object overhead. In contrast to the other two human figures, this one seems to be a women, because it lacks a penis. Just behind the boat we see three swimming reindeer, and the impression we get is that the crew in the boat are in the process of either killing the animals or leading them across open water. A little farther down on the same panel there is a smaller boat with three persons in it. One of these is holding a T-shaped tool. The contrasts between these human figures tend to suggest different sexes, although it is not easy to decide which are men and which are women. The very fact that sex is depicted suggests that this was important in the context portrayed. At other times it appears that persons and their actions were the important centre of focus, and that gender and sex were irrelevant. In still other instances, the impression given is that the boat itself, and what it symbolises, is most important, such as the somewhat unusual boat (Figure 144) amongst the lowermost figures in Kåfjord. The boat appears to have a bird's head on its stem and overlaps a large figure of a goose. On the whole, the human figures and their activities on board boats vary somewhat when compared with the previous period. Human figures are now depicted carrying T-shaped and curved implements, and in some cases sea creatures are harpooned. In no instances are fish depicted with a fishing line or hunters with bows and arrows.

Just as amongst the older figures higher up on the rock, it is very rare to find figures carved atop one another, and when this occurs, it was very likely intentional. Perhaps it was an act designed to show that the earlier figures no longer had meaning. Or it was maybe a means by which to link the figures with one another or to allow the power in the new figures to dominate over the old.

The youngest boats in the period are found 16 metres above sea level on a small rock outcrop near the residence building at Apana Farm; originally, the outcrop was a small islet. The lack of a distinctive elk's head on the stem (Figure 146) may suggest that the traditional, close link between boats and elks has now been broken or is in the process of being discontinued. As the land rose, the islet became a small tongue of land projecting out into the water. Direct contact with the high water mark gradually disappeared as water receded. Given these circumstances and the fact that the figures are likely older than the panel farther down on the rock, these boat figures were created about 3000–2700 BC.

Figure 141
The longest boat figure in Alta. On board are three distinct human-like figures, in addition to vertical lines which may be the remnants of four additional human figures.

Figure 142
Two boats with crew members harpooning whales and seals.

Figure 143
Here, a crew member is harpooning what appears to be a seal whilst a reindeer stands by and observes. Again, there are three people in the boat; perhaps it was a necessary routine to hunt seals and small whales with a crew of at least three so as to be able to manage the boat and the catch.

The reindeer looking on suggests that the figures comprise a mixture of a hunting tale and a narrative in which the reindeer was one of the characters. In other words, this may have been a portrayal of a reality that existed only in the imagination.

Figure 144
The large boat was pecked into the rock later than the large swimming bird. On the stem to the left is an elk's head, whilst the stern is elongated and straight. There seem to be two gunwales, as if the perspective is from above and at an angle down into the boat. Like the other boats from this period, the keel has been lengthened both fore and aft.

140 PERIOD III COMMUNICATING WITH THE WORLD OF BEINGS

Figure 145
A boat with a distinct elk-head stem and six human figures (?) on board, three tall ones with heads and arms, and three shorter figures. Two of the long figures are raising axe-shaped (?) implements, perhaps as a part of a ritual or an actual hunting posture (?). It is impossible to be sure.

Figure 146
The boat figures at Apana Farm are being copied onto plastic foil. They are heavily weathered, difficult to see, and they lie just next to the old farmhouse. This is an area that is often in use by adults and children. The chalk figure was drawn by an interested and inquisitive little boy. The figures are now protected beneath a platform. The boats are the youngest from Period III.

EQUIPMENT

Figure 147
Might this represent a fish-trap or a floating cage made of braided willow or the like? In the middle there is space for the catch. The pointed end of the cage would have been turned against the current. The figure has been carved over a large reindeer, but it is impossible to determine the difference in age between the two.

Tools and weapons occur relatively infrequently in the rock art of this period. There is a large spearpoint in the midst of reindeer figures, and perhaps the point symbolises the hunt itself or the killing of the reindeer (Figures 32, 118). Compared with the objects found from the same time period, the point may have been created using a compact, fine-grained implement of sandstone or slate. On another panel there is a relatively large tanged point with a triangular blade; it was also made on the model of a point made of the same material. Spears are depicted in connection with human figures, whereas bows and arrows are absent.

An elder gentleman who visited one of the panels thought that one of the figures (Figures 147, 148) resembled a cage made in the old days for keeping fish alive. The chamber was made of willow braid, and the cage was anchored and set afloat in the river, with the pointed end against the current. If this was the intention, why was it desirable to keep fish (salmon) alive in a river that was rich with fish in all seasons of the year? A good alternative supposition is that the figure depicts a fish-trap used in the river.

Figure 148
By rubbing carbon paper onto a sheet of paper laid directly on the rock, all indentations become visible and appear as white sections. The white lines are a combination of glacial striations and carved lines in the rock art figures.

The details of the fish-trap become relatively distinct.

ABSTRACT FIGURES

Figure 149
Fringe patterns. Perhaps this depicts embossing on a hide pouch.

Figure 150
Patterns.

Compared with the previous period, there are relatively few abstract figures or patterns. They differ much from the older figures and it is not immediately possible to match them with any specific prototype. Two of these are very elaborate. One lies on a relatively horizontal surface and can be described as a quadratic, open frame with an intricate lined pattern on the inside which, when extended, forms fringes outside the frame (Figure 149). The figure resembles an ornate hide pouch with fringes. The other, which lies on a slanting surface, consists of vertical, parallel zigzag lines and incised points above them (Figure 150). They were undoubtedly associated with something, such as symbols for meaning and identity that we cannot fathom today.

SUMMARY

As in earlier times, the population based their existence on fishing, hunting, trapping and gathering. They knew how to exploit the abundant and varied resources year-round in the coastal, fjord and inland areas. Dwelling features from settlements have been found in several places along Altafjord, amongst these in Hjemmeluft/Jiepmaluokta, but the sparse investigations that have been carried out provide little basis for enabling us to determine the extent to which the inhabitants were permanent residents or migrants who moved between dwelling sites at different times of the year. Surveys conducted on Sørøya (Simonsen 1964, 1996; Andreassen 1985; Hesjedal et al. 1996;) and in the Hammerfest area (Hesjedal, Niemi and Ramsstad 2009), along Alta River (Simonsen 1992, 201) and inward across the Finnmark plateau (Engelstad 1978) show that resources were exploited in all areas. Exploitation of resources and settlement varied seasonally. The implement inventory changed over time, changes that can be traced throughout Finnmark and northern Fennoscandia and southward across Scandinavia. It is evident that there was direct and indirect contact between people across large geographic areas. There was bartering and collaboration, and people moved. The population in the Finnmark was by no means isolated, despite the fact that they lived as far north as possible from the more populated areas to the south. The extent to which changes traceable in the rock art interrelate or coincide with other changes in the prehistory of the region is unclear. There are indeed some links and coincidences, but because it is difficult to date the rock art within the period of a millennium, it is difficult to be certain. The differences from the rock art of the previous period are discernible. If the younger motifs in their entirety replace the older motifs, this would tend to suggest major changes in the myths that were told and in the modes of communication between mortal humans and the other-than-human beings.

Even though the repertoire of motifs from the two periods is approximately the same, there are nevertheless features in many of the figures that make them different. The differences are seen in complex figures such as boats, reindeer and elk, as well as in geometric patterns, but not in the basic, simple line figures. In addition, there are differences within the figure categories (reindeer, boats, etc.), a fact that suggests differences in group affiliation, stories and rituals.

There is a general continuity in the choice of the large land mammal motifs, human figures, boats, geometric patterns, fish and fowl, as well as in what is not shown in the rock art panels. No figure can be interpreted as a dwelling place. There is a focus on certain aspects of outdoor life and activities, but indoor activities are completely absent. The continuity in the choice of main motifs suggests that the objective of communication remained unchanged, although the details varied. Despite the fact that scenes with elk-head poles no longer occur and that few boats are depicted with bird or reindeer heads on the stem, the continued link between elks and boats suggest that the elk continued to have a role in the rituals and world view of the population. Complicated compositions showing elks, people, elk-head poles and reindeer drive fences are absent during this period.

The fact that the figures were pecked into rock panels in the same area as before shows that these continued to be places where people met and communicated with one another and with the other-than-human

Figure 151
The prehistoric settlement in the Hjemmeluft area was located on the terraces around the bay, some metres above the contemporary high water mark. About 3000 BC the ocean covered the rocks in the foreground. Some 4700 years would pass before it was possible to build the boathouse on the site where it is today.

Figure 152
All of the main figure categories are found on this panel: reindeer, elk, two birds and a large halibut, human-like figures, boats and geometric patterns. In terms of form and content, they are somewhat different from those created at Hjemmeluft at the head of Altafjord. The stories and rituals may have been the same, but it seems that the approach was slightly different. Perhaps the form and content signalises differences in the stories and identity of the people who created the rock art, told the tales and performed the rituals.

beings. One possible explanation for the combination of change and continuity in relation to Period II is that the rock art reflected a mix of old and new ideas, beliefs, cosmology, myths and identities from the hunter-trappers who already inhabited the area, and from hunters and trappers in other areas.

There are fewer rock carvings in Period III than in Period II, but uncertainty as to whether the older carvings were used in subsequent years does not imply that there was a reduction in the use of the motifs as a means of communication. Nevertheless, figures typical of Period III are only in a few instances carved into more elevated rock surfaces along with the older figures.

The number of visible rock carvings must have varied with the seasons. On some of the panels, the carvings have been located at the transition between ice-free rock at sea level and inwards under the ice and snow that covered the rock above the highest water mark.

The carvings at an higher altitude were covered with ice and snow. During the remainder of the year these rock surfaces were easily accessible and the figures were visible; people were of course aware of the older figures. But we do not know if visibility was necessarily a factor. Perhaps the mere knowledge that they were there was equally as important, and in practice, they were therefore always accessible.

The human figures are now associated to a greater extent with activities in boats rather than on land. In some cases, people are holding weapons and implements. In four instances, sea mammals such as whales and seals are being harpooned from boats, whilst in other instances humans are depicted only by simple line figures in boats. One human figure has a halibut on his hook, but the rest appear to be linked with land activities. There are three scenes portraying types of sexual intercourse, and two human figures are seen lifting implements. The earlier common scenes portraying humans hunting animals with bows

Figure 153
The lowermost and youngest figures on the western side of Hjemmeluft show a herd of large reindeer. As such, they differ from all other figures in Period III, and they are yet another example of the individuality in figures and panels.

Figure 154
Perspective drawing of one of the small panels showing a small bear cub, elk, reindeer and boats (Figure 128). A two-centimetre wide vein of quartz runs diagonally through the panel. This vein may have had a meaning for the communication of which the figures were a part, and consequently it may have been one of the reasons why the figures were carved here.
Drawing: Ernst Høgtun

PERIOD III COMMUNICATING WITH THE WORLD OF BEINGS

148　PERIOD III COMMUNICATING WITH THE WORLD OF BEINGS

Figure 155 (p. 148)
Storsteinen [The Large Rock] in Bossekop is the panel in Alta with the largest commixture of figures from different periods, II, III and IV. Altogether there are some 600 figures on the 50-square-metre surface area. It represents the most compact collection of figures in Alta and contains everything from human-like figures to geometric patterns, often carved over one another. Based on calculations of sea level and the shape of the figures, some are from the very end of Period II, whilst most are from Periods III and IV.

One of the uppermost figures is that of a woman on a reindeer's back, her arms overlapping a boat with an elk's head (Figure 58). Human figures vary from those that are fully carved and have eyes and rib bones to simple stick figures, some of which have a non-human head (mask?). To the left in the panel is a large human-like figure entangled with animal figures, and at the bottom centre is a similar figure carrying a staff and standing inside a semicircle.

The animal figures are dominated by reindeer carved in contour, with and without body patterns; some are pregnant and others have fully carved bodies. In one instance, down to the right, there is a human-like figure with its hands on the back of a tethered reindeer. Close observation will also reveal the contour of a nearly life-size reindeer at the bottom left of the panel, to the right of the reindeer that is gestating. There are dogs (?) mating, fully carved animals resembling stretched hides; at the bottom is a small whale behind a reindeer and several types of geometric patterns. Two of these are cross-shaped and of a type that is found at Amtmannsnes and in Kåfjord, as well as among the rock art at Kanozero on the Kola Peninsula (Kolpakov & Shumkin 2012).

This is a fantastically rich and varied panel and is in itself a perpetual object of study. The stories that were told and illustrated are numerous, rich in content and complicated, from the time the rock emerged from the sea until the time the tide no longer washed over the foot of the rock. When direct contact with the sea was broken, it seems that the rock lost its function as intermediary link in the communication between people and the other-than-human beings.

Figure 156
One of the figures on Storsteinen in Bossekop. Both the body and the shape suggest that it represents something other than a human. The figure has an individuality that may associate it with a special story or event and with the person who carved them, but it may have been used repeatedly, either alone or in combination with other figures on the stone. Notions and meaning in terms of use and the individuals who used the figures may have changed over time. Eventually it lost its meaning and was forgotten. å

and arrows are completely absent in this period. The same is true of the scenes with elk and elk-head poles that seem to illustrate rituals.

On the whole, the animal figures dominate, particularly reindeer and elk, and without human figures depicted with them. There are both isolated animals and herds. The form and inner body patterns of reindeer and elk are somewhat different than earlier, and on some panels there are now reindeer figures with fully carved neck relief. These were probably created towards the end of Period III and are not found in the later periods. Some of these differences can best be seen if one compares figures with illustrations associated with Periods I and II.

Dwelling features and cultural objects found in the areas show that people remained in sites over shorter or longer periods of time. The rock art sites, as earlier, were possibly places where people from the coast and inland could gather once or several times a year for various social purposes, to form partnerships, to trade or to communicate with the other-than-human beings. If one were to judge from the earliest sources pertaining to Sami settlement in Fennoscandia, a settlement that took advantage of the area's topography and changes in nature, the largest and most long-lasting gatherings were held during winter. This was a time for socialising; agreements were entered into, coming seasons were planned, and bartering took place. A gathering of this type during the winter season in prehistoric time can explain both why new rock art was rarely created between the older figures – which at the time would have been covered by ice and snow – and why the figures were so strongly associated with the shoreline.

PERIOD IV
2700–1700 BC

Figure 157
Section of the largest panel of rock art from Period IV. The figures are considerably more complex and detailed than earlier ones. They differ from the figures of Period III and also from those of the next period, Period V. This applies particularly to the human-like figures standing in rows across the rock surface. The rock is rich in quartz, and this is perhaps one of the reasons why the figures were carved on these very surfaces. This might mean that quartz had a special significance in the dialogue with the other-than-human beings, and it is possible that it was regarded as a power itself. The figures to the far left are incised on a long and narrow vein of quartz; a broad vein of quartz also runs throughout the entire panel.

Figure 158
A human-like figure, probably a woman wearing a large headdress. Headgear like this may be associated with public rituals performed by a religious leader, perhaps a shaman. Changes in the figures in contrast with the previous period are very pronounced and suggest comprehensive changes in the beliefs, stories told and rituals performed.

PERIOD IV · COMMUNICATING WITH THE WORLD OF BEINGS

Towards the middle of the third millennium BC, there were marked changes in dwelling structures, which may in turn reflect social changes. As mentioned earlier, it is difficult to assign precise dates to changes we find in rock art. This is due to uncertainties arising from dating methods, the nature of the material itself and comparison with the other archaeological features. Changes did not occur everywhere and at the same time. There were differences in changes at both the regional and local levels. In the third millennium BC we find major changes in motifs and figures innermost in Altafjord as well as in the other archaeological material in Finnmark.

Among other things, one now finds dwelling features from larger buildings when compared with earlier periods – dwellings that housed several families or were large homes for individual families. The dwelling features are oblong-shaped with two hearths and an inner floor area of about 20 to up to 50–60 square metres. A few of them are even larger. They have entrances on the gable walls or in at the centre of the long walls, and some have smaller rooms at the inner ends. Some were embedded a half-metre into terraces or on sloping terrain so that they give the impression of being very deep. Others were built on more shallow groundwork, but they are nonetheless very visible today because of the banks of soil and refuse mounds that are often found on the front side of the dwelling sites. In the Alta area, dwelling features of this type have been found at Elvebakken and in Tollevik. The dwelling sites on an excavated site in Tollevik date from the period of about 2300–1800 BC (Gill 2006), although we are unable to link them directly to the people who created the rock art in Period IV. The probability, however, does exist. Many of the dwelling features have undoubtedly been destroyed by modern building, so that the basis for claiming that localisation is representative is relatively weak.

In the first half of the second millennium BC, a period called the Early Metal Age begins, so named because of finds of a few imported tools and cups, as well as ceramics mixed with threads of asbestos. (Olsen 1994; Hesjedal et al. 1996; Skandfer 2012). A re-dating of a copper dagger from Karlebotn suggests that the first metal may have been imported to Finnmark well over 1000 years earlier (Hood & Helama 2010), whereas the dating of asbestos ceramic was corroborated. In eastern Finnmark, another type of ceramic had already been in use for some 2500–3000 years (Skandfer 2003; Olsen 1994). In other words, difficulties in understanding the general cultural development and its possible relation to the rock carvings make rock art chronology a very approximate undertaking.

Figure 159
The rock art at Amtmannsnes (the low-lying promontory in the foreground) is quite different from the older figures in Hjemmeluft and Kåfjord. There are only a few contemporaneous figures in Hjemmeluft and Kåfjord, and it is almost as if the activities associated with the rock carvings moved from Hjemmeluft and Kåfjord eastward to Amtmannsnes.

Figure 160
The present settlement covers well over 50 per cent of the area at Amtmannsnes. Most of these are private homes and one industrial building. The rock art panels and the prehistoric dwelling sites cover a large area extending from the industrial building and residential area down to the northern shoreline. The area is a protected cultural heritage site. The picture was taken facing west-northwest.

During the first half of the second millennium BC, there is a distinct difference further south in the country between rock art associated with the agrarian society and that associated with the hunter-gatherer society. These differences are so pronounced that they are interpreted as evidence that the societies had a different system of beliefs, in addition to a different social structure and economy. The archaeological material in the north suggests continuity, whilst at the same time changes in material culture and the rock art suggest strong influences from the outside. There was an exchange of ideas and knowledge between inhabitants within local areas and also between other areas of the country, partly as a result of trade and contact between neighbours across more or less large geographic areas, and partly due to the influx of new people to other areas. There was a co-mingling of knowledge, ideas and beliefs.

Most of the rock carvings from Period IV in Alta are found in two areas in the centre of the head of Altafjord, in contrast to the earlier panels located mainly farther to the west. On one of the panels (Figure 155) there is a noticeable overlapping with figures from earlier periods. The mix of figures on Storsteinen may suggest that newcomers blended their own beliefs with local, traditional beliefs, or that they took advantage of existing sacred shrines to demonstrate their own power over those who already inhabited the area. The newcomers must have seen the rock art that was already carved on the stone. An alternative explanation might be that the population that already lived in the Alta area were influenced by new ideas and incorporated them into their own system of beliefs. The composition of figures also shows continuity from Period III through the choice of motifs, whilst at the same time their form, content and relative significance seems to have changed.

On the panels that are typical for Period IV, no figures have been identified as boats. This means, of course, nothing more than that boats were no longer a meaningful expression in the rituals associated with the figures, not that boats per se did not exist. Mythology appears to have changed; the narratives are new, and they no longer impart the same traditional tales and rites. Whatever the case may be, the absence of boats suggests a pronounced break with the tradition of earlier periods.

In addition, two figures in Hjemmeluft/Jiepmaluokta and a few figures in Kåfjord may have been created during the same period of time. The location of the new rock carvings in the east and the older panels in the west, as well as one panel between the two where old and new rock art forms and content are mixed,

may suggest that the differences reflect two different groups of people having a somewhat varying notion of imagery used to depict the world. Thus, we need much more knowledge about the dwellers in the fjord basin if we are to resolve this issue.

One characteristic feature of the rock carvings at Amtmannsnes is that the lines are broader than in the older figures. This is primarily due to the nature of the stone on which the figures are pecked; it is soft and therefore easily exposed to weathering. Weathering has worn down the edges and the peck marks so that the lines have become broader and smoother than they were when originally incised. The fact that the carved lines were originally narrower is clearly evident on both Storsteinen and in some well sheltered, less weathered figures on one of the panels at Amtmannsnes (Figure 164). The technological difference in relation to Period III is not as important as one might conclude.

There are more overlapping figures from this period than from any other period of time during which rock carvings were made. In certain instances, one gets the impression that the overlapping was intentional, but it is uncertain whether this owes to a wish to impart an intended meaning or whether the place and rock surface was the most important factor behind overlapping. Most of the overlapping at the Amtmannsnes II panel, for example, is found on the section containing a broad vein of quartz (Figures 162, 163). There are also many other occurrences of quartz in the rock surface. Quartz, and the heavy concentration of quartz veins, must have had some significance for the choice of surface area where the rock art was created, for example on areas of the panel considered most sacred. Among other qualities, quartz can produce sparks and create flashes of light from the energy created when rubbing one piece against another. On another, smaller panel, there is a broad vein of quartz along the lower edge of the rock. On a broad section approximately two metres wide just above the quartz vein are several hundred figures compactly carved and overlapping one another, making many figures difficult to distinguish from

Figure 161
The figures at Amtmannsnes were hardly made any earlier than the time when the mean water level was 14 metres higher than today's level, that is, on the lower edge of the rock surface where the figures are currently located. Amtmannsnes at the time was a small island on the eastern side of Mount Komsa. The rock art panels are marked in red.
Aerial photo: © Geovekst

Amtmannsnes IIB, Alta County

Vein of quartz (NB. the symbol is explained in the figure text.)

the others. Above this, the rock surface flattens out, but here only a few rock carvings have been found (Figure 165).

As was practised earlier, the nature of the rock, the presence of quartz, colours and structure played a role in the choice of the surface on which the rock art was created and in the placement of the figures in relation to one another. One example is a human figure (Figure 155) placed upside-down in relation to the incline of the panel. This is a complex figure. The eyes and nose are carved out, and the head appears to have a "halo" around it, or maybe a kind of headdress. The arms are short, and on both sides of the body there is a zigzag ending in a "claw". These appear to be the figure's legs. At the bottom of the body two lines extend out in a v-shape, perhaps representing the female sex organ. This is not a portrayal of a human, but rather a depiction of a supernatural creature having human-like traits. The head of this upside-down figure ends at exactly the edge of the quartz vein; it was carved upside-down maybe precisely because the head is to be associated with the powers represented by the quartz. In this respect, the rock itself, or part of the rock, becomes a part of the composition.

PERIOD IV COMMUNICATING WITH THE WORLD OF BEINGS

Figure 163
The large Amtmannsnes panel seen facing south. The lichen cover has been removed using ethanol, and the white coloured rock appeared. This is perhaps how the rock looked when the mean water mark rose to the level where the heath is now, at the lower edge of the panel. Both the colours and the structure in the rock were distinct and were possibly one of the reasons why the figures were carved into the surfaces. The rock is full of strains of quartz, and the quartz itself was perhaps regarded as having magical qualities. The broad vein is clearly visible, extending in a north-south direction.

Figure 164
Only a few of the figures on the Amtmannsnes panels have been spared from weathering and have maintained some of their original form. Notice that the figures on this panel were pecked into a limited portion of the rock surface and just above a broad vein of quartz.

Figure 162
The largest and most comprehensive panel at Amtmannsnes. The rock is relatively soft, and the figures are therefore somewhat rounded at the edges as a result of weathering. A broad vein of quartz runs throughout the panel in a north-south direction; the quartz is also spread over the entire panel in smaller, but distinct sections. Along with some wide fissures in the rock, the vein of quartz played a role in the choice location for the figures' placement. For example, on the upper side of the vein human-like figures are placed in a row, whereas on the underside towards the north they overlap profusely and the content is different. To the far left (south), the figures, composition and distribution are again different. One gets the impression that the rock's topography and structure were part of the stories and rituals when the figures were made. This means that the creators of the rock art regarded the rock surface, the figures and their surroundings as parts of a whole, one in which the people and other-than-human beings communicated with one another for a number of different purposes.

PERIOD IV COMMUNICATING WITH THE WORLD OF BEINGS

Figure 165
Copy of a panel (Figure 187) compiled by laying 23 large sheets of paper (70 × 100 cm) directly on the rock and rubbing the surface with an overlay of carbon paper so that all the indentations, including the incised figures, appear as white outlines. This was a difficult panel to document, partly because the figures are heavily weathered and overlap one another and the rock surface is uneven and slants, so that the sunlight cannot create clear contrasts. The panel contains figures that resemble humans but are definitely other-than-human beings, reindeer, elk, halibut and geometric patterns. Many figures could not be reconstructed.

Photo: Adnan Icagic

PERIOD IV COMMUNICATING WITH THE WORLD OF BEINGS

Figure 166
Human- and insect-like figure standing with its head directly above a broad vein of quartz (Figure 162). In contrast to the other figures on the panel, this is the only one positioned upside-down in relation to the slant of the rock. The body is oblong and ends at the bottom in a funnel shape. The head is peculiar, as if wearing a headdress; the short arms and legs end in claws. A zigzag line runs from the legs, parallel with the body. This represents something other-than-human being, perhaps one of many creatures occurring in peoples' notions and narratives and maybe depicting one of the powers with which people needed to communicate.

PERIOD IV COMMUNICATING WITH THE WORLD OF BEINGS

HUMAN FIGURES

Figure 167
Human-like figures, other-than-human being. The large figure to the left, by virtue of a perforated phallus, represents a man, whereas the reindeer inside the body suggests an unnatural pregnancy and a being that is something other than human. The figure to the right has both a penis and breasts. Both figures have facial features, similar head shape and "hairstyle". To the right of these is a woman-like figure with a "head ornament" (Figure 158). The figures all stand on or directly above a thin, but distinct vein of quartz and a horizontal zigzag line. Night photo.

The human figures depicted by a thin or broad line, such as those that were predominant during Periods I–III, are now rarely present. Relatively few resemble normal human bodies. The figures are also larger in size than earlier figures. In two instances, the figures give the impression of a person wearing a costume, as if in a ritual aimed at contacting the other-than-human beings. The bodies are now often carved in full outline and are filled with horizontal or vertical lines. Another new feature is that many figures have eyes, a nose and a mouth and hair or antlers. Some are male, some female, and still others are hermaphroditic, and many of these figures can hardly be said to depict people. Portrayal goes beyond the normal features of the human body and suggests traits belonging to other-than-human beings such as deities or other supernatural creatures. In the following, some of these figures on the largest of the panels from this period will be described.

Some figures have human bodies and a face-mask or a non-human head. These can be interpreted as people wearing masks, for example a leader of rituals, but also, equally plausible, as depictions of other-than-human beings. One has a head like an animal with small antlers whilst, at the same time, the hands and feet are touching elk or reindeer (Figures 162, 168). Another has a large and complex headdress (Figure 158), and the presence of a vulva shows unmistakably that this is a woman. The head shapes vary from those that are flat and wide with a point sticking up from the top, to those that are round and have facial features such as eyes, nose and mouth. By comparison with the older figures, it is now common to depict facial features, with the exception of the few simple line figures.

The row of human-like figures with varying appearances in the centre of the panel (Figures 162, 169)

penis. Continuing to the right, the next figure has both breasts and a penis; this too is a hermaphroditic figure. All four figures have approximately human form and represent a combination of man and woman (Helskog 1995, Engelstad 2001).

Following these is a figure having physical traits that more closely resemble a human (figure 158). The distinct vulva suggests this is a woman who is in the process of performing a ritual; she is wearing a headdress that associates her with the power she is addressing as a ritual leader, for example a shaman. If one follows the row of figures from left to right, the first is a geometric figure, then a figure with a small, full-body carved head and a long body with 12 "rib bones". Following this is a tall figure with a distinct face and a body with vertical lines. Further to the

Figure 168
Human-like figure with a headdress and antlers. Both feet are connected with reindeer figures, and the left arm is touching a young reindeer. The contact between the various figures is considered to be intentionally depicted as part of a story or myth associated with people's beliefs. (See Figure 162 for the scale)

Figure 169
A row of human-like figures.

are all special and unique individuals. Because of weathering some of the figures are difficult to see, whilst others are very distinct, such as a 210-cm-long prostrate figure with eyes, nose and mouth and an abnormally long rib pattern (Figure 170). Below this figure and out towards the right is a zigzag line beneath a row of human figures (Figures 162, 169). The one to the left is leaning towards the right and has a small human figure inside its body, as if it is pregnant, whilst the carved lines between the legs suggest a penis. The shape of the head is difficult to make out, but seen as a whole, this seems to be depiction of a supernatural being than a mortal human. The figure to the right has a peculiar head and arms, and the one to the latter's right is pregnant with an animal – a reindeer or elk – at the same time having a pecked line between its legs possibly representing a perforated

right is a figure with "horns" and a long body with 18 "rib bones" and a penis, and finally another simple line figure. To the right on the same panel is a large figure with facial features and a robust, rounded body with a smaller figure in its belly. This figure seems to have a vulva and therefore necessarily represents a pregnant female creature, perhaps one of the powers (Figures 162, 188).

All these figures are carved in above a vein of quartz in the rock, but none have been incised in the vein itself. One reason for this may be that quartz is a hard material that is difficult to carve. Another explanation may be that the quartz was not to be marred, at the most not to be touched because it was regarded as a material imbued with strength and power. The vein of quartz is broadest to the right of the panel, and at

Figure 170
The largest human-like figure amongst the rock art carvings in Alta. It is 210 cm long with at least 15 rib bones, arms extended downward, and the head has eyes, a nose and a mouth. One end of the zigzag line is just below the figure's head; the zigzag appears to link many of the human-like figures with one another. In contrast to the other figures, it is placed horizontally on a relatively flat section of the rock surface and above the broad vein of quartz that can be seen at left in the photo. Quartz was very likely associated with some form of magical power.

the point where it disappears with the rock into the ground, a human-like figure stands upside-down with its head edge-to-edge with the quartz vein (Figure 166). As a symbol, this figure may have a different relationship to the vein of quartz than the other figures. If the world view entailed that the universe consisted of worlds existing underground, on the earth and in an overworld, then this may suggest that the figure represents a power standing in another world, one that is directly related to the vein of quartz. The long veins of quartz run almost like rivers across the rock, and perhaps these were one means by which one could travel between the various worlds of the universe. The notion that contact between the worlds goes via rivers and in water rapids and waterfalls was relatively common amongst the Arctic peoples in early historical time – a notion that perhaps also applied to special features such as quartz veins that "flowed" across the surface of the rock. In this light, the rock surface may symbolise the environment in which the figures find themselves. At the same time, the rock art surface also relates to the shoreline and the local natural surroundings.

On the largest of the panels there are a couple figures that resemble arrowheads or spearheads with human features; they have heads, arms and legs (Figures 162, 171). They are not humans, but if people believed that these creatures, spirits or divinities lived in human-like societies, they may reflect some of the traits of the actual societies in which these people lived. Both seem to be of female, whereas in our modern culture, weapons of this type are normally associated with men and hunting. In all societies, including the fishing-hunting-trapping societies, roles are divided between women and men, and there are rules and taboos that apply to both sexes. It is not possible, however, to draw clear conclusions about prehistoric societies based on analogy to historical societies, including those that survived on hunting, trapping and fishing, because there must have been large differences between more modern societies and the prehistoric ones. The connection between arrow/spearheads and the female figures in rock art can nevertheless be interpreted in the light of other knowledge: death, reproduction and resurrection were associated with females, and women as well as men hunted. Life along the Finnmark coast at the time must have been hard and dependent on extensive cooperation, division of labour and respect between men, women and children.

In the sections with the majority of overlapping figures, there is a row of human-like creatures with bodies filled out with an inner panel of horizontal and vertical lines giving the body a chequered pattern (Figures 162, 172). These figures are not found in other parts of the panel. The fact that figures differ in various parts of the rock surface suggests a conscious choice in placing the figures, as if the rock surface was partitioned off intentionally and designed according to whom and what the rituals were intended to address, and to what the figures were supposed to represent. Perhaps the positioning of figures on the large panels reflects the various powers and their place in the universe, or seasonal, ritual differences.

The other panel with the broad vein of quartz is located a few metres away, but on the same rock outcrop. Here there is not only extensive overlapping of figures (Figures 164, 165, 187), but the composition itself is somewhat different and there is significantly less variation in figure types. The large, elaborate figures with facial features and rib bone patterns are absent. Most of them have a rounded body; they are broad-boned and have a simple round head, but there are also simple line figures and a tall, thin figure with parallel lines marking its body, arms and legs.

As a whole, the figures with the human traits in Period IV seem to depict other-than-human beings to a much greater extent than earlier. However, this is only one of several significant differences in comparison with the figures in the earlier period.

Figure 171
A human-like figure with a body shaped like a spear or arrowhead. The tanged point resembles a vulva more than a penis and therefore can be assumed to represent a female.

Figure 172
Human-like figures with chequered, round bodies. Like most other figures, they very likely depict other-than-human beings. The extensive overlapping with other figures is found only here and on Storsteinen; overlapping was perhaps done in order to entirely integrate the figures with one another and with the rock surface in a meaningful whole.

REINDEER

Some motifs are relatively easy to identify as being reindeer since they are depicted with shorter legs than elk and they have typical antlers. The shapes vary. In addition, there are a few figures that are difficult to identify as reindeer or elks, and some of the figures resemble roe deer and red deer.

Most of the reindeer figures have short lines extending vertically from their heads; these may represent ears or antlers that begin to grow out in spring. Others have neither ears nor antlers, and this may suggest that the figures depict animals in wintertime after shedding their antlers and early in spring before the antlers begin to grow. The fact that only one reindeer with a smaller reindeer in the belly region has been found does not mean that there was no general interest in unborn life; animal figures also include gestating female deer – many have rounded bellies that can carry unborn offspring.

As in earlier periods, female reindeer are portrayed more often than bulls.

The population of reindeer and elk always includes a majority of female animals; the bulls roam together in summer, and they fight with each other during the autumn rut for the right to mate with as many females as possible. This struggle for supremacy does not seem to be depicted in rock art at all.

Animals in small groups and having about the same shape may represent small herds. As earlier, some animals have vertical lines inside their body outline, perhaps representing rib bones, whilst others lack lines; this is a continuation of the variations we find in the older reindeer figures in Period III. In the depiction of most animals, reindeer and elk alike, the legs are outlined to a much greater extent than earlier by sets of two lines (Figure 173). This gives them unique identities, although we are unable to determine them. They may be clan markers, special powers or animals in rituals and special stories that people told one another.

Figure 173
A small reindeer with all four legs indicated by separate lines and a rib pattern in the body cavity. Night photo.

Figure 174
Detail of a gestating reindeer (from Figure 175).

Figure 175
The photograph shows one of the panel from Period IV. The rock is teeming with figures, but it is difficult to see details because the figures are shallow and weathered. At the bottom, we see figures of reindeer, and one can see other figures up across the rock surface. See Figure 186 for a graphic copy of the panel. The two strong lines in the upper right are abrasions from studded tyres made by a reckless off-road motorcyclist.

PERIOD IV COMMUNICATING WITH THE WORLD OF BEINGS

OTHER MEMBERS OF THE DEER FAMILY

Compared with reindeer, there are relatively fewer elk figures, although it is sometimes difficult to distinguish between the two types of animals. The ambiguity we see in some of the figures is a continuation from earlier periods.

There are two exceptionally large figures on two different panels. The largest is 2.3 metres long and has large hind quarters and a small head (Figure 176). It lies at the lowermost edge of the panel, nearest the sea. In the forequarters there is a rib pattern, and inward from the middle of the back there is a line forming what appears to be a sack – a natural feature that elks do not have. The lack of antlers suggests that this may be an elk cow, and beneath the muzzle is a smaller figure, probably a calf. Actually all of the elk figures lack antlers, and although one or two have a dewlap, this suggests that elk cows remained more important than bulls as identity markers in myths, rituals and the cosmological worldview. In contrast to earlier periods, however, there is an absence of clearly defined gestating elks. For example, although three elk figures stand together in a small group, it can be difficult to determine whether the figures are represented individually or are part of a composition that includes the surrounding figures, since there is no clear repetition of the combination of figures.

In relation to the previous periods, the shape of elk has also changed somewhat. Now they appear more quadratic in shape, and the legs are often carved with double lines. Most have a simple rib pattern inside the body area.

Some of the animal figures from this period have formal similarities with figures found in Trøndelag and in Western Norway farther south in the country, where they are classified as red deer and roe deer (Hagen 1970; Mandt and Lødøen 2005). These are species that are unknown in Northern Norway during this time period. None of the figures are entirely identical with the natural, physical animal. This is well illustrated in the depictions over time of the large animals in the deer family. Animal figures having similar shapes in two different geographic areas were not necessarily perceived as being the same animal, particularly if the shape differs from the animal's natural, physical appearance. Conversely, this implies that figures with varying shapes might also be perceived as the same animal. The red deer-like

Figure 176
The largest of the animal figures in the Amtmannsnes panels when it was documented for the first time in 1980. The turf that covered the figure was removed and later replaced. The animal is of the dear family, and in front of it is a smaller animal, perhaps a calf.

PERIOD IV COMMUNICATING WITH THE WORLD OF BEINGS

Figure 177
As in Figure 176, it is difficult to determine whether this is an elk, a reindeer or another member of the deer family. The first impression one gets is that this is an elk with a dewlap, new antlers and large ears. But inside the body one sees a smaller animal figure, as if the larger animal is gestating and, if so, the figure probably represents another member of the deer family because the cow has not developed antlers. In this line of reasoning, the figure may represent part of a ritual involving a desire for regeneration/rebirth to ensure that animals will continue to exist side by side with humans as a source of food, raw materials and as an other-than-human being presence. (The sheets of paper are 70 × 100 cm large)
Photo: Adnan Icagic

Figure 178
Photo taken with low-angled lighting of the head of the cow within the deer family in the photo above.

figures have very complex shapes, and the question is whether their presence in one area possibly led to other similar figures being created outside the area where the animals lived. The coast is a powerful and efficient channel of communication, with contacts made with both the north and the south. Such contacts are seen in other archaeological material, and there is no reason why the same type of contact cannot be traced in the rock art. No bones have been identified in the archaeological material from the northernmost regions of Norway that would indicate that red deer existed in Alta at this time. The deer-like figures suggest that the people who carved them had clear notions regarding how deer should look and the conceptions associated with them. Why else should they take the trouble of carving them onto the rocks? The figures can perhaps also be attributed to one of the migrant groups that came to Finnmark during this period.

Figure 179
Judging from their shape, these two deer figures are difficult to classify. Are they reindeer, elk or something else? Many of the animals from Period IV give the impression of being based on prototypes other than reindeer or elk.

BEAR

Three figures possibly depicting bear have been found from this period. Compared with Period III it is more difficult to recognize scenes on the basis of bears' natural behaviour or in conjunction with other figures. Scenes involving bears being killed, such as those in Periods II and III, have not been found. Generally, bears are depicted far less frequently than in any of the previous periods of time.

Figure 180
A bear shown with human figures and reindeer figures. Because of compact overlapping and weathering, it is difficult to distinguish many of the figures from one another.
(See Figure 165 for the scale)

OTHER ANIMALS AND FISH

As in the two previous periods, there are relatively few other fauna depicted – whether they be mammals, fish or fowl – aside from reindeer, elk and occasional other members of the deer family. There is one snake (Figure 181) and some animals (Figure 182) that are difficult to identify – reindeer calves, running dogs or bear – and possibly a heavy-bodied terrestrial bird. Marine life is attributed little importance, less than in Periods II and III. No boat figures have been found, and the only figures directly associated with maritime activities are two halibuts (Figure 183). Halibut is the only fish figure present, as in the previous period.

In Period IV as in the two foregoing periods, halibut, the largest fish in the sea, is not only the fish that is most desirable to hook, but also the one that represents a power that people needed to be on good terms with in order to ensure continued fishing luck. It must have been far more difficult, and more dangerous, to land a halibut using only hide-covered boats, sinew lines and bone hooks than it is today with modern light craft and nylon fishing tackle. Halibut almost rival bears in terms of size, strength and rareness. Perhaps the halibut in the sea was regarded as having a role and power similar to what bears had on land.

Figure 181
The head of the snake-like figure is in contact with the left foot of the pregnant human-like figure, which depicts something other than a mortal person. The contact between the two is assumed to be intentional, perhaps reflecting a supplication for fertility in a ritual or story. There is a bulge in part of the snake's body, as if it has recently eaten.

Figure 182
Upper right: two short-legged animals, and farther down, a possible ground-feeding bird. Notice the animals with long legs, ears or short horns, racing about wildly. One of these has a head and posture resembling that of a bear as much as a reindeer or elk. At top right there are two elks and at far left a figure resembling a (patterned) erect phallus.

Figure 183
Two halibut amongst reindeer or elk figures.

ABSTRACT FIGURES

Figure 184
Cross-shaped figure together with a human-like figure. Night photo.

Figure 185
The northernmost figures on the largest panel from Period IV. A geometric, mushroom-like figure, a fabulous animal, two reindeer/elk and a human-like figure with a perforated phallus. We lack the knowledge necessary to determine what the figures once meant and the roles they had, both individually and as a group, in stories and rituals.

In the same manner as the transition between Periods II and III, there is a change in the abstract figures from Period III to Period IV. We now find an occurrence of new and unusual geometric patterns. The most striking are the long zigzag lines; in one place, four parallel lines extend from the top of the panel down to the lowermost figures where the rock meets the gravel at its base (Figures 162, 179). Another zigzag line consists of two parallel vertical lines, whilst a third is a line extending horizontally beneath a large human figure and below a long row of human figures. What might they represent and what do they symbolise? The figures reflect some kind of movement. Suggested interpretations include the northern lights, waves on the sea or on rivers, for example a river on which the departed travel into the realm of death. On the large panel in Kåfjord there is a similar short figure with five parallel lines, of which the 5, 2 × 4 and 3 lines intersect in a cross. This may suggest that there were connections between the eastern and western panels in Altafjord during this period. A similar impression is given by a rare cross-shaped figure (Figure 184). The fact that this was also found on a rock art panel on the southern Kola Peninsula (Kolpakov & Shumkin 2012) suggests contacts with the inner, eastward areas of the Kola Peninsula. The cross-shaped figures are special, and the similarities suggest that there was not only contact between the inhabitants of the Kola Peninsula and the people in West Finnmark, but also that they may have shared similar beliefs and rituals. In two instances the figure is associated with a reindeer that has its muzzle in against the figure itself (Figure 155).

Another geometric figure closely resembles a chequered mushroom (Figure 185) and a third looks like a large phallus (Figure 182), whereas others are even more ambiguous. On the whole, few geometric motifs have been found.

SUMMARY

Figure 186
The first rock art panel discovered at Amtmannsnes. By rubbing carbon paper over paper laid on the rock, all indentations, including the figures, appear as white sections on a dark background. For the most part, the figures represent reindeer, but there are also elk, other members of the deer family and human-like figures. In addition, there are many lines that have remained unidentifiable up to the present time.
Photo: Adnan Icagic

Figure 187
The figures on this panel heavily overlap, and because of weathering it is difficult to distinguish them from one another. With only few exceptions, all figures are concentrated above the broad vein of quartz running along the bottom edge of the rock. It is as if the quartz had some significance for the choice of locality and for the contact sought between people, the figures and the other-than-human beings.

In relation to Period III there is continuity in the main categories of motifs carved into the rock: people, elk, reindeer, bear, fish, fowl and various patterns. The main differences lie in the figures' relative relationships, shape and appearance and in the absence of boats and boat-related activities. Much of the orientation towards water and the sea that was found in the three previous periods is absent in Period IV, although this does not mean that boats were no longer important as a means of transportation or a way of exploiting the resources. They undoubtedly remained just as important as they were earlier, but they were no longer meaningful media in the communication imparted by the rock art. The rock carvings in Alta from Period IV may also be a local phenomenon, and one cannot conclude that the absence of boats on these panels necessarily applies equally to rock art panels elsewhere in northern Fennoscandia. In an older panel, a cross-shaped pattern was found that resembles Period IV figures at Amtmannsnes and Storsteinen, whereas in Hjemmeluft/Jiepmaluokta there are only two figures that outwardly appear to belong to Period IV. The scarcity of figures suggests that ritual activities in Hjemmeluft/Jiepmaluokta and Kåfjord were severely reduced, or that ritual activities associated with rock art were carried out in conjunction with the older rock carvings. Although there was no total stop in the production of rock art in Hjemmeluft/Jiepmaluokta and Kåfjord, it appears that a decision was made to carve rock art in areas farther to the east, near Mount Komsa. It is in these areas that the clearest traces of contemporaneous dwelling sites have been found.

When the mean water mark was 14 metres higher than today's level, Amtmannsnes was still a small island east of Mount Komsa. The area in front of the rock carvings would therefore have been below the mean water mark and would not have been inhabitable. People must therefore have lived at about 16–17 m above the present mean waterline, that is, slightly above the high water mark, and objects (flakes and scraping implements) have been found in a limited area. Investigations of the flat of land in front of the rock carvings have turned up flakes and scrapers made of chert that show people lived here for brief or more extended periods of time. The places where the objects were found are on the whole significantly larger than the higher-lying places higher up. When the plateau was inhabited, the mean water mark could not have been any higher than about 11 m above today's level, which leads to the conclusion that the settlement could not be much older than approximately 1000 BC. The issue, then, is to determine the location of the settlement associated with the rock art and whether the rock art was carved into the rocks between the mean and high water mark. The fact that the rock carvings are located along an approximately two-metre-high belt along the same elevation strengthens the argument that they were primarily created between the mean and high water mark.

The more low-lying settlement, therefore, must have been younger than the carvings. This does not mean that people from the younger settlement were unfamiliar with the rock art or did not ascribe meaning to them in rituals or other events.

If it is correct that the rock art was mainly linked with the area between mean water level and other tidal levels and rock surfaces washed over by waves, this means that Amtmannsnes was in use as a ritual site for a period of about 1000 years. In the course of this time, the exposed areas of the rock panels emerged an additional five metres out of the sea, which means that the flat area below the rock art was dry and inhabitable.

The plan drawing showing the largest panel (Figure 162) also reveals differences between the figures above and below the broad vein of quartz, as if they represent different entities or different dimensions. On the largest panel where there is room to carve figures below the quartz vein, we see that the figures are both different than the ones on the upper side of the quartz and are densely overlapped with

subsequent carvings. Similar overlapping is found on the smaller panel, where most of the figures lie concentrated just above the vein of quartz. Here there is only space for a few figures beneath the quartz vein. The similarities in the figures, the concentrated overlapping and density of figures near the vein of quartz suggest that the vein itself was a significant factor in choosing to concentrate the rock carvings at precisely this location.

The third panel (Figure 186) from this period is on the whole different from the other two panels. The rock type is the same as that of the other two, and there is a lot of quartz. The variation in figures is scant; reindeer and elk are predominant, and in addition there is a large, somewhat stylised elk and a human figure. Stylistically the figures resemble those found on the other panels at Amtmannsnes.

The choice of motifs that are depicted and not depicted suggests continuity, including the basic features portrayed. In many respects the exploitation of natural features in the rock surface corresponds to the meaning associated with the rock art in the previous two periods. The absence of boats and the richness of detail in the human figures suggest certain changes in what communication through rock art was all about or with whom it was intended to communicate. This perhaps means that new contributors had emerged – people who had a different or stronger control over rituals and meanings than earlier, although there is not necessarily a direct connection between changes in form and style, increased richness of detail, complexity and new creators of rock art. These newcomers, perhaps new groups, settled in the Altafjord area and established their own ritual site with rock art near Mount Komsa, that is, Amtmannsnes and Storsteinen in Bossekop. In the area near the older rock carvings almost no new rock art was created during this period.

Almost concurrently with the beginning of Period IV, significant changes also occurred in the other archaeological material. The large dwelling features that turned up in the coastal and fjord area are interpreted as being multi-family dwellings, for example two family dwellings in which each family had its own hearth (Simonsen 1958b, 1961), or which perhaps housed several families (Helskog, 1984), or else the size of the dwellings reflect the power and status of a single family (Schanche, 1994). A house excavated in Tollevik is dated from this period (2300–1800 BC) and may be one of the dwelling sites for those who created and used the rock art from Period IV.

The human-like figures in and of themselves are considerably more individualised than earlier. At the same time, the connection with one activity or another seems to be absent. Perhaps this reflects that status and roles were more socially stratified than earlier, either as a result of local, internal change or because people having different beliefs than earlier came to settle in the Alta area. Seen from a quantitative perspective, there was no continual creation of new carvings. Therefore, they must have been created at intervals, or in the beginning of the period, by immigrants who needed to distinguish their identity from that of the local inhabitants. The contrasts to the older carvings are so great that it is highly improbable that they could represent the local population's response to the newcomers and the new ideas they brought with them to the Alta area. Alternatively, the rock art is a mixture of ideas combining those of the people who already lived in the area and those of the newcomers. In Period IV, other-than-human beings depicted in human form are now portrayed with different and more abundant body details than earlier. The figures differ and the composition of the panels is markedly different from earlier practice. The relocation towards the east of the rock art areas in Alta during Period IV, along with the changes in the form and content of the figures, may suggest that newcomers having slightly different systems of beliefs from those of the local inhabitants came to settle in the area.

Rock art in Alta during this period has certain similarities with features found to the east on the Kola Peninsula and to the south in Trøndelag and Western Norway. They resemble one another enough to suggest that there was contact with, and influence

Figure 188
The figures cluster together above and beneath the broad vein of quartz. Some are human-like, such as the pregnant female figure at top left, whilst in the centre one sees a tall, straw-like individual. To the right of the figure with the mask and horns is the sole human-like figure positioned with its head against the vein of quartz. All are different and have unique identities. The same is true of the animal figures, and on the whole, the panel comprises a jumble of identities that were all linked with stories and rituals in conjunction with beliefs. People of the era had a truly rich spiritual life, one that was an integral part of daily existence.

Figure 189
People in prehistoric times had a large diversity of stories, on the same level as what has been documented in historical time. The stories can express experiences, belief in other-than-human beings as spirits, good and evil powers/beings, in the conviction that almost everything has a soul and in all creatures' ability to communicate with others. Some of this was expressed in religious and profane rituals, some through socialisation and some through the figures on the rocks in Alta. The figures in the photo are other-than-human beings, beings that played an active part in human mortals' everyday life, whether activities in the area of resource exploitation and economics, conflict, celebration or affairs of the heart. Night photo under artificial light.

Figure 190
The figures on the southern part of the largest panel at Amtmannsnes have the same individuality as the rest. All are different, and the large human-like figures are predominant. Some of these have hair (?), eyes, a nose and a mouth, and the bodies are different in content as well as size. One has a body like an arrow or spearhead. Even the simple line figures are different from one another. The animals are all of the deer family, and reindeer are predominant. (See Figure 162 for the scale)

from, these areas but the other archaeological material suggests that contact towards the east-southeast was at least of the same frequency. At some point towards the end of the second millennium BC, figures were no longer carved at Amtmannsnes and on Storsteinen, and Hjemmeluft/Jiepmaluokta became, once again, the central rock art area.

PERIOD IV COMMUNICATING WITH THE WORLD OF BEINGS

Figure 191
Who does this figure depict, with the detailed facial features, hair (?) standing on end, short arms and hands with two fingers and an oval body? The figure appears to portray something other than a mortal human, but of masculine nature, or is it hermaphroditic?

PERIOD V
1700–500 BC

Figure 192 (p. 178)
In Period V, boats appear again in the rock carvings in Alta. The largest of all the boats on this panel is carved upside-down into the rock, as if it occupies another dimension than the others. They are different from the older boat figures as well as from the figures found eastward across the Kola Peninsula and in Karelia; they do, however, resemble figures found farther south in Scandinavia. It seems that contact with people in the south increased.

Figure 193
The differences between the seasons are vast; here, between late summer and winter. People's lives were adapted to the great changes in temperature, fauna and flora, and they always communicated with the other-than-human beings. The rock art from Periods V and VI is found on the promontory on the eastern side of the bay, at the end of the rainbow. The photos show the contrast between late summer and winter. The white marker posts in the foreground pinpoint dwelling features from the Stone Age. The panels with the rock art are found throughout this area. The pictures are taken from the museum facing north.

Figure 194
Some 2500 years ago people were probably as happy as they are today when the sun returns after the dark season, even though the frost mist rose from the fjord and snow still covered the land. People surely had their own ways of celebrating the solstice, as we have today. We do not know whether the figures from Periods V and VI out on the promontory to the right were important in exactly this connection, because people very likely had many rituals that did not involve or include rock art.

PERIOD V COMMUNICATING WITH THE WORLD OF BEINGS

Towards the middle of the second millennium BC, figures were again carved into the rock panels at Hjemmeluft/Jiepmaluokta, at Apana Farm. Compared with the previous periods, the number of rock carvings is now severely reduced. As the land gradually rose, it might be calculated that as many as 1000 years might have passed between the time the three boat figures at 16.5 metres above sea level (MASL) were carved and the new boat figures at 11 m were made, proceeding on the assumption that they were always created between the low and mean water mark (Figure 195). There are also three prehistoric dwelling sites in this area. The oldest of these is located on what was a small, flat promontory 14.5–15.5 MASL below the panels dated to Period III.

Random surveys uncovered flakes from implement production throughout the entire area. Knives and tanged points of slate or sandstone had been found earlier in the western portion. During construction work in 2006, additional objects made of quartz and quartzite were found. According to former residents in the area, there were also depressions in the terrain, probably remains of dwellings, which had been filled with soil to make the terrain flatter. The dwelling features may be contemporaneous to the carvings found on the rocks a few metres lower. The three boat figures (Figure 146) and the reindeer on the rock at the far end of the promontory are probably older than these dwelling features.

Figure 195
The level of the mean tide when it was 11 metres higher than today's. Some panels containing rock art, marked in red, are located just above this level whilst other rock surfaces are still under water and would have become available later for making rock art. At the outermost point there is a small islet. The high tide level would have been about 1.5–2 metres higher than the level of the mean tide depending on weather conditions. This means that people probably built their dwellings on the flat section between 14.5–15.5 metres above today's mean sea level.
Aerial photo: © Geovekst

Figure 196
The figures from Period V are located on the rock surfaces above, between and below the walkway that meanders throughout the terrain. Beneath the turf in the foreground is a dwelling site that is younger than the panels in the foreground, but contemporaneous to those lying at the lowermost end of the walkway, that is, Period VI.

The terrain is relatively flat. When the land rose, the distance to the shoreline increased markedly. On the other hand, the shore displacement was not as fast as before so that the shoreline sections could still be used for creating rock art over a relatively long period of time before the direct connection between the rock surface and the water was broken. Boats are again an important motif, and the panels are significantly different from Period IV in terms of content and composition. The large, complicated human figures no longer occur, and the shapes of most types of figures such as reindeer/elk and humans have changed, and boat figures have become numerous. Compared with the comprehensive changes in figures from Period II to Period IV, the changes from Period IV to Period V are equally distinct. What occurred, and why?

Figure 197
The split whale spout at the upper right suggests that this is a north-caper. Behind it is a round fish, almost like a moonfish, and a reindeer. Below these is probably another north-caper, and to the left, a halibut. As was typical for the figures from this period, the reindeer are small, and many have relatively large antlers that are disproportionate to their body size.

PERIOD V COMMUNICATING WITH THE WORLD OF BEINGS

HUMAN FIGURES

Figure 198
The human figures from the period are mainly line figures with outstretched arms. Upper right: a figure of a woman with three fingers and lips of the vulva (See Figures 199–200).

All human figures are now made as simple line figures. On one panel, two human-like figures are sitting on their haunches and have feet with three toes (Figure 200). Their arms stretch out to the sides, their hands have three fingers, and the figures represent supernatural powers rather than mortal humans. Most of the other human-like forms are simple line figures standing either upright or upside-down, with their legs apart and arms outstretched. The placement of arms and legs varies and was likely assigned special meanings and identity.

Another panel (Figure 201) consists of three very virile male figures side by side; these are either mortal humans or other-than-human beings. The very pronounced genitalia suggest a focus on reproduction and fertility.

One small panel has six human-like figures (Figure 202) pecked into a small, sloping panel. At bottom left is a figure that is partially full-body carved. It appears to be holding a bow towards the right, and above this are two simple human figures: the one on the left is

Figure 199
A small panel on which reindeer and human-like figures are predominant. Notice the two figures squatting on their haunches as if they are in a birthing position.

incomplete. To the right are three figures who seem to have drawn their swords, and the two to the right are confronting one another (Figure 203). All three have a round, carved-out section above the torso which may represent shields, a feature associated with warriors of the Bronze Age. The three sword fighters represent an entirely new element in the rock art of Alta. These were pecked either by people who came from elsewhere, most likely by boat from the south, or by people who depicted something they had seen or heard about. It is unclear whether the figures portray real people, other-than-human beings, or foreigners wishing to make their mark in Alta. Whatever the case may be, there was clearly contact between the populations in the north and south. Perhaps this depicts a meeting between two groups – the foreigners with shields and swords, and the locals carrying bows and arrows or unarmed.

Figure 200
No human has only three fingers and three toes. The figures portray something other than human, although a female, and the squatting position suggests that she is giving birth. The red paint was added to enhance visibility.

PERIOD V COMMUNICATING WITH THE WORLD OF BEINGS

183

Figure 201
Three virile male figures.

Figure 202
The panel with human figures carrying swords, shields and bows and arrows.

Figure 203
Human figures with swords and round shields from the Bronze Age.

PERIOD V COMMUNICATING WITH THE WORLD OF BEINGS

REINDEER AND ELK

Although it can be difficult to distinguish between elk and reindeer figures, it seems that most animals with or without antlers and carved at heights of between 9.5 and 11 MASL depict reindeer. The ritualistic meaning of the elk in rock art has diminished for the people who lived in the Alta area, and the reindeer is the predominant land mammal depicted. The absence of elk figures may owe to a real setback in the elk population due to changes in nature and the subsequent reflection of this fact in the reduced role they had in rock art. However, there is nothing to corroborate this decrease in the elk stock, and on the whole we lack knowledge about the stocks of various animal species. The current stocks in the region today appear to be the most plentiful in historical time. Local assertions that elk came to Alta in 1941 suggest that the stock was small for a period of time prior to that year, but it is impossible to determine how far back in time this had been the case.

Practically all of the reindeer figures have antlers. Some have large, double antlers, and it seems as though this feature is meant to distinguish bulls from cows, despite the fact that old cows can have antlers just as large as those of reindeer bulls. In eight instances the animals – which would normally be interpreted as bulls due to their exceptionally large antlers – have large bellies, as if they are gestating (Figures 204, 205). Perhaps these depict both cows and bulls, with the females giving birth early in spring after shedding their antlers. If the variation

Figure 204
A small reindeer figure with over-dimensioned antlers and short legs that are disproportionate to its body. It appears almost as if it is pregnant, although the large antlers are a sign that the figure may depict a reindeer bull.

in the antlers can be ascribed meaning, this depicts reindeer in the period from summer; they shed their antlers sometime during winter. Only a few reindeer figures have antlers at an early stage of their growth. The large number of animals with antlers represents a clear break with the tradition of earlier periods when reindeer without antlers, or with very small antlers, were relatively common motifs. Based on the relationship between animals without antlers or with small antlers (females) and those with large, full

antlers (bulls), it seems that there is an emphasis on the male animals, in contrast to earlier periods.

One possible explanation is that the reindeer bull became just as important a symbol of procreation as the cow was for propagation of the species, and that the male animals were therefore assigned a more prominent role in the worldview than they had previously had. Perhaps this reflects that people were in a process of increasing control over the animals

Apana Gård felt VI

Figure 205
Most of the small reindeer figures have relatively large and well developed antlers, indicating that the season is late summer. Two have large round bellies, as if they are pregnant. The human-like figures are simple line figures, and at the bottom we see four boats typical for the time, as well as a large halibut.

through a form of reindeer-taming comparable to the relationship between reindeer and people amongst the Skolt people (East Sami) in the 1900s, a relationship that exists still today amongst the Nenets and other Northern Eurasian peoples.

Although the panels are small, it is difficult to determine whether the motifs are parts of a composition or stand alone independently. In some instances there are distinct groupings of the figures, such as small herds of reindeer, sometimes with human figures and boats, other times not.

Figure 206
A herd of reindeer with well developed antlers, perhaps bulls that have herded together during summer.

Figure 207
Reindeer, human figures and boats.

PERIOD V COMMUNICATING WITH THE WORLD OF BEINGS

Figure 208
The special features suggest that the animal had an identity that made it unique from the other figures. We do not know the meaning it had, but it perhaps depicts an individual associated with a legend or mythological concept.

PERIOD V COMMUNICATING WITH THE WORLD OF BEINGS

189

OTHER ANIMALS

In addition to reindeer, the rock art illustrates other animal species, although very few in number, and there is a single depiction of a male red fox. Marine life is represented by three halibut figures having a body pattern of horizontal and vertical lines, possibly illustrating the vertebral column and dorsal ribs (Figures 205, 209). In addition, there are three figures that resemble whales. One of these appears to be a humpback whale rotating as it leaps into the air (Figure 199). One of the others is shorter and stouter, and the spout goes out in two directions from the blow holes (Figures 210, 211). In this ocean area, only North-capers (North Atlantic right whale) have double spouts. The third is just beneath the others; it has very faintly outlined and has the same shape as the whale above it. Behind the top whale figure is a round figure resembling a moonfish. The general impression one gets is that other animals, including fish and whales, are represented just as infrequently as in the earlier periods. Bird figures seem to be totally absent. Otherwise, one finds a bear depicted with two human figures (Figures 209, 210) and one male red fox (Figure 211).

Figure 209 (p. 190) A large halibut with carved lines inside the body possibly depicting a part of the skeleton. The figure is relatively indistinct, partly because of lichen vegetation and partly because the pecked lines are shallow. The outline of the tail is relatively shallow and indistinct. It may appear that this figure, like many of the others in Alta, is incomplete, but we cannot be certain as to whether the figure was considered to be a sufficient expression of the meaning with which it was associated and whether it was thereby perceived as complete.

Figure 210 Graphic copy of a bear with people. Below: two human figures and probably a north-caper whale (Eubalena glacialis), recognizable by its dual, v-shaped spout.

Figure 211 Male red fox. The figure has been enhanced with red paint.

Figure 212 Whale with a double spout, very likely a north-caper (Eubalena glacialis). The figures have been enhanced with red paint.

BOATS

Figure 213
A boat with an animal's head (horse?) on the stem, and tall human-like figures. Night photo.

Boats, as symbols, have returned to rock art. They are different in shape from earlier boats. The distinctive elk's head that decorates the stems of the boats in Periods I, II and III is now totally absent, whilst four boats have stem heads that may depict horses, similar to those of some boats in southern Scandinavia. Because of the relatively softly sloping terrain, it is possible that we have several types of boats between 11 and 9.5 metres above sea level that belong to different periods of time. One of these is found on five small panels between 11 and 10 MASL. The other is on two panels at an elevation of about 9 and 10 MASL.

The highest elevated group of boats all have a rectangular hull with an elongated keel and gunwale, and most have short vertical lines running up from the hull, possibly representing crew members. On one of the panels there are only six figures, four or five of which are boats. In several other instances, boats are carved upside-down on the rock (Figures 192, 214, 215), as if the vessels have capsized in turbulent water or are in a totally different world. In addition, it appears as if one human figure is floating above one of the three boats at the lower edge of the panel, perhaps a shaman in the process of being transformed from one state into another (Figure 192).

This type of boat (Figures 192, 214) is known from several places along the coast in Nord-Trøndelag, Western Norway and in Bohuslän on the Swedish west coast; it dates from the Bronze Age. The similarities in figures between the various regions suggest that they are depictions of an actual boat type that existed in the Scandinavian coastal areas. We know that there was contact between the coastal populations of different regions, and in fair weather, the distances by boat were relatively short. In poor weather, however, the distances could be perceived as overwhelming. Boats resembling these have not been found in the rock art eastwards on the Kola Peninsula and in Karelia to the south, a fact which suggests that differences developed in the regional boat traditions.

The different traits amongst the boat figures in Alta suggest that there were variations in the elongation of the keel and gunwales on real boats. In one of the youngest boats from this period there is a crew of seven rowers, each holding a single paddle oar (Figure 216). The figure is somewhat indistinctly carved and incomplete; the lines are shallow and not always fully incised.

On another nearby panel there are four similarly indistinct carved boats with elongated keels and gunwales (Figures 213, 215). The elongation curves upward and the crew of three of the boats are all depicted differently. They have disproportionately long bodies in relation to the size of the boats, and they give the impression of depicting beings that might not be human. One boat, carved upside-down on the rock surface, resembles the boats on the other panels from this period. This boat has a horizontal line just above the keel line, as if to represent a water surface. On the same panel there is a small herd of young reindeer, some with large bellies, perhaps indicating that they are gestating, and all of them have gigantic antlers like reindeer bulls. Based on the elevation above sea level, these figures are the youngest in the period.

Figure 214
As is the case for many of the panels, it is not possible to determine whether the figures belong together in a composition or were perceived as individual figures in isolation, or whether they varied according to the story being told or the ritual being performed. The reindeer figures to the right are facing north; some have large antlers and others do not. It seems that these factors were meant to show variations in a small herd late in the summer season. At the same time, there is a boat carved upside-down in relation to the slope of the rock, and at the bottom is a large halibut with a skeleton-like pattern in its body. The difference in orientation and placement on the rock is not without meaning. For example, has the halibut been placed at the bottom of the panel merely arbitrarily, at exactly the place where the water line would have been in relation to life on earth? In other words, does the placement reflect a perception of the world in which people lived or in the stories they told? If so, was the boat carved upside-down a little higher on the rock placed there arbitrarily?

Rock art is food for thought, although unambiguous and definitive answers can seldom be found.

The figures have been enhanced with white chalk in conjunction with documentation work.

PERIOD V COMMUNICATING WITH THE WORLD OF BEINGS

Figure 215
These boat figures very likely represent the youngest in the period. Three have an animal's head on the stem, a type of stem head found in southern Scandinavian rock art that is interpreted as a horse's head. To the left: a boat carved upside-down in relation to the slope of the rock. Between them, a reindeer with large antlers; to the far right, another reindeer with a round belly, as if it is gestating.

Figure 216
The only known boat figure with paddles in Northern Scandinavian rock art. The figure appear to be incomplete.

PERIOD V COMMUNICATING WITH THE WORLD OF BEINGS

SUMMARY

The differences in relation to the figures in the previous period IV can be associated with the different ways people understood and related to their surroundings in beliefs and rituals. Two entirely different worlds in mythology and the belief system appear to be presented. The composition of figures in Period V is simpler, although this does not necessarily mean that the stories, mythological content and rituals became simpler. The large, detailed human-like figures are absent, and the boat is once again a part of the symbolic system. There are also far fewer figures.

The dominance of reindeer and a few whale figures in addition to the relatively numerous boat figures reflect, as in earlier periods, a certain selectivity in the use of symbols. Considering the fauna in its entirety, we know that the rock art also represented only a small and selective choice of motifs and did not reflect the diversity of the natural resources that were exploited. Nevertheless it is probable that many of the rituals performed were associated with exploitation of resources because life was at all times dependent on sufficient provisions. Moreover, the communication of which rock art was a part encompassed all sides of life and daily existence, including birth, healing, death and social fellowship between people. This was most likely how things had been from time immemorial. It is probable that the acts associated with rock art also laid the premises for entering into agreements and creating alliances between various groups of people, from both the coastal regions and the inland areas.

Based on shore displacement, the distribution of figures and the number of panels located between 11 and 9.5 MASL in this relatively gently sloping terrain, we get the impression that the rock art was made during the era known in northern Norway as the Early Metal Age and elsewhere in the country as the Bronze Age. It is difficult be more precise concerning the dates, and on the basis of approximate dating of the mean water level at 9.5 MASL, the youngest figures might have been made about 400–500 BC. It was maybe at the end of this time period that various hunting, trapping and fishing populations were perceived, by themselves and others, as a people with many shared traits, and these came to be described under common, generic terms such as Terfinns, Finns and Samis (Hansen & Olsen 2004). It was also towards the end of the last millennium BC that the pit houses in the coastal areas appear to go into disuse and were replaced by dwellings founded directly on the ground. A dwelling structure that is similar to the Sami "bæljegamme"(circular turf hut) has been found at Slettnes on Sørøy Island. This is a type of dwelling that is relatively easy to construct and is associated with increased mobility in the society (Olsen 1993; Hesjedal et al. 1996). However, simple types of dwellings have always been built in conjunction with seasonal migrations and exploitation of resources. Although few surveys have been carried out in the areas around Altafjord, there is much to suggest that cultural changes here correspond with the changes that took place in the nearby fjord, coastal and inland areas.

The economic basis for the settlement was still hunting, trapping and fishing – activities that varied seasonally. As earlier, there were varying degrees of permanent residence and seasonal migration. In the coastal area, good boats and access to varied resources have always been the mainstays for a relatively stable population, along with a high degree of mobility within and between the seasons of the year.

Marine life is represented through the handful of halibut figures, the whale and the boats. The boat figures are not modelled only on local boats; they are also of a type found in a few rock art panels along the coastline down to Western Sweden, where they have been dated as being from the Bronze Age, that is, approximately contemporaneous with the boats in Alta. If one interprets the lines as representing crew members, most of the boats appear to be very small. The somewhat larger boats have the same basic shape, but with more lines denoting crew members. The similarities suggest that there was a high level of contact and exchange between people in the coastal areas.

Although there are ample stocks of fish, fowl, reindeer and smaller furred animals in the inland areas, the climate is colder than along the coast and the basis for settlement is less substantial. The reindeer, a very important resource, migrate towards the coast during spring, return in autumn and are then hunted in great numbers during this period.

Perhaps some people based their livelihood so heavily on reindeer that they migrated with the animals between the coast and the inland in order to have constant access to the resource. If the scope of control was so comprehensive as to encompass the maintenance of small herds, these groups would have differed from other groups which were stronger oriented towards the coast.

Figure 217
It is autumn and the first snowfall is in the wind. The figures from Period V lie alongside the walkway from the barn with the white foundation down to the rock surface surrounded on three sides by wooden platforms. The youngest figures, Period VI, are found on this outcrop.

A distinction of this kind is difficult to make on the basis of observations of the rock art, although both land-based and marine resources and activities are depicted. There were variations in resources used, but one of the common features, aside from beliefs and religion, was that reindeer were still tamed as decoy animals and perhaps also as draught and pack animals; in addition, there was organised drive hunting.

Reindeer figures are predominant in the rock art. Many appear to be gestating and have enormous antlers, whilst elk figures are practically totally absent. Reindeer now appear to be assigned the role that had been previously held by elk. It seems as though elk may have suffered a setback, both in real life as well as in mythology and rituals. The role change may be linked with increased control over wild reindeer and a different type of communication with the other-than-human beings. Reindeer "husbandry" most likely involved only a small portion of the population, and perhaps in the inland areas where reindeer ranged during winter. Historical sources suggest that the combination of individual hunting and organised drive hunting existed throughout several thousand years until the herds of wild reindeer were strongly diminished and the remaining reindeer were controlled and owned by the Sami Siida society from the 1700s and onward.

Figure 218
The surface has been cleared and the figures are marked with chalk before they are photographed and copied onto plastic foil. The figure to the upper left resembles a human. All the animals are reindeer. There are also three boats. The lowermost boat to the left is a common type found at this height above sea level, whilst the one that can be faintly seen to the right is unique, because it has paddles (see Figure 216).

Figure 219
The boat at the bottom of a panel, probably one of the youngest boats from Period V, is from the latter part of the Early Metal Age. On the stem to the right is an animal's head, possibly a horse, and on board are some tall, shapeless human-like figures. The partially incomplete body shapes give them different identities, but we are unable to say if these represent people, other-than-human beings or both.

PERIOD VI
500 BC – 100 AD

Figure 220
The youngest figures lie on the outcrop in the foreground. All vegetation has been cleared away, and rain gives an impression of how things looked when the mean tidal water washed across the rock some 2500 years ago. Boat figures can be seen on the right (see Figures 223, 224), and in the foreground to the left is yet another boat figure, all with traces of red paint which made them more visible to visitors.

Up in the left portion of the rock surface are four boat figures, two of which can be seen in the photograph. The drawing of Figure 223 on page 204 shows that all the figures are oriented in relation to the slope of the rock. Therefore, the figures on the far side of the rock cannot be seen in this overview.

Figure 221
The boat approaching the hunter and the elk displays a form and content that suggests seafarers from far-off southern areas. Similar boats are found in Rogaland, Østfold and in Bohuslän in southern Sweden, whereas the dancers and "drummers" are unique. The boat and dancers reflect a ritual or a story, although it is impossible to determine whether the basis derives from customs of local or southern origin, or is a fusion of impulses from the peoples of different regions. The elk and "hunter" on skis suggest local knowledge, and the composition likely expresses an encounter between people of different cultural backgrounds.

Once again, there are distinct differences between the rock art from the previous period and the younger rock carvings. According to a dating of the mean tide level at 8.5 metres above today's level, the figures at the bottom cannot be much older than approximately 2000 years, that is, roughly coincidental with the birth of Christ. The figures at the top, at 9.5. metres above sea level, can hardly date from any further back in time than 500 BC. The figures are the youngest in the Alta area.

Radiocarbon dates, along with objects from a dwelling site 11 MASL, suggest that the site was inhabited between about 500 BC and some point in time in the first centuries AD. This would have been contemporaneous with the youngest rock carvings. By comparison with the dating of shore displacement, the dwelling site cannot be much older than 1000 BC. Asbestos ceramic and slate arrowheads, plus scrapers and chert flakes have been found here. The fact that the site of the settlement is small, delimited and near the water, but not sheltered towards the north, suggests this was a summer camp site. During the last millennium BC the climate changed, and in about 500 BC the climatic conditions became similar to those of the past 2000 years. It was a little colder; the forested areas receded somewhat, and there may have been some changes in the fauna.

The third category of traces of human activities includes flakes of quartzite and chert found in the gravel between the rock art panels all the way down to 8.5. MASL, that is, at the time the area was above the water line in the first centuries after the birth of Christ.

Like the transition between the previous periods, there are clear, major and pronounced changes in the rock art motifs, from a heavy predominance of reindeer and boats to an era when boat figures take over. The 26 figures suggest that they were created rather sporadically, probably associated with special occasions.

As in many of the other panels, there is a division between life on land, represented here by a figure of an elk and a hunter, and life in or on the sea, represented by a whale and boats. The crewed boat figures are predominant, and there is only a single elk representing land animals and depicted in front of a human figure on short skis and carrying a bow and arrow (Figure 221). The other animal figure (Figure 223) may represent a whale.

The figure on skis is the only one of its kind north of Rødøy in Southern Helgeland. In addition to the skier, there is another individual human figure and a

Figure 222
When the mean water mark stood at today's nine-metre contour line, most of the rock surface was accessible for carving figures. The youngest figures that were pecked into the rock are found inside the two lowermost red circles above the simulated mean water level.
Aerial photo. © Geovekst

pair of foot soles with laces, all of which likely date from the Bronze Age or Early Iron Age.

All the boats on the panel are different from the boats of the previous period. Three are outlined with a simple, narrow line denoting the hull and a simple raised prow in the form of an animal's head, and two have vertical lines possibly representing crew members. The boats lie near one another on the highest (left) part of the panel. The most complex boat figure has 12 simple human-like figures. The stem and stern are raised, and towards the stem there is a tall construction that resembles the raised stern (Figure 221). The impression given is that this is a larger boat than any found from previous periods. The 12 human figures are in motion, as if dancing. The two in the middle appear to be beating drums, and the rest are standing on one foot and leaning slightly forward. The portrayal is extraordinary, but what it depicts – an actual ritual or a mythological event – is unknown. Forms of dancing must have been part of human existence, then as now. (If this depicts an actual ritual, it suggests that boats must have had a deck solid enough that one could dance on it, despite the fact that there is no evidence of this in the extant archaeological material.)

Figure 223
Most of the figures from Period VI are found on this panel. Fifteen of the figures show various types of boats; some have distinct human-like figures on board whilst others have single, straight lines possibly also representing humans.

A couple of the other boats also give the impression of being large and solid, plank-built vessels almost large enough to be called ships (Figure 224). On board one of these are 33 human figures; the two figures at the front have heads, arms and legs. Like in the previous boat, these two are positioned facing one another. Clearly these represent more important persons than those depicted only by a straight line and a head. The stem is tall with an open spiral at the top. A line has been pecked from the stern, resembling either a steering oar or a mooring line. Beneath this large boat is a similar, smaller boat with only seven crew member lines, and at the bottom is a larger boat with 29 crew member lines; this boat also has a spiral at the top of the stem and stern.

There are relatively large variations, both in shape and size, between the boat figures on this small panel; from those having tall stems and large crews to those like the one on the right of the panel, which is somewhat u-shaped and has no crew.

At the bottom to the left is the outline of a boat with tall stems and a tall construction towards the bow. These variations in boat types may reflect actual, physical variations. There are two examples of the latter type of boat figure, both amongst the few lowest-lying figures at Hjemmeluft/Jiepmaluokta. This type of boat is known from Trøndelag and Western Norway and all the way south to Bohuslän in Southern Sweden and is associated with the Late Bronze Age or Early Iron Age. It is doubtful that the rock art boats were exact, detailed copies of actual boats, but it is safe to assume that the general traits reflect a certain physical reality. The plank-built Hjortespring boat found in Denmark and dated from about 200 BC is a good example of similar relationships (Crumlin-Pedersen & Trakadas 2003). Here we find larger boats with large crews that could make long journeys, as well as smaller boats with more limited capacities that could be used for travel or for exploitation of resources in the fjords and nearby coastal areas. The differences between the large, complex craft with large crews and the small, individual boats may also reflect a difference between seafarers from distant places and the local population. Rock art shows that there was contact between people from the north and south.

SUMMARY

In the same manner as the changes seen between Periods IV and V, the differences from the motifs of Period V may mean that they might have been associated with people who shared a culture that was significantly different from the earlier hunting and trapping society. The rock carvings in Periods V and VI are found only on panels in Alta. They may express only local characteristics, rather than representing broader regional changes in the use of symbols. To elaborate further on this requires more knowledge about the rock art of the rest of Northern Norway, and until then, the rock art from Period VI in Alta can only be regarded as a local phenomenon. It is impossible to determine whether the large boats were associated with shorter visits by people coming from the south or whether these people settled and remained in the region. Boat types that are mainly known from further south in the country may represent seafarers who wished to make their mark through rock art added to the local population's ritual site and thereby assert some type of dominance. If the visitors settled permanently, we have to conclude that the 26 rock carvings were used repeatedly, provided they were linked with rituals. The figures between 8.5 and 9.5 metres above today's mean water level are the youngest figures in Alta. This marks the end of rock art used as a bearer of metaphors and symbolic meaning in beliefs and rituals in the Alta area.

The boat is now the most important figure, a symbol associated with lakes, rivers and the sea. Because of their similarities with prototypes further south in the country, the largest boats, those with tall stems and many crew member lines, give the impression of representing influences from the southern areas. The smaller boats, however, may represent local crafts. But our knowledge about boat technology and boat types is too insufficient to permit us to say that these types of boats did not exist along the entire northern coast. Boats were still symbols, although this does not necessarily imply that the meaning attributed to them remained the same as that of earlier periods. The different types might mean hardly more than that there was variation in boats along the lengthy coast

Figure 224
Some of the boats from Period VI. The differences in form and content give them different identities, such as in use, stories or rituals. On the panel at the top of the photo is a figure resembling a whale with its jaws open. The figures have been enhanced with red paint to make them more visible.

Figure 225
When the lichens are removed, the structure and colours in the rock and carved figures emerge more clearly. The outline of the keel and gunwale on this boat follow glacial striations in the rock. Both stems are raised, and the one on the left (the stern?) has a small extension at the top. The keel line below the left stem also appears to have been extended. There are 18 crew member lines on board.

The circular peck marks in the stem to the right appear to be part of the outline of a stem belonging to yet another boat figure.

from the North Atlantic to the Baltic Sea, then as now. Boats were a lifeline, and one can conclude that boat technology was advanced and well adapted to their function and to local conditions.

If the boats in Alta were carved by the local population, this may mean that they have begun using motifs or a system of symbols influenced by people who lived further south along the coast. The elk, skiers with a bow and arrow, and perhaps the whale and the two small boats represent the local population, their use of symbols and mythology.

The absence of reindeer figures in Period VI apparently contradicts the argument that reindeer figures in Period V can be associated with fledgling control, domestication and ownership of reindeer. However, the motifs first of all do not represent a prehistoric menu, because most of the resources, in the form of figures, are missing, except for one elk and one whale. Secondly, if the motifs were linked with seafarers who were not part of the northern, local hunting and trapping society, but instead to a hierarchical agrarian society having a different symbolic regime, then the emphasis on boats is in line with the symbols used by these societies. Therefore, it is improbable that the absence of reindeer figures can be explained by a reduction in hunting and possible domestication of reindeer over several centuries. Historic sources such as Tacitus in the first century AD and the so-called Report of Northern Norwegian chieftain Ottar at the end of the 800s (approx. 890 AD), describes a northern population whose exploitation of the resources was carried out primarily through hunting, trapping and fishing (Simonsen 1996, Storli 2004). This is a continuation of the modes of exploitation that we know from prehistoric times. Reindeer had a central place in hunting, and late in the 800s, some reindeer were also kept in corrals.

The absence of dwelling features from large structures during this period, and the remains of a semi-circular building structure with an outline somewhat similar to a Sami dwelling structure (Bæljegamme) found at Slettnes on Sørøy Island, are interpreted as an indication that the population, in addition to hunting, trapping and fishing, chose a migrant existence more associated with reindeer herding as their primary livelihood, in contrast to earlier (Hesjedal et al. 1996; Olsen 1993). This may be one of several reasons for the changes we see in settlement patterns. Another may be that dwelling types changed during the last millennium BC. The coastal area was, and still is, the zone that sustains the largest number of people. A third reason may be that competition for resources in the coastal and inland areas increased because trappers from outside now began to place greater pressure on the resources and hence also on the local population. It was probably towards the end of the last millennium BC that chiefdoms began to be established along the northern coast, entailing exerted power, appropriation of resources and trade of raw materials. We know very little about the effects that these had on the settlements in Finnmark. Moreover,

good boats made it possible to journey north and eastward to hunt, trap and barter, and to otherwise do whatever the newcomers saw fit to do, backed by the power they had, and perhaps even to drive out segments of the population that already relied on the resources of the area. The large boats in the rock art are maybe a depiction of this external pressure. Thus, parts of the local population were forced to make changes and to give up control over the resources that were earlier in their possession.

The fact that rock carvings after this period were no longer created in the Alta area or any other place in the northern areas does not mean that rock art was no longer used. They may still have been an important part of rituals and observances of myths, legends and stories, and also as symbols in communication between one another and between mortals and other-than-human beings. Images as a medium of communication continue to be used, but they are only sporadically carved or scratched into rock surfaces. For example, in Badjelánnda in the northern Swedish inland, figures scratched into the rock surfaces have been found, dating from the Middle Ages, and are associated with Sami exploitation of the area (Mulk & Bayliss-Smith 2006). At the summit of Aldon, a Sami sacred mountain on the northern side of Varangerfjord, there are a few figures (Simonsen 1979b) which must have been created long after the end of the era of rock carving in Alta. Certain line drawings of the same type as those in the rock art continued to be used as painted figures on drums.

In addition, there are figures painted in reddish ochre on vertical rock walls. Some of these are perhaps only a couple of centuries old, whilst others may have been painted many thousands of years ago.

Figure 226
One of the simplest boat figures from Period VI. The figure is shallow and indistinct.

Figure 227
The boat figure is very shallow and difficult to make out. It appears that the bow is outlined by two connected lines whilst the stern may be outlined as a vertical line and an extended keel. Between these there are eight vertical lines suggesting a crew of eight. One of these is longer than the others, probably to denote a special identity.

Figure 228
The contour of the boat is marked with small, compactly carved and shallow indentations. It is almost as if the figure is not yet complete; it can be seen only under proper light and close examination.

This is probably one of the youngest figures on the panel.

PERIOD VI COMMUNICATING WITH THE WORLD OF BEINGS

Figure 229
It is January. The sun has turned but has not yet appeared over the horizon to bring its warmth and rays of light. It is cold; vegetation is still overwintering under the snow. Shown here: the walkways and rock carvings from Periods V and VI.

PAINTINGS

Figure 230 (p. 210)
On a rock wall in Transfardalen is a figure located 20 metres above sea level and which appears to be a whale leaping into the air. It is painted with a reddish ochre colour typical of all the painted figures in Fennoscandia.

Figure 231
On a dark, dry and "hidden" rock surface are a few painted figures of people and animals. The red ochre colour is often faint and difficult to make out. There are several figures on the panel, the most visible of which is a human figure on the right between the tree trunks. Like the carvings, these painted figures gave meaning to rituals and stories; judging from location and content, the meaning was somewhat different. The two types of figures overlap one another in time.

The earliest use of red ochre as a pigment dates back 100 000 years and was found in the Blombos Cave in South Africa (Henshilwood et al. 2011). In Europe, the oldest known use of red ochre as a colour is associated with the Paleolithic cave paintings in France some 30,000 years ago. In Fennoscandia, red ochre was used to decorate ceramics as far back as 5000 BC. Painted figures have been found in Finland (Kivikås 1995; Lahelma 2008), in Sweden (Kivikås 2003), on the Fisher Peninsula (Shumkin 1990) in North-western Russia and in Norway. The fact that paintings exist all over the country suggests that this was a relatively common communication medium, but one that does not nearly comprise the same number of figures as those carved into rock surfaces.

Much uncertainty surrounds the dating of the painted images in northern Eurasia, because it has not been possible to trace the binding agent or other organic material in the colour which can be dated by radiocarbon. The paint was applied using brushes or directly using fingers. Dating are based on finds from nearby prehistoric dwelling sites, on the style and content of the figures, on assessments of the age of silica membranes covering the paintings and on the relationship to shore displacement in the areas of the finds. Like rock art, the dating of the paintings are indirect and not direct. This also means that we must remain open to the possibility that some of the figures may be only a few hundred years old, whilst others may be as old as 6000–7000 years. The paintings in Finland are estimated to date from about 5000–1500 BC (Lahelma 2008), whilst those found in Sweden, Norway and on the Fisher Peninsula on the Russian Kola Peninsula are estimated to date from 5000–500 BC. The basis for dating the paintings is relatively weak. If they were linked to changes in sea level, some of the paintings in the Alta area would be more than 7000 years old (Andreassen 2008.) Again, discrepancies and uncertainties prevail.

Based on elevation above sea level, some of the paintings in Alta may be older than the rock art; some may be contemporaneous and others younger. Another uncertainty factor is the length of time red ochre can last on a rock surface exposed to the changing Arctic climate along the Altafjord, particularly since the paintings were located so close to the water that they were subjected to salt wash and sea spray. There are two areas in the Alta area with a total of eight small panels having a few figures of animals, people and geometric patterns. The rock walls are partially exposed to wind and sunlight, but all of them are located in places that are sheltered from rain, and the paintings are exposed to direct sunlight only during relatively brief periods. In addition, in the cases where a transparent membrane of silica leached from the rock covers the figures, the pigment is preserved by this silica coating. This can explain why the colours can last on the exposed surfaces for several thousand years.

Figure 232
Upper left: a human figure (see Figure 233); Right: a reindeer and a type of pattern. On the white rock to the right of the human figure (at the level of the feet), a line has been incised as part of a now unidentifiable, small figure. It is impossible to determine whether the two types of figures are contemporaneous, but the combination of the two is highly uncommon.

The white line along the figure's contour is chalk residue from documentation in 1967.

Figure 233
Notice that the figure has two hues of red. The torso is relatively dark red in colour. In the centre of the head and around it, as well as parts of the body, the colour is reddish brown. This detail photo shows the figure after the colours were digitally enhanced. The uncommon colour combination and arms ending in two circles distinguish the figure's identity as one of the powers to which people related. No mortal human has arms ending in circles.

The largest panel was first mentioned by Paulaharju in 1926 (Pauljaharju 1973), but no one knows how long the local inhabitants had known of its existence. This is the panel with the largest variation in figures: human-like figures (Figure 230–232), a reindeer, perhaps a whale, a large chequered pattern and many lines that are difficult to interpret. The surface of the rock has many cracks, and parts of the figures have fallen off and been destroyed. On another panel located on a steep and inaccessible mountainside, there are eight line figures, two of which are human figures painted upside-down (Figure 235), similarly to some of the rock carvings. Perhaps the inference is that the figures are in different dimensions. One possibility, for example, is that they represent deceased persons, or powers in a world below the one inhabited by mortals. At the bottom of the panel there is a human figure positioned horizontally.

In another instance, a reindeer and a human figure are found six or seven metres up on a steep mountainside. To paint this figure would have required the artist to hang from a rope or to stand in a boat during the era when the water level was higher. A fourth panel consists only of a large grid pattern (Figure 29).

Just as in the rock art, the composition of figures in the painted panels varies in the number of figures depicted, the type of figures and their arrangement, as if each panel had a meaning and identity of its own. The variation might mean that they were connected, like the carved figures, with different rituals, histories, seasons and groups of people. If carved and painted figures were complimentary to one another, one might expect that the aim of the figures was somewhat different.

On the whole, the paintings along the coast of Troms and Finnmark appear to be contemporaneous with the rock carvings, but there is far less variation in motifs. The motifs are mainly people, reindeer, elk and geometric patterns. This is in contrast to the paintings found in the coastal areas of Nordland, all of which were found in caves; with one exception, all the figures are human. The greater variation of painted figures on the open rock surfaces suggests a communication medium that has a broader spectrum of meaning than that of the cave paintings, and the difference in locality suggests differing purposes. The paintings in the caves are always located at the threshold between light and darkness (Bjerck & Storvik 1995; Bjerk 2012), perhaps between mortal life as it was lived outside the caves and other-than-human beings life – the powers – in the realm of darkness. The intensity of light at the entrances to caves changes between summer and winter, gradually dwindling as one enters the darkest season of the year. In summer the sun remains above the horizon 24 hours a day during the two summer months, with the least difference between night and day falling when the sun is highest in the sky at the summer solstice. The large seasonal differences have always affected life in the northern regions, and the placement of the figures in caves shows that the factors of light and darkness were important in the context of rituals. Like in the rock art, structure and colour in the rock surfaces were possible factors in the choice of location and of specific caves in which the figures were painted.

The paintings in the Alta area face the sunset, with light and the sun dwindling into darkness; conversely, the figures are in the shade when the sun rises in the east. In one instance we find paintings on the ceiling of a small overhang oriented towards the west. These are paintings that remain continually untouched by sunlight; at most, they exist in a grey zone between light and darkness. In this respect, it is worth mentioning that one of the figures in the large Ruoksesbakti panel

Figure 234
The little reindeer figure is painted approximately six metres above the ground on a nearly vertical surface. The placement would have required that the artists stood on a type of scaffold, were suspended from a rope or stood in a boat, if the painting was made at a time when the sea level was higher up along the wall. The figure is painted upside-down, an orientation that breaks with most of the other figures, both carved and painted. Perhaps the figures are associated with different worlds – the upside-down figure with the world that lay below the one inhabited by mortal humans and animals. Through the medium of figures, people communicated with life in all dimensions of existence, whether above the earth, on it or under it.
Photo: Bjørn Hebba Helberg

PAINTINGS COMMUNICATING WITH THE WORLD OF BEINGS

in Porsangerfjord, the neighbouring fjord to the east, is painted on the underside of a protruding rock overhang and is thus also protected from direct light.

With the exception of this figure, the paintings on the western side of Porsangerfjord are found on rock surfaces oriented towards the east. If locality and orientation have some association with light, and particularly with sunrise and sunset, one might expect to find panels oriented in both directions along the two fjords. The fact is, however, that the paintings in Alta and Porsanger were found by chance, and variation in locality and orientation does not provide an unambiguous picture, in contrast to that provided by the cave paintings, of the role of light as a factor in the choice of location.

Figure 235
Upper left: a human-like figure. Centre: two figures are upside-down, and to the right is yet another figure painted in red. Bottom: a painted human-like figure in horizontal position. The differences have meaning and probably refer to a specific story or ritual. It is difficult to see the figures.

Figure 236A

Figure 236B

Figure 237A

Figure 237B

Figure 238

Figure 239

Figure 236
Distinct remnants of painted figures on the underside of a small overhang. In one photo, the reddish-brown lines can be seen, and in the other version in which the red colour has been digitally saturated, the figures emerge distinctly. At the top, the figure appears to be a human integrated in a geometric pattern, or possibly with the antlers of a reindeer. On both left and right are remnants of other figures. The teeth of time have taken their toll on the figures, and it is uncertain whether my interpretation is correct or not.

Figure 237
This indistinct figure also becomes sharper with the help of digital tools. The geometric figure to the left resembles a bow and arrow; the one in the middle is human-like, but here too it is impossible to draw any categorical conclusions.

Figure 238
A complicated human-like figure painted on the underside of an overhang protruding from the wall on the largest of the Ruoksesbákti panels on the west side of Porsangerfjord. This panel containing the largest and most substantial collection of figures north of the Arctic Circle, is dated to about 2000–500 BC.

Figure 239
In the centre of Hell, the cave at Trenyken on the outmost island in the Lofoten archipelago, we find a broad-legged, human-like figure with three fingers on each hand and three "horns" sticking straight up from the head. This can hardly be a depiction of a human; it is instead one of the powers that comes into view when rays of light penetrate as far as possible into the cave entrance. To the right: some indistinct figures. Over the figures: graffiti defacement.

PAINTINGS COMMUNICATING WITH THE WORLD OF BEINGS 215

A NORTHERN FENNOSCANDIAN PERSPECTIVE

Figure 240
This is perhaps the most well-known of the Zalavruga panels at the mouth of the River Vyg at the far south-western side of the White Sea in Russia. Up to the left, one sees the tracks of skis and poles from three hunters who have pursued three elks and are now killing them with spears and bows and arrows. Amongst the figures to the right are boats with people who have harpooned small whales. The scene depicts hunting and trapping – scenes that may have been used to communicate with the powers in order to ensure supplies of food and provisions.

217

Map of Stone Age rock art from Fennoscandia

Rock art and Landscapes.
Studies of Stone Age rock art from Northern Fennoscandia

Jan Magne Gjerde © 2010

- Carving
- Painting
- Polished

Figure 241
The distribution of rock art made by the populations of Fennoscandia who based their livelihoods on hunting, trapping, fishing and gathering in prehistoric times.
(From: Jan-Magne Gjerde 2010)

The oldest figures in northern Scandinavia are the seven panels with animal figures ground in nearly full natural size into rock surfaces in Nordland County. They may be older than the first figures carved in Alta and the rest of Fennoscandia, and they suggest that figures created on the rock surfaces as part of the communication between humans and other-than-human beings may go back to the first settlement in the northern part of Nordland County.

In relation to the coastal and fjord areas of Northern Norway, the Alta panels in their entirety represent the largest and most comprehensive collection of rock art from the hunter-trapper and fisher population in the region. No panel is identical to any other, and no other areas having rock art have been used over a comparable period of time.

Nevertheless there are some similarities in the choice of what is depicted (and not depicted), and in many instances there are striking similarities between the shapes of the figures. It is obvious that emphasis was placed on depicting figures similar to prototypes, but although reindeer have always looked the way they look today, the figures vary to a great extent. Some of these variations may be a accidental, some may be the product of individual skills, but there are too many recurring patterns through time and space to make this the sole explanation. The structure in the variations suggests that certain norms needed to be observed. How else can one explain the great similarities in contemporaneous figures across large geographical areas? Is the similarity between the large elk figure at Bukkhammaren outside Tromsø and the large elk found in the oldest panel at Kåfjord in Alta simply fortuitous? And are the differences between the two panels merely accidental? How can one explain the similarities and differences between the figures at Slettnes and the contemporaneous panels in Alta? The likeness in the figures may indicate a commonly shared heritage in the stories given meaning through rituals by people in the different areas; likewise, the differences may reflect separate identity markers for various groups of people, families, clans, tribes and settlement inhabitants. The degree to which differences in figures and compositions may reflect differences in material culture and social organisation, beliefs and rituals amongst these hunting-, fishing- and gathering societies, however, is difficult to ascertain. In this respect, the additional archaeological evidence, such as remnants of dwelling structures, implements and evidence of resource exploitation, may provide additional information. The people who lived at the prehistoric dwelling sites located in the same area or region as the rock art were most likely the very creators and users of the rock carvings. For example, the rock art in Alta was associated with people who lived in the coastal, fjord and inland areas in Finnmark and Troms and much less likely with the rock art located in other regions such as Northern Sweden, the Kola Peninsula and Karelia.

The figures and panels in Alta also differ from those on the islands of Lake Kanozero on the Kola Peninsula, with whale scenes (Shumkin et al. 2009; Kolpakov and Shumkin 2012), and from the scenes featuring skiers and white whales in the south-western White Sea area (Savvatejev 1984). Likewise, they differ from the panels with the large number of swan figures on the eastern side of Lake Onega (Poikalainen

Figure 242
Some of the large figures at Leiknes in Ofoten. The killer whale is 7.63 metres long and is the largest figure in all of Fennoscandia's rock art.
Photo: Mari Karlstad

Figure 243
The figures on the islands in Lake Kanozero on the Kola Peninsula are distinctive despite their similarity to some on the panels in Karelia towards the south and in Alta to the west. Here we see a boat with stem shaped like an elk head and a harpoon line to a small whale.

Figure 244
The water washing over the figures may symbolise a river. A large white whale harpooned from six boats is swimming in the river. There are also bear figures, perhaps scavengers or depicted as a symbol/power associated with hunting and trapping.

2000; Ravdonikas 1936a, 1936b) and from the Nämforsen panels in Northern Sweden with their predominance of elk figures (Hallstrøm 1960, Tilley 1991), and finally from the panels in Trøndelag further south in Norway.

The regional differences are obvious and indicate that the stories told and the figures and rituals all had differing content and characteristics. They reflect differences between the peoples in the various regions. It is impossible to delineate any exact geographical or territorial boundaries between these, and in all likelihood there were contacts throughout the coastal area from the White Sea to Trøndelag, the Bay of Bothnia and Karelia. However, the farther the dwelling sites were from one another, the less contact there was between them, such as between Alta, Lake Onega and Trøndelag and Western Norway (Lødøen and Mandt 2005, 2010).

The animal figures in the rock art reflect some of the fauna in the various regions, but they do not reflect the relative natural conditions. The fauna depicted mirrors what people considered to be important. Too many land animals, birds and other fauna are absent to claim otherwise. The same is true of the depictions of life and activities associated with saltwater and fresh water. For example, humpback whales and orcas are found in Alta but are absent from the rock carvings in the White Sea area, Lake Onega and the rock paintings in Finland. Belugas/white whales very likely existed both along the Norwegian coast and in the White Sea, but they occur commonly only in the rock art of the White Sea area and a few in the Onega area (Gjerde 2009, Kolpakov 2007, Poikalainen 2007). In Northern Norway there are no distinct figures of white whales. The rock art of Northern Sweden features elk almost exclusively, whilst in the North-Norwegian coastal area we find both elk and reindeer figures. It is quite clear that the largest animals were the ones that were depicted, animals that must have been very important as sources of food, as elements in the stories that were told and the rituals involving rock art that were performed. In addition, the widespread distribution of elk, reindeer and white whale figures may reflect some regional differences in the fauna as well as in the various cultural groups.

To the extent that rock art also reflects identity, it is probable that there were some general

Figure 245
At Nämforsen in Sweden there are some 2600 figures (Larsson & Broström 2011), mainly elk and human-like figures, boats, a few salmon and geometric patterns. Six thousand years ago they were located at the mouth of the river in Bottenviken, but as the land rose, their link with the riverbed was gradually broken. The figures have been enhanced with paint.

differences between the populations in the two areas. Similar factors evident from the other archaeological material underpin the possibility that there were several cultural groups in the region from the Scandinavian Peninsula in the west to Karelia in the east (Stolyar 2000, 2001). It is likely that the rock carvings and rock paintings in one area were associated with the same group of people but having somewhat different purposes. Because no rock art panel is identical to another, it is probable that some differences may be linked to local groups, clans and their identity. In other words, the figures reflect regional differences in fauna and what is depicted, various stories, rituals, identities and features of material culture at the regional as well as local level.

At the same time, there are clear differences in the way the figures changed over time in terms of form, content and composition in the various areas. The development of no one area is identical with another. There have been numerous and greatly changing differences and similarities throughout time. The variations seen in the archaeological material, including the rock art, from the Norwegian coast in the west and eastward into Russian Karelia show a complicated cultural diversity we are only just beginning to discover (Hood 2012; Skandfer 2012).

The rock paintings in Northern Norway have been traditionally dated to the last 1500 years BC, but some of them are undoubtedly significantly older (Andreassen 2008). Finnish and Swedish research shows that the paintings can also be dated to a time as far back as 5000 BC. In Finland, where the only paintings and choices of motifs found are relatively limited, it is estimated that they are no younger than 1500 BC (Lahelma 2008, Kivikas 1995, 2003).

In about 1700–1500 BC there was a general decline in production of rock art in the northern areas, including Finland and Russian Karelia, whereas there was a sharp increase in rock art associated with the cultures of the Bronze Age (1700–1500 BC) further south in Scandinavia, in regions where the local economy was based on agriculture and animal husbandry, fishing, trapping and bartering. In contrast, relatively few rock carvings can be dated to this period amongst populations in the northern areas who based their subsistence on hunting, fishing and gathering.

The last 500 years BC were an era of upheaval in northern Europe, entailing great changes of a climatic, societal and technological nature. This is the period that coincides with the advent of iron technology in northern Europe. It is also the beginning of the

Figure 246 (p. 222)
The paintings on the rock surfaces in Finland share many common features with those found in the rest of Fennoscandia. Here we see human figures and elk in the Värikallio panel in Northern Finland.
Photo: Jan Magne Gjerde

Figure 247
All the figures along Lake Onega in Karelia were made on the rock surfaces just above the surface of the water. When the water level is highest or in windy weather, the water washes up across the panels. The proximity of rock art to water is the same as in Alta and represents a commonly shared trait of rock carvings in all of Fennoscandia.

Figure 248
The animal figures that dominate the Holtås panel deep inside Trondheimsfjord show similarity to the figures in Period IV in terms of form and content. Both are dated to the youngest part of the Stone Age or early Bronze Age. This can be interpreted not only as a consequence of the contact that existed between north and south, but also as evidence of similarities in artistic style and the content of stories and rituals, as well as changes in rock art over time.

variations in climate that we know occurred during the past two thousand or so years.

Although emphasis has been placed on changes throughout time, it must be pointed out that the very fact that rock art was created in Alta spanning a period of about 5000 years, plus the general tendencies in relation to the types of figures that were chosen (or not chosen), whether carved or painted, show a continuity that cannot be considered incidental.

A NORTHERN FENNOSCANDIAN PERSPECTIVE COMMUNICATING WITH THE WORLD OF BEINGS

FINAL PHASE OF ROCK ART

Figure 249
These figures at the top of the sacred Sami Mount Aldon on the northern side of the Varangerfjord have been dated to 1400–1700 AD. (Simonsen 1979b: 481)

Figure 250
These figures from Badjelannda in Northern Sweden are dated to between 800–1350 AD (Mulk & Bayliss-Smith 2006).

Creation of rock art in the northernmost areas of Europe principally ended some 2000 years ago. Only a few carved figures have been found that date from a later point in time. Some were incised with an iron chisel, such as at Aldon in Varanger (Simonsen 1979) and Melhus in Southern Trøndelag; others were scratched into the steatite surface in Badjelánnda in inland Northern Sweden (Mulk & Bayliss-Smith 2006). These figures are dated to the period between 800–900 to 1500–1700 AD and bear witness to the fact that the tradition of carving figures into rock surfaces continued well into modern historical time. They may be associated with Sami beliefs and cultural traditions. It has been suggested that there was a possible development from the pre-Christian rock carvings and on through the Sami Iron Age up until the time of drum art (Simonsen 1979b: 481, Helskog 1987, Mulk & Bayliss-Smith 2006). It is certain that both the figures carved on the rocks in pre-Christian and post-Christian time, and the Sami drums, represented a part of the communication between mortal humans and the other-than-human beings.

Until the brutal christianization of the Sami culture in the 1700s, figures were painted and scratched onto the drums used by shamans and other members of the Sami societies in rituals aimed at communicating with the other-than-human beings. The drums are a portable medium of communication in contrast with the panels of rock carvings. We do not know, however, how long the drums had been in use (Simonsen 1979; 479–482). They were likely in use long before the Middle Ages because they appear to be depicted amongst the earliest rock carvings in Alta, but we do not know if the figures were painted on the drumheads or were hung from the frame, or if the frame was marked, for example to indicate the number of bears the drum owner had killed (Friis 1871).

The fact that rock art practically disappeared over a large geographical area and amongst all groups of people suggests a very strong and substantial external influence and change in culture. Elements associated with beliefs and rituals involving bears continue to exist strongly in the Sami culture, whilst other elements, such as symbolism involving elks, have been gradually assigned a smaller degree of importance. In other words, changes and the introduction of new ideas and practices have not replaced all existing ideas, beliefs and practices. Some continue in their

earlier forms and suggest continuity and/or common traits that co-mingled with the new; some traits were incorporated and some disappeared altogether.

The mix of existing and new beliefs and symbols and the change in secular symbols over thousands of years reflect not only communication between people and cultures in various regions of northern Europe, but also the ability of people to acquire and adapt to new knowledge, ideas and conceptions. This adaptability has always existed.

Figure 251
A scene from Period II showing four people moving forward. Two are carrying what may be the spoils of the hunt (a bird?). The figure to the left has an expansion in the chest area (breasts?) and is carrying a pole in its left hand. Behind these is a person holding a round object in his left hand and a stick in the right hand, perhaps a drum and a drumstick.

Figure 252
The figures on the drumhead were painted reddish-brown using the sap from alder bark. These figures are painted on a Sami magic drum from the 1600s in Torne Lappmark in Northern Sweden. They depict various powers, humans, animals, boats, tents and, in the centre, a round symbol of the sun.
(See Manker 1950: 420–423)

FINAL PHASE OF ROCK ART COMMUNICATING WITH THE WORLD OF BEINGS

WORLD CULTURAL HERITAGE IN ALTA

The World Cultural Heritage site in Alta is nothing less than fantastic. The figures comprise a handsome picture book offering the engaged reader, whether a casual viewer or a scientific researcher, the opportunity to interpret the images. The meaning that rock art had in various societies through thousands of years will always be a topic of debate. There are regional and local differences, both in a religious and a secular perspective, from prehistoric time and up until today. The study of these differences encompasses a number of different technical specialities, experts in various disciplines, approaches and methods, in a diversity and combination that will always be necessary in order to better understand. This is the situation today, but it has not always been so. The motifs used in parts of the stories and myths in rituals encompassed a body of symbols that were well known to people. They were part of the knowledge that people had about themselves and others; they created and reinforced identity, and some of them served as documentation of specific events.

Nearby several of the rock art panels, traces of dwelling sites have been found that allow us to associate them with the people who created and used the figures. These are both dwelling features from settlements and areas where they made and used implements (Figure 254). Because research has focused until now on the rock art, knowledge about the settlements is extremely limited. Finds do not differ notably from other dwelling sites in the fjord areas of Finnmark and do not provide any basis for claiming that they had any particular association with rituals. The proximity to an unusually large number of figures over a long period of time nevertheless suggests that the head of Altafjord was a place where people met, performed rituals and communicated with each other and with the other-than-human beings for thousands of years. The paintings were an integral part of this as well, but no traces of dwelling sites have been found in the immediate proximity of these. The terrain in which the paintings are located is steep and impassable. Taking into account location and content, it appears that the rock art and the paintings complemented one another.

In the course of the years after about 5000 BC and up until modern historical time, there were clearly observable changes in the content and form of rock art, changes that have been grouped in this study under six time periods. We see both continuity and discontinuity in the figures; some undergo change whilst others remain unaltered. The figures that remained in use as a part of the communication are primarily those depicting large land animals, people and boats. What changed were the relative relationships between figures and their form and content. Parallel with these changes are other signs of change found in the extant archaeological material – structures and technology – which bear witness to the possibility that new ideas may have become part of the stories related and of beliefs and rituals, as well as technology (Helskog 1988, 2000). The changes are relatively distinct and represent some of the strength of the material, as well as one of the main

Figure 253 (p. 226)
It is probable that people believed that everything in the surroundings was alive, or could be living and possessed a soul. This also applies to the hunter-gatherers in historic time in Fennoscandia, in Siberia and other parts of the world as well. For various reasons, places and living beings were perceived as sacred and inhabited by various powers. Other phenomena of nature were perceived as openings between the world of mortals and that of other-than-human beings. In places such as these, contacts and dialogues between mortals and other-than-human beings were initiated. Based on the figures in this photo – snowshoes, boats, people, foot soles, dolphins, reindeer and an abstract pattern – the commuinication comprised many different themes and purposes.

Figure 254
The white posts mark two shallow depressions indicating dwelling sites of the people who likely created and/or used the figures during Periods II and/or III. The dwellings measured about 6 × 4 metres interior area, founded on a terrace of pebbles and therefore well drained. Random investigations in the dwelling sites yielded no finds.

Figure 255
The figure shows a section from the period having the greatest number of figures in Alta. This was very likely also the longest period of rock art. We see human figures with elk-head poles, boats, reindeer, elk, dolphins, bears, spears, abstract patterns, and a halibut on a fishing line and, at the top, possibly the face of a human-like being. In the subsequent periods, both the number and diversity of figures declines dramatically up until about two thousand years ago, when the use of rock art appears principally to have ended.
Photo: Adrian Icagic

reasons why the rock art in Alta has been designated a World Cultural Heritage site. Another reason is that the figures themselves are stunning, and the many unique compositions featuring bear, reindeer, elk and human-like figures impart stories about which we can only speculate.

Continuity over 5000 years shows that the figures held important roles in both sacred and secular contexts. The changes in form and content suggest both that there were variations over the same theme, such as the relationship to bears, and that some stories changed and others disappeared. The changes between the six periods suggest that the concepts the figures represent did not remain static throughout the years when rock art was created. When changes in the general characteristics of rock art coincide with other changes, it is likely that we are in the presence of a large diversity of changes, although this does not permit us to claim that changes were dependent

Figure 256
The rock carvings show that elk (Alces alces) were an important symbol in people's beliefs and rituals. The fact that bones of elk have not been found in the refuse mounds of the Stone Age does not necessarily mean that elk were not hunted animals, but rather that the remnants were disposed of in another way. Judging from the rock art, we can conclude that elk were an important element in the fauna. The figure is from Period II.

on one another. In other words, the many meanings of rock art can be researched both in relation to the society of which it was a part and in relation to the changes that took place between the forms of society.

In terms of content, all six periods are very different in terms of the numbers of figures, their form and content. After the few figures representing Period I, there is an "explosion" of figures during Period II, followed by a reduction in each of the subsequent periods leading to a paucity of figures in Period VI. For this reason, and because of the large variation in content, Period II has proportionately been given much more space than the other periods. Provided that the temporal placement is correct, it is clear that many more figures were created during the period of approximately 4800–4000 BC than were made in any other time period. Alternatively, the figures may have been created over a longer period of time than assumed, an issue which will debated in the years to come. The difficulties involved in dating the rock art in Alta and in other places entail that debate concerning to the age, content, continuity and degree of change will continue.

The substantial changes in form and content, in the very expression of figures, for example in the human-like figures in Periods III and IV, are grounds to believe that there were significant differences in people's conceptions relating to other-than-human beings. Whilst many of the figures in Period III may depict people in action, the figures in Period IV have primarily non-human characteristics. Between Periods IV and V, and Periods V and VI, the changes are equally large, although they are significantly different. For example, in Period V there are boat figures, in contrast to Period IV, and 99 per cent of the animal figures depict reindeer. Amongst the few figures in Period VI, 88 per cent are boats depicted with other shapes than in Period V, and there is also an elk and a skier. The marked changes between the periods suggests both that depictions in concepts in stories, beliefs and rituals changed over time, and that there were local variations in relation to the rock art found in other places. The diversity can be explained by hypothesizing that there was always a considerable contact between people in the northern regions; new ideas were adapted or replaced older ideas, newcomers moved into the area, and it was also important to maintain and signalise their identity.

It was important for people to maintain good relations with the other than human beings when their environments changed as a result of moving to new places for permanent or seasonal settlements, and to observe rites associated, for example, with births, illness and death, hunting and trapping. Communicating with the world of beings applied to the present as well as the future.

In this perspective, the similarities and differences between the rock art in Alta and northern Fennoscandia are fascinating and complex. No panels are identical, although there are many common features and similar figures. How can they be explained? Does each panel have an identity that refers to a specific story or group of people, such as a family or clan? Rock art as a visual medium in the communication between people

Figure 257
One of the features that characterise Period II is the depiction of reindeer enclosures illustrating drive hunting, the most efficient form of hunting reindeer, where people drive the animals over a cliff, into bodies of water, into a net or an enclosure and kill them. The photograph shows one of the large enclosures in Alta and its interplay with the colours and topography of the rock (see Figures 55 and 57). Inside the enclosure there is a human figure with a spear (?), 42 reindeer and a bear standing in the entrance of its den. The figures provide a good illustration of efficient hunting techniques, and the presence of the bear reminds us that the message itself is perhaps as much about the perception people had of the relationship between animals, people and the powers. Is there a relationship between bears and hunting reindeer? Why else would one find a bear in the middle of such an enclosure?

Rock art like this is not found anywhere else in the world.

Figure 258
A human-like figure with one arm shaped almost like a bird's wing. The other limb resembles a human arm. Extending up from the groin is an erect penis (?). Period III.

and other people as well as between people and other than human beings represents a body of identifying, fortifying and sustaining symbols. One question that frequently arises is whether some persons were more privileged or had more of a right than others to communicate with or via the figures? Were the figures communal assets or were they reserved for a few privileged users? Was there a distinction between private and public use of the figures? There is no clear and unequivocal answer to these questions. The interpretation that a special elite, shamans, performed the rituals as a link between mortals and the other-than-human beings has often been based on the idea that such persons, men or women, were common amongst hunting, fishing and pastoral societies in the northern regions in historical time (Stoljar 2000M; Berg 2004; Lahelma 2008). This does not rule out the possibility, however, that others also used the rock art in similar ways, in both a private and public context. These special persons undoubtedly decided where the figures were to be created. The choice of location can have been based on several factors. The location of the

figures in the shore zone or in the immediate vicinity of water had a meaning, perhaps as a meeting place between mortal humans and the other-than-human beings residing in the sky, on earth or under the earth and in/under water. Within this zone special places were chosen because of their suitability for communications between humans and other-than-human beings. Some of these places may have been chosen due to features such as veins of quartz, various colours and faults in the rock, depressions, etc.

Another question is whether mythology, legends and symbols represent a general superstructure shared by people throughout the entire northern Fennoscandia, or whether they were associated with specific, local populations or individuals. The answer is certainly a combination of the two. There are special figures and features in the rock art of Alta that make them germane to the rock art found at other places. The fact that these figures and features change over time suggests not only that there was direct and indirect contact between the people in Alta and those of other places, but also that certain features in the system of beliefs, rituals and illustration of life were commonly shared. At the same time, all of them have traits that give them unique identities.

In a society that has no clear distinction between people and the natural surroundings, people and other-than-human beings communicated with one another in order to obtain, explain or illustrate certain aspects of life, whether they be a successful hunt, fishing, love, illness, revenge, death, the existence of animals, the cyclical changes of seasons, the weather, stars, northern lights, mountain formations, colours, etc. People must have perceived this as an essential need, and because most of what existed might have possessed a soul like the humans did, there was principally no difference between human beings and the others. In this respect, all details had a meaning, and people must have been aware of, and explained, these details in other ways than through modern, rational science. The colours and structure in the rock resembling a bear may have been perceived as something other than the bear encountered in physical nature, but nonetheless as a bear in the rock (Figure 67). In other words, the colours, structures and topographical shapes in some places and at various times may have been just as important for the meaning of the rock art as the figures per se. Human-like faces such as naturally formed on rock surfaces associated with painted figures in Finland may have had such a role. Other places had "openings" in the rock itself; colours, structures and minerals had a meaning (Tansem & Johansen 2008). Along with the figures, such natural features may have carried meaning, but it should not be concluded that this was always the case. There appear to be no clear answers, and obviously there were differences and changes through time and space.

The visibility of the figures and structures in the rock surface also varies according to the angle of light falling on them. In low sunlight, the shadows are long and bring out the structure in the rock and in the figures, whereas in direct light and under cloudy skies visibility is poor. Direct sunlight in the Alta area, and in the rest of the Arctic region, varies greatly with the seasons, from a circle lying low on the horizon to a radiant globe high in the sky, to a sun that never rises above the horizon for two months of the year. Humid conditions also bring out the structures in the rock surfaces. Yet another factor is that the figures in the tidal zone were directly visible only during certain hours of the day. My belief is that these factors probably also played a role in the choice of times when rituals were to be performed, or were able to be performed. Forty years of experience with rock art in the Alta area has taught me how important light is for examining the figures, even though they were created

Figure 259
The illustration of possible breasts and the lack of a penis suggests that this figure is a female, although it is doubtful that it is a human. To the left, below the compass, is a human figure, and to the right, figures that appear to be reindeer, humans and abstract shapes. They are very indistinct. From Period IV.

Figure 260
The rock carvings on the shores of Lake Kanozero on the southern side of the Kola Peninsula were discovered in 1997 (Kolpakov & Shumkin 2012). Amongst these we find scenes such as the one in this photo, where a large white whale is being harpooned from four boats. Down to the right there is a herd of reindeer/elk, and above them another white whale being harpooned. In terms of content, the panels are very unlike those in Alta and show some of the differences in stories told and the way identity was signalised.

Figure 261
One of the panels on the eastern side of Lake Onega in Karelia. The swan is the most frequently found (44%) motif. Some of these are up to two metres tall; following these, there are figures of elk, humans, boats, implements and abstract shapes. In contrast to those found in Alta, these figures have always been located in the shore zone, and it is obvious that ice and water have eroded away parts of the rock around the figures. As in Alta, the colours and structures in the rock may have been ascribed meaning and were therefore one of the reasons why the figures were created in these shoreline zones.

in the tidal zone. Light brings the figures and the rock surface to life.

The rock art in Alta was created and used by people in societies whose existence was based on hunting, trapping, fishing and gathering of plants and berries. Beliefs, stories and religious or profane practices would have been strongly associated with the exploitation of resources, the concept of subdivision of the world and all other aspects of human existence. To survive successfully, it was necessary to perform the right acts/rituals (sacred or profane) through forms of communication with people and other-than-human beings. Communication encompassed all aspects of life from daily routines such as hunting and fishing to major occurrences such as sickness and death. Rock art was a part of this communication, hence the title given to this book *Communicating with the world of beings*.

Figure 262
The boat figures in Alta changed form and content many times over 5000 years. Some have features in common with figures in other areas of Fennoscandia, but differences may suggest that they were adapted to different purposes, geographic and climatic conditions, and also served as identifiers of various beliefs and identities. The boat figures from the Late Iron Age and up until more modern time can be seen in a similar perspective. This boat was probably created towards the end of Period V or during Period VI. The lines are narrow and indistinct, and on the bow one finds what appears to be an animal's head – a horse, reindeer or something else. This is one of four similar boat figures found on one panel, and it is unique in a Northern Fennoscandinavian perspective.

To attempt to understand this communication it has been necessary to consult ethno-historical descriptions and studies of the beliefs, rituals, stories and social organisation of societies primarily based on hunting, trapping, fishing, gathering and/or reindeer husbandry. In other words, societies in Fennoscandia and Siberia, Greenland, Northern Canada and Alaska, where the natural conditions are relatively similar to Northern Fennoscandia during prehistoric time. This material is very diverse, opening for many alternative interpretations. There are no definitive answers.

The archaeological material in Northern Fennoscandia shows that there were technological and societal changes, as well as a degree of continuity, throughout all of prehistoric time and into historical time. The settlements in the coastal and inland areas were founded on hunting, trapping and fishing, and judging from the archaeological research and historical sources, the people who lived in Finnmark and Northern Troms some two thousand years ago were primarily of Sami origin (Hansen and Olsen 2004: 41, Simonsen 1979b, Hætta 1994,1995). A source to be taken into account is that of the Northern Norwegian trader Ottar (who lived near what is now the city of Tromsø) who reported to King Alfred of England in about 890 AD that to the north there was a sparsely populated area almost exclusively inhabited by Sami, although there had also been Norse hunting and trapping expeditions in these northern regions.

The few figures dated to the Middle Ages and more modern time, as well as the figures of Sami drums, also suggest continuity in the use of figures in communication with other-than-human beings and as illustrations of specific identities. Thus early Sami beliefs and practices, concepts and ways of exploiting the natural resources are important sources for understanding the use and meaning of the rock art in Northern Fennoscandia.

The rock art expresses a worldview that was imparted via an aesthetic, visual medium that will remain an object of admiration and future research. It is a heritage left to us by the earliest settlers of northern Fennoscandia and a treasure that we are morally obligated to protect and preserve as best we can. It is a part of the region's soul.

Figure 263
Altafjord, a magnificent body of water for boating and enjoying the landscape of which the rock art was and still is an integral part. It is midnight and summer solstice.

REFERENCES

A

Andreassen, R. L., 2008. Malerier og ristninger – bergkunst i Fennoskandia. *Viking*, 71, 39–60.

Andreassen, R. L., 2011. Rock art in Northern Fennoscandia and Eurasia – painted and engraved, geometric, abstract and anthropomorphic figures. *Adoranten*, 1–13.

Anisimov, A., 1963. Cosmological concepts of the people in the north. In H. Michael (ed.) *Studies in Siberian Shamanism*. Toronto: University of Toronto Press, 157–229.

B

Berg, B., 2004. Sjamanisme og Helleristninger. *Gjenreisningsmuseets skriftserie*, 2, 48–59; Hammerfest: Gjenreisningsmuseet for Finnmark og Nord-Troms.

Bjerck, H. B. & K. O. Storvik., 1995. *Menneskene i kollmørket: hulemalingene i Revsvika*, Bodø: [Nordland fylkeskommune].

Bjerk, H. B., 2012. On the Outer Fringe of the Human World: Phenomenological Perspectives on Anthropomorphic Cave Paintings in Norway. In K. A. Bergsvik & R. Skeates (eds), *Caves in Context. The Cultural Significance of Caves and Rock-shelters in Europe*, 48–64. Oxford: Oxbow Books.

Bogoras, V. G., 1975. *The Chukchee*, New York: AMS Press.

C

Carpelan, C., 1975. Elg och bjørnhuvudføremål från Europas nordliga delar. *Finsk Museum*, 5–67.

Clottes, J. & Arnold, M., 2003. *Chauvet Cave: the art of earliest times*, Salt Lake City: University of Utah Press.

Crumlin-Pedersen, O. & Trakadas, A. (eds), 2003. *Hjortespring: a pre-roman iron-age warship in context*. Roskilde: The Viking Ship Museum.

E

Edsmann, C.-M., 1994. *Jegaren och makterna: samiska och finska bjørneseremonier*, Uppsala: Dialekt och folkeminnesarkivet i Uppsala.

Elgström, O. & Manker, E., 1984. *Björnfesten : en bildberättelse*, [Umeå]: Norrbottens museum.

Engelstad, E., 1986. *The Iversfjord locality a study of behavioral patterning during the Late Stone Age of Finnmark, North Norway*, Ann Arbor, Mich.: University Microfilms.

Engelstad, E., 1988. Pit-Houses in Arctic Norway. An Investigation of their Typology Using Multiple Correspondence Analysis. In T. Madsen (ed.), *Multivariate Archaeology. Numerical Approaches in Scandinavian Archaeology*, 71–84. Aarhus: Aarhus University Press.

Engelstad, E., 2001. Desire and body maps: all the women are pregnant, all the men are virile, but ... In K. Helskog (ed.), *Theoretical Perspectives in Rock Art Research*, 263–289. Instituttet for sammenlignende kulturforskning, Ser B: Skrifter Vol CVI. Oslo: Novus forlag.

Era-Esko, A., 1958. Die Elchkopfskulptur vom Läthojarvi in Rovaniemi. *Suomen Museuo*, (65), 8–18.

Evers, D., 1988. *Felsbilder arktischer Jägerkulturen des steinzeitlichen Skandinaviens*. Stuttgart: Steiner.

Evers, D., 1991. *Felsbilder : Botschaften der Vorzeit*. Leipzig: Urania.

F

Friis, J. A., 1871. *Lappisk Mythologi : Eventyr og Folkesagn; Lappiske Eventyr og Folkesagn*. Christiania: Cammermeyer.

Furuset, O., 1995. *Fangstgroper og ildsteder i Kautokeino kommune*. In Stensilserie B Tromsø: Institutt for Samfunnsvitenskap, Universitetet i Tromsø, 60.

G

Gill, T., 2006. Utgravninger i Tollevika, Alta kommune 2005. Rapport. *Topografisk arkiv*. Tromsø: Tromsø Museum – The University Museum.

Gjerde, J. M., 2009. Kvithvalens landskap og helleristninger ved Vyg, Kvitsjøen, Nordvest-Russland. *Viking* 72, 49–72.

Gjerde, J. M., 2010. *Rock art and Landscapes. Studies of Stone Age rock art from Northern Fennoscandia*. Ph.D. A dissertation for the degree of Philosophiae Doctor, Faculty of Humanities, Social Sciences and Education. Tromsø: The University of Tromsø.

Gjessing, G., 1932. *Arktiske helleristninger i Nord-Norge*. Oslo: Aschehoug.

Gjessing, G., 1936. *Nordenfjelske ristninger og malinger av den arktiske gruppe*. Oslo: Aschehoug.

Gjessing, G., 1942. *Yngre steinalder i Nord-Norge*. Oslo: Aschehoug.

Gjessing, G., 1945. *Norges steinalder*. Oslo: Norsk arkeologisk selskap: Forthcoming: Tanum.

Gurina, N. N., 1956. *Oleneostrovskij mogil'nik: vstupitel'noj stat'ej V.I. Ravdonikasa*. Materialii Issledovania po Arkeologii CCCP, 47. Moscow: Akademi NAUK.

H

Hagen, A., 1976. Bergkunst. *Jegerfolkets helleristninger og malninger i norsk steinalder*. Oslo: Cappelen.

Halinen, P., 2005. *Prehistoric hunters of northernmost Lappland: settlement patterns and subsistence strategies*. Helsinki: Finnish Antiquarian Society

Hallström, G., 1938. *Monumental Art of northern Sweden from the Stone Age*. Stockholm: Thule.

Hallström, G., 1960. *Monumental Art of northern Sweden from the Stone Age: Nämforsen and other localities*. Stockholm: Almqvist & Wiksell.

Hansen, L. I. & Olsen, B., 2004. *Samenes historie*, Oslo: Cappelen akademisk forlag.

Helskog, E., 1983. *The Iversfjord locality. A study of behavioral patterning during the late stone age of Finnmark, North Norway*. Tromsø: Tromsø Museum Skrifter, vol XIX.

Helskog, K., 1984. The Younger stone age settlement in Varanger: North Norway: settlement and population size. *Acta Borealia*, 1 (1984), 1, 39–70.

Helskog, K., 1985. Boats and Meanings. A Study of Change and Continuity in the Alta fjord, North Norway, from 4200–500 BC. *Journal of Anthropological Archaeology*, 4, 177–205.

Helskog, K., 1987. Selective Depictions: A study of 3700 years of rock carvings from Arctic Norway and their relationships to the Sami drums. In Hodder, I. (ed.), *Archaeology as long-term history*. Cambridge: Cambridge University Press.

Helskog, K., 1988. *Helleristningene i Alta: spor etter ritualer og dagligliv i Finnmarks forhistorie, Alta*: K. Helskog, distributed by Alta museum.

Helskog, K., 1995. Male and femaleness in the sky and the underworld – and in between. In K. Helskog & B. Oslen, *Perceiving Rock Art: Social and Political Perspectives*, 247–262. Instituttet for sammenlignende kulturforskning, Ser B: Skrifter XCII. Oslo: Novus forlag.

Helskog, K., 1999. The Shore Connection. Cognitive Landscape and Communication with Rock Carvings in Northernmost Europe. *Norwegian Archaeological Review* 32 (2), 73–94.

Helskog, K., 2000. Changing Rock Carvings – Changing Societies? A case from arctic Norway. *Adoranten. Scandinavian Society for Prehistoric Art*, 5–16.

Helskog, K., 2009. Interpreting Bear Imagery in the Spirit of Gutorm Gjessing. In Westerdahl, C. (ed.), *A Circumpolar Reappraisal: The Legacy of Gutorm Gjessing*, 123–32. BAR International Series 2154, Oxford: Archaeopress.

Helskog, K., 2010. From the tyranny of the figures to the interrelationship between myths, rock art and their surfaces. In G. Blundell, C. Chippindale & B. Smith, *Seeing and Knowing. Understanding rock art with and without ethnography*, 169–187. Johannesburg: Wits University Press.

Helskog, K., 2011. Reindeer corrals 4700–4200 BC: Myth or reality? *Quaternary International* 238, 25–34.

Helskog, K., 2012. Bears and Meanings amongst Hunter-fisher-gatherers in Northern Fennoscandia 9000–2500 BC. *Cambridge Archaeological Journal* 22:2, 209–36.

Henschilwood, C. S., Francesco d'Errico, F., van Niekerk, K. L., Coquinot, Y., Jacobs, Z., Lauritzen, S-E., Michel Menu, M. & García-Moreno, R., 2011. A 100,000-Year Old Ochre Processing Workshop at Blombos Cave, South Africa. *Science* 334, 219–222.

Hesjedal, A., 1994. *Helleristninger som tegn og tekst : en analyse av veideristningene i Nordland og Troms*, Tromsø: Institutt for samfunnsvitenskap, Universitetet i Tromsø.

Hesjedal, A., Storli, I. & Olsen B., 1996. *Arkeologi på Sletnes: dokumentasjon av 11.000 års bosetning*. Tromsø: Tromsø Museum Skrifter 26.

Honko, L., Timonnen, S., Branch, M. & Bosley, K., 1993. *The Great Bear. A thematic Anthology of Oral Poetry in the Finno-Ugrian languages*, Peiksamaki: The Raamattutalo Press.

Hood, B., 1988. Sacred Pictures, Sacred Rocks: Ideological and Social Space in the North Norwegian Stone Age. *Norwegian Archaeological Review* 21 (2), 65–84.

Hood, B., 2012. The Empty Quarter? Identifying the Mesolithic of Interior Finnmark, North Norway. *Arctic anthropology*, 49, 105–135.

Hood, B. & Helama, S., 2010. Karlebotnbakken reloaded: shifting chronological significance of an iconic late stone age site in Varangerfjord, North Norway. *Fennoscandia Archaeologica*, 35–43.

Hætta, O. M., 1994. *Samene : historie, kultur, samfunn*. Oslo: Grøndahl Dreyer.

Hætta, O. M., 1995. Rock carvings in a Saami perspective: some comments on politics and ethnicity in archaeology. In K. Helskog & B. Olsen, *Perceiving Rock Art: Social and Political Perspectives*, 348–356. Oslo: Novus forlag.

Hætta, O. M., 1996. Archaelogy – A link between past and present? In E. Helander (ed.) *Awakened voice*, 13–20. Kautokeino: Nordic Sami Institute.

I

Ingold, T., 2000. *The perception of the environment : essays on livelihood, dwelling and skill*, Routledge.

K

Kalstad, J. A., 1997. Slutten på trommetida – og tiden etter. *Ottar* 217, 126–84.

Khlobystin, L., 2005. Taymyr. *The Archaeology of Northernmost Eurasia*. Contributions to Circumpolar Archaeology 5, National Museum of Natural History. Washington: Smithsonian Institution.

Kivikäs, P., 1995. *Kalliomaalaukset : muinainen kuva-arkisto*, Jyväskylä: Atena.

Kivikäs, P., 2003. *Ruotsin pyyntikulttuurin kalliokuvat suomalaisin silmin*, Jyväskylä: Kopijyvä.

Kolpakov, E. M., 2007. Petroglyphs of Kanozero: typological analysis. In *Kanozero Petroglyphs. Rock history of Kanozero. 50 centuries, 10 years from the opening day*, 64–65. The Kirovsk international conference on rock art.

Kolpakov, E. M., Murashkin, A. I. & Shumkin, V. Y., 2008. The Rock Carvings of Kanozero. *Fennoscandia archaeologica*, 25, 86–96.

Kolpakov, E. M. & Shumkin, V. Y., 2012. *Rock Carvings of Kanozero*. Saint-Petersburg: St. Petersburg State University Faculty of Philology.

L

Lahelma, A., 2008. *A Touch of Red. Archaeological and Ethnographic Approaches to Interpreting Finnish Rock paintings*. Iskos, 15, 278.

Larsson, T. B. & Broström, S. G., 2011. *The Rock Art of Nämforsen, Sweden. The survey 2001–2003*. Umeå: Department of historical, Philosophical and Religious Studies, Umeå University.

Lødøen, T. & Mandt, G., 2010. *The Rock Art of Norway*. Oxford: Oxbow Books.

M

Mandt, G. & Lødøen, T., 2005. *Bergkunst*. Oslo: Samlaget.

Manker, E., 1938. *Die Lapische Zaubertrommel I*. Acta Lapponica I. Stockholm: Thule.

Manker, E., 1950. *Die Lappische Zaubertrommel II.* Acta Lapponica VI. Stockholm: Hugo Gebers förlag.

Moshinskaia, V. I., 1953. *Materialnaia kultura I khoziaiastvo Ust'-Poloya.* Russian Academy of Sciences, Moscow.

Mulk, I.-M. & Bayliss-Smith, T., 2006. *Rock art and Sami sacred geography in Badjelánnda, Laponia, Sweden: sailing boats, anthropomorphs and reindeer.* Umeå, Sweden: Dept. of Archaeology and Sami Studies, University of Umeå.

Myrstad, R., 1996. *Bjørnegraver i Nord-Norge.* Hovedfagsoppgave, Institutt for samfunnsvitenskap 100. Tromsø: University of Tromsø.

N

Nummedal, A., 1929. *Stone Age Finds from Finnmark.* Oslo: Aschehoug

O

Olsen, B., 1993. Hus mellom steinalder og historisk tid. *Ottar* 194, 36–46.

Olsen, B., 1994. *Bosetning og samfunn i Finnmarks forhistorie.* Oslo: Universitetsforlaget.

P

Pauljaharju, S., 1973. *Finnmarkens folk.* Stockholm: Rabén & Sjogren.

Poikalainen, V., 2000. Prehistoric Sanctuary at Lake Onega. In A. Kare (ed.), *Mayandash. Rock Art in the Ancient Arctic,* 242–287. Rovaniemi: Arctic Centre Foundation.

Poikalainen, V., 2007. Onega Petroglyphs. In *Kanozero Petroglyphs. Rock history of Kanozero: 50 centuries, 10 years from the opening day,* 73–76. Kirovsk: The Kirovsk international conference on rock art.

R

Ravdonikas, V. I., 1936a. Kizucheniyu naskal'nykk izobrazhenii Onezhskogo ozera i Belogo Morje. *Sovjetskaya Archeologica,* 1936 (I), 9–50.

Ravdonikas, V. I., 1936b. *Nazkal'nye izobrazenija Onezkogo ozera i Belogo Morja.* Moscow: Izdatel'tsvo Akademii Nauk SSSR.

Renouf, M. A. P., 1981. *Prehistoric coastal economy in Varangerfjord, North Norway: the analysis of faunal material and the study of subsistence patterns in the inner area of Varangerfjord during the younger Stone Age, from 5800 to 2500 B.P.* Doctoral dissertation, Cambridge, UK (see also: *Prehistoric hunter-fishers of Varangerfjord, Northeastern Norway: reconstruction of settlement and subsistence during the Younger Stone Age.* Oxford: BAR international series; 487. 1989.

Røed., K., Ø-Flagstad, H., Bjørnstad, G. & Hufthammer, A. K., 2011. Elucidating the ancestry of domestic reindeer from ancient DNA approaches. *Quarternary International* 238, 83–88.

S

Savatejev, Y., 1970. *Arkheologicheskiye pamayatniki nizovya reki Vyg 1: Petroglifi.* Leningrad: Akademii Nauka.

Savvatejev, J. A., 1984. *Karelische Felsbilder*. Leipzig: Seemann.

Schanche, K., 1994. *Gressbakkentuftene i Varanger. Boliger og sosial struktur rundt 2000*. Doctoral dissertation, 271 pp, Institutt for samfunnsvitenskap. Tromsø: Universitetet i Tromsø.

Shumkin, V., 1990. The Rock Art of Russian Lappland. *Fennoscandia Archaeologica*, VII, 53–67.

Shumkin, V., 2009. http://kae.rekvizit.ru/olen/olintr.htm

Simonsen, P., 1958a. *Arktiske helleristninger i Nord-Norge II*. Oslo: Aschehoug.

Simonsen, P., 1958b. Recent research on East Finnmark's Stone Age. *Rivista di Scienze Preistoriche*, 13(1), 131–50.

Simonsen, P., 1961. *Varanger-funnene II. Fund og udgravninger på fjordens sydkyst*, Tromsø.

Simonsen, P., 1962. *Nord-Norges bosetningshistorie i oldtiden*. Tromsø: Tromsø museum.

Simonsen, P., 1979a. *Juntavadda og Assebakte : to utgravninger på Finnmarksvidda*. Tromsø: Universitetsforlaget.

Simonsen, P., 1979b. *Veidemenn på Nordkalotten, Yngre Steinalder*. Stensilserie B – Historie 4 Tromsø: Institutt for Samfunnsvitenskap, Universitetet i Tromsø.

Simonsen, P., 1991. *Fortidsminner nord for polarsirkelen*, Oslo: Universitetsforlaget.

Simonsen, P., 1992. *Alta-kraftverkene : kulturhistoriske registreringer og utgravninger 1983*, Tromsø: Tromsø Museum, universitetets museet i Tromsø.

Simonsen, P., 1996. Ottar fra Hålogaland. In S. Nesset & H. Salvesen (ed.), *Ultima Thule: et skrift i anledning universitetetbibliotekets utstilling om det ytterste nord*, 31–42. Ravnetrykk 7. Tromsø: universitetsbiblioteket i Tromsø.

Simonsen, P., 2001. Alta-kraftverkene. Kulturhistoriske registreringer og utgravninger 1984–1987. *TROMURA*. Tromsø: Tromsø Museum.

Simonsen, P. & Odner, K., 1963. *Fund og udgravninger i Pasvikdalen og ved den østlige fjordstrand*. Tromsø: Tromsø Museums Skrifter VII (III).

Skandfer, M., 2003. *Tidlig, nordlig kamkeramikk: typologi, kronologi, kultur*. Dissertation for the degree of dr.Art. electronic resource. Tromsø: Universitetet i Tromsø.

Skandfer, M., Grydeland, S. E., Henriksen, S., Nilsen, R. & Valen, C. R., 2010. *Tønsnes havn, Tromsø kommune, Troms. Rapport fra arkeologiske utgravninger i 2008 og 2009*. TROMURA, 40, 219 sider.

Skandfer, M., 2012. Technology Talks: material diversity and change in Northern Norway 3000–1000 BC. In Prescott, C. & Glørstad, H. (eds), *Becoming European*, 128–143. Oxford: Oxbow Books.

Sognnes, K., 2003. On shoreline dating of rock art. *Acta Archaeologica*, 74, 189–209.

Stolyar, A. D., 2000. Spiritual treasures of ancient Karelia. In A. Kare (ed.), *Mayandash*, 136–173. Jyväskylä: Gummerus Kirjaoaino Oy.

Stolyar, A. D., 2001. Milestones of Spiritual Evolution in Prehistoric Karelia. *Folklore*, 80–126.

Storli, I., 2004. Ohthere – viking and World Traveler. In S. Wickler (ed.) *Archaeology of North Norway*, Way North, Tromsø: Tromsø University Museum.

Søborg, H. C., 2006. Mannen i mitt liv og bergkunsten i Alta. In R. S. M. Brandon, K. K. Innselet & T. K. Lødøen (eds); *Samfunn, symboler og identitet – Festskrift til Gro Mandt på 70-årsdagen*, 423–438. UBAS Nordisk 3 – Arkeologiske Skrifter. Bergen: Universitetet i Bergen.

T

Tanner, V., 1929. *Antropogeografiska studier inom Petsamo-området*. I. Skolt-lapparna, Helsinki: Societas Geographica Fenniae.

Tansem, K. & Johansen, H., 2008. The World Heritage Rock Art in Alta. *Adoranten*, 65–84.

Tilley, C., 1991. *Material culture and text: the art of ambiguity*. London: Routledge.

V

Vorren, K.-D., 1976. På spor etter det eldste jordbruk i Nord-Norge. Hva kan botanisk forskning fortelle? In *På sporet etter fortidens mennesker i Nord-Norge*, 13–18.

Vorren, Ø., 1958. Samisk villreinfangst i eldre tid. *Ottar*; nr 17 (1958 nr 2), 42 s.

Vorren, Ø., 1975. Undersøkelser over villrein fangstanlegg i Norges samestrøk. In H. Hvarfner, *Jakt och fiske: nordiskt symposium om livet i en tradisjonell jäger- och fiskarmiljö från förhistorisk tid fram till våra dagar*, Luleå: Norrbotn museum.

Vorren, Ø., 1998. *Villreinfangst i Varanger fram til 1600–1700 årene*. Stonglandseidet: Nordkalott-forlag.

Vorren, Ø. & Manker E., 1976. *Samekulturen: en kulturhistorisk oversikt*, Tromsø: Universitetsforlaget.

Z

Zachrisson, I., 1981. En björngrav från Jämtland. *Jåmten: Heimbygdas årsbok*, 74, 83–88.

Zachrisson, I. & Iregren, E., 1974. *Lappish bear graves in Northern Sweden : an archaeological and osteological study*. Early Norrland 5. Stockholm: Kungl. Vitterhets-, historie- och antikvitetsakademien.